PIONEERS OF MODERN DESIGN

Sir Nikolaus Pevsner, who was born in 1902 and educated at Leipzig, is Emeritus Professor of the History of Art at Birkbeck College, University of London, and from 1949 to 1955 was Slade Professor of Fine Art and a Fellow of St John's College, Cambridge. He took a Ph.D. in the History of Art and Architecture in 1924 and was successively connected with the Universities of Leipzig, Munich, Berlin, and Frankfurt. For five years he was on the staff of the Dresden Gallery, and whilst a lecturer at Göttingen University from 1929 to 1933 he specialized in the history of art in Great Britain.

Since its inception he has edited the *Pelican History of Art* and *Architecture* and has written over thirty volumes of *The* Buildings of England by counties. He is a Royal Gold Medallist of the R.I.B.A., an honorary doctor of Leicester, York, Leeds, Keele, Warwick, Zagreb, and Oxford Universities, an honorary fellow of St John's College, Cambridge, F.S.A. and F.B.A. He is also reckoned among the most learned and stimulating writers on art alive.

His book on Italian Painting of Mannerism and Baroque is considered a standard work, and among his other publications are: An Inquiry into Industrial Art in England, German Baroque Sculpture, High Victorian Design, Sources of Modern Art, The Englishness of English Art (Reith Lectures, 1955) and Pioneers of Modern Design. The last two have been published in Penguins. He has also written Studies in Art, Architecture and Design, The Anti-Rationalists and Some Architectural Writers of the Nineteenth Century; and is coauthor of the Penguin Dictionary of Architecture. His latest book is A History of Building Types (1976) which won The Wolfson Literary Award.

Sir Nikolaus is a widower and has three children and several grandchildren. He lives in Hampstead.

PIONEERS OF MODERN DESIGN

FROM
WILLIAM MORRIS
TO
WALTER GROPIUS

Penguin Books

Penguin Books, Ct3, Madison Avenue, New York, New York 10022, U.S.A.
Penguin Books, Gt5 Madison Avenue, New York, New York 10022, U.S.A.
Penguin Books Australia Ltd, Ringwood, Victoria, Australia
Penguin Books Canada Ltd, 2801 John Street, Markham, Ontario, Canada L3R 1B4
Penguin Books (N.Z.) Ltd, 182-190 Wairau Road, Auckland 10, New Zealand

First published by Faber & Faber under the title Pioneers of the Modern Movement, 1936 Second edition published by the Museum of Modern Art, New York, 1949 Copyright © The Museum of Modern Art, 1949

This revised and partly rewritten edition published by Penguin Books, 1960 Reprinted 1964, 1966, 1968, 1970, 1972 Reprinted with revisions 1975 Reprinted 1976, 1977, 1978, 1979, 1981

Copyright © Nikolaus Pevsner, 1960, 1975 All rights reserved

Printed and bound in Great Britain by William Clowes (Beccles) Limited, Beccles and London Set in Monotype Plantin

Except in the United States of America, this book is sold subject to the condition that it shall not, by way of trade or otherwise, be lent, re-sold, hired out, or otherwise circulated without the publisher's prior consent in any form of binding or cover other than that in which it is published and without a similar condition including this condition being imposed on the subsequent purchaser

To

T.B., T.B., W.B., W.A.C., W.G.C., J.P. and D.F., P.S.F., P. and E.G., H.R., F.M.W., the A.A.C., the C.I.

in gratitude

Contents

	LIST OF PLATES	9
	FOREWORD TO THE FIRST EDITION	15
	FOREWORD TO THE SECOND EDITION	16
	FOREWORD TO THE PELICAN EDITION	17
I	Theories of Art from Morris to Gropius	19
2	From Eighteen-fifty-one to Morris and	
	the Arts and Crafts	40
3	Eighteen-ninety in Painting	68
4	Art Nouveau	90
5	Engineering and Architecture in the	
	Nineteenth Century	118
6	England, Eighteen-ninety to	
	Nineteen-fourteen	148
7	The Modern Movement before	
	Nineteen-fourteen	179
	NOTES	219
	SUPPLEMENTARY BIBLIOGRAPHY	241-4
	SECOND SUPPLEMENTARY BIBLIOGRAPHY	245
	TABLE OF NAMES AND DATES	254
	INDEX	256

List of Plates

- 1. Carpet from the Great Exhibition of 1851
- 2. Shawl from the Great Exhibition of 1851
- 3. Silverware from the Great Exhibition of 1851
- Owen Jones: Pattern design, from the Journal of Design and Manufactures, 1852
- 5. Pugin: Ornamental design, from Foliated Ornament, 1849
- 6. Morris: The Daisy wallpaper, 1861
- 7. Morris: Hammersmith carpet. The Little Tree pattern
- 8. Morris: The Honeysuckle chintz, 1883
- 9. Dresser: Cruet set and tea-kettle, 1877-8
- 10. De Morgan: Plate, 1880s. (Victoria and Albert Museum, London)
- Webb: Red House, Bexleyheath, Kent. Built in 1859 for William Morris
- Webb: The chimney-piece in Red House, 1859. (National Buildings Record)
- 13. Webb: No. 1 Palace Green, Kensington, London, 1868. (A.F. Kersting)
- Shaw: New Zealand Chambers, Leadenhall Street, London, 1872–3.
 (National Buildings Record)
- Shaw: The architect's house, Ellerdale Road, Hampstead, London, 1875. (National Buildings Record)
- Nesfield: Kinmel Park, Abergele, Wales, 1871 or earlier. (National Buildings Record)
- 17. Shaw: No. 170 Queen's Gate, London, 1888
- Godwin: The White House, Tite Street, Chelsea. Built for Whistler in 1878. (National Buildings Record)
- 19. Richardson: Stoughton house, Cambridge, Massachusetts, 1882-3. (Henry-Russell Hitchcock)

- 20. White: Newport Casino, 1881. (Monograph of the Work of McKim, Mead & White. Architectural Book Publishing Co. Inc.)
- 21. White: Germantown Cricket Club, Philadelphia, 1891. (Monograph of the Work of McKim, Mead & White. Architectural Book Publishing Co. Inc.)
- 22. Renoir: The Judgement of Paris, 1908. (Mrs Louise R. Smith, New York. Photograph Knoedler Gallery, New York)
- 23. Cézanne: Bathers, 1895-1905. (Philadelphia Museum of Art, W.P. Wilstach Collection)
- 24. Van Gogh: *Portrait*, 1890. (Collection Mrs Hedy Hahnloser-Bühler, Winterthur, Switzerland)
- 25. Manet: Jeanne (Springtime), 1882. (Metropolitan Museum of Art, New York)
- Gauguin: Yellow Christ, 1889. (Albright Art Gallery, Buffalo, New York)
- 27. Gauguin: Women at the River (Auti Te Pape), c. 1891-3. (Museum of Modern Art, New York, Lillie P. Bliss Collection)
- 28. Vallotton: *The Bath*, 1890. (Collection Paul Vallotton, Lausanne, Switzerland)
- 29. Denis: April, 1892. (Rijksmuseum Kröller-Müller, Otterlo)
- Seurat: A Sunday Afternoon on the Island of the Grande Jatte, 1884–6. (Art Institute of Chicago, Helen Birch Bartlett Memorial Collection)
- 31. Rousseau: Self Portrait, 1890. (Modern Gallery, Prague)
- 32. Ensor: Intrigue, 1890. (Royal Museum, Antwerp)
- 33. Khnopff: Poster, 1891
- 34. Toorop: Faith Giving Way, 1894. (Municipal Museum, The Hague)
- 35. Hodler: The Chosen One, 1893-4. (Kunstmuseum, Berne, Switzerland; Boissonnas)
- 36. Munch: The Cry, 1893. (National Gallery, Oslo)
- 37. Mackmurdo: Title-page, 1883
- 38. Burne-Jones: Pelican, 1881. (William Morris Gallery, Walthamstow)
- 39. Burges: Chimney-piece in his own house, Melbury Road, Kensington, c. 1880. (National Buildings Record)
- 40. Beardsley: Siegfried, 1893
- 41. Toorop: The Three Brides, 1893. (Rijksmuseum Kröller-Müller, Otterlo)
- 42. Munch: Madonna, 1895

- 43. Sullivan: Auditorium Building, Chicago, 1888. Bar. (Chicago Architectural Photographing Co.)
- 44. Horta: No. 6 rue Paul-Émile Janson, Brussels, 1893. Staircase
- 45. Van de Velde: Chairs for his own house at Uccle, near Brussels, 1894-5
- 46. Gallé: Glass vase. (Museum of Modern Art, New York; David Royter)
- 47. Tiffany: Glass vases. (Museum of Modern Art, New York; G. Barrows)
- 48. Guimard: Castel Béranger, No. 16 rue La Fontaine, Passy, Paris, 1894-8
- 49. Eckmann: Decoration of two pages in the magazine Pan, 1895
- 50. Obrist: Embroidery, 1893
- 51. Plumet: Interior
- 52. Gaudí: Crypt of Santa Coloma de Cervelló. Begun in 1898. (MAS; Museum of Modern Art, New York)
- Gaudí: Parque Güell, Barcelona. Begun in 1900. (Amigos de Gaudí, Barcelona; Museum of Modern Art, New York)
- Gaudí: Sagrada Familia, Barcelona. Transept, 1903–26. (Zerkowitz, Barcelona; Amigos de Gaudí, Barcelona; Museum of Modern Art, New York)
- 55. Gaudí: Sagrada Familia, Barcelona. Detail from the top of one of the transept towers. (Zerkowitz, Barcelona; Amigos de Gaudí, Barcelona; Museum of Modern Art, New York)
- Gaudí: Casa Batlló, Barcelona, 1905-7. (Zerkowitz, Barcelona; Amigos de Gaudí, Barcelona; Museum of Modern Art, New York)
- 57. Gaudí: Casa Milá, Barcelona, 1905-7. (MAS; Amigos de Gaudí, Barcelona; Museum of Modern Art, New York)
- 58. Benyon, Bage, & Marshall's flax-spinning mill, Ditherington, Shrewsbury, 1796
- 59. Lorillard: Building in Gold Street, New York, 1837
- 60. Bogardus: Building for Harper Bros, New York, 1854. (Brown Brothers, New York)
- 61. Jamaica Street warehouse, Glasgow, 1855-6. (Annan, Glasgow)
- 62. Ellis: Oriel Chambers, Liverpool, 1864-5. (Stewart Bale)
- 63. G. T. Greene: Boat store at Sheerness Naval Dockyard, 1858-61. (Eric de Maré; Architectural Press)

- Johnston and Walter: Jayne Building, Philadelphia, 1849–50.
 (John Maass)
- 65. Coalbrookdale Bridge, 1777-81. (Reece Winstone)
- 66. Pritchard: Design for the Coalbrookdale Bridge, 1775
- Telford: Design for a cast-iron bridge to replace London Bridge, 1801. (Science Museum)
- 68. Brunel: Clifton Suspension Bridge, Bristol. Designed 1829-31.
 Begun in 1836
- 69. St Alkmund, Shrewsbury, 1795. Cast-iron tracery. (West Midland. Photo Services Ltd, Shrewsbury)
- 70. Loudon: Designs for conservatories, 1817
- 71. Boileau: St Eugène, Paris, 1854-5. (Roger Viollet, Paris)
- 72. Viollet-le-Duc: Illustration from the Entretiens, 1872
- 73. Dutert and Contamin: Halle des Machines, Paris International Exhibition, 1889
- 74. Eiffel: Eiffel Tower, Paris, 1889
- 75. Sullivan: Wainwright Building, St Louis, 1890-91
- 76. Burnham and Root: Monadnock Block, Chicago, 1890-91
- 77. De Baudot: St Jean de Montmartre, Paris, 1894-7 (Chevojon Frères, Paris)
- 78. Voysey: Design for a wallpaper, c. 1895
- 79. Voysey: Stags and Trees, printed linen, 1908
- 80. Voysey: Toast rack and cruet set
- 81. Voysey: The Orchard, Chorleywood, Hertfordshire, 1900
- 82. Gimson: Chairs, 1901
- 83. Heal: Wardrobe, 1900. (Heal & Son Ltd)
- 84. Mackmurdo: 8 Private Road, Enfield, c. 1883
- 85. Mackmurdo: Exhibition stand, Liverpool, 1886
- 86. Voysey: House in Bedford Park, near London, 1891
- Voysey: Studio, St Dunstan's Road, West Kensington, London, 1891
- 88. Voysey: House at Shackleford, Surrey, 1897
- 89. Voysey: Perrycroft, Colwall, Malvern Hills, 1893
- Voysey: Lodge and stables, Merlshanger, near Guildford, Surrey, 1896
- 91. Voysey: Broadleys on Lake Windermere, 1898
- 92. Smith and Brewer: Mary Ward Settlement, Tavistock Place, London, 1895

- 93. Townsend: Whitechapel Art Gallery, London, 1897-9
- 94. Townsend: Horniman Museum, London, 1900-1902
- 95. Mackintosh: School of Art, Glasgow, 1896-9. (Annan, Glasgow)
- 96. Mackintosh: School of Art, Glasgow, 1907–9. Interior of library. (Annan, Glasgow)
- 97. Mackintosh: Cranston Tearoom, Sauchiehall Street, Glasgow, 1904. Interior. (Annan, Glasgow)
- 98. Mackintosh: School of Art, Glasgow, 1907-9. Library wing. (Annan, Glasgow)
- 99. Mackintosh: Hill House, Helensburgh, near Glasgow, 1902-1903
- 100. Berlage: House, 42–4 Oude Scheveningsche Weg, The Hague, 1898. Stair well. (A. Dingjan, The Hague)
- 101. Mackintosh: Cranston Tearoom, Buchanan Street, Glasgow, 1897-8. (Annan, Glasgow)
- 102. Klimt: Tragedy, 1897
- 103. Mackintosh: Dining-room for the House of a Connoisseur, 1901
- 104. Perret: Block of flats, 25 bis rue Franklin, Paris, 1902-3
- 105. Garnier: Industrial City, 1901-4. Administration Building
- 106. Garnier: Industrial City, 1901–4. Under the canopy, Administration Building
- 107. Garnier: Industrial City, 1901-4. Railway Station
- 108. Garnier: Industrial City, 1901-4. Four private houses
- 109. Garnier: Industrial City, 1901-4. Street
- 110. Garnier: Industrial City, 1901-4. Theatre
- 111. Garnier: Industrial City, 1901-4. Palm Court
- 112. Maillart: Tavenasa Bridge, 1905. (Bill, Robert Maillart, Girsberger, Zürich)
- 113. Sullivan: Carson Pirie Scott Store, Chicago, 1899 and 1903-4. (Chicago Architectural Photographing Co.)
- 114. Sullivan and Wright: Charnley House, Chicago, 1891. (Chicago Architectural Photographing Co.)
- 115. Wright: Winslow House, River Forest, Illinois, 1893
- 116. Wright: Project for the Yahara Boat Club, Madison, Wisconsin, 1902
- 117. Wright: Heath House, Buffalo, New York, 1905. (Gilman Lane)
- 118. Wright: Coonley House, Riverside, Illinois, 1908. Interior. (Henry-Russell Hitchcock and the Frank Lloyd Wright Foundation)
- 119. Wright: Design for a skyscraper, 1895

- 120. Wright: Larkin Building, Buffalo, New York, 1904. (Henry-Russell Hitchcock)
- 121. Wright: Larkin Building, Buffalo, New York, 1904. Interior
- 122. Endell: Elvira Studio, Munich, 1897-8
- 123. Endell: Studies in basic building proportions, 1898
- 124. Olbrich: The Sezession, Vienna, 1898-9
- 125. Olbrich: Hochzeitsturm, Darmstadt, 1907-8
- 126. Hoffmann: Convalescent Home, Purkersdorf, 1903-4
- 127. Hoffmann: Palais Stoclet, Brussels, 1905
- 128. Loos: Shop interior, Vienna, 1898. (Kulka, Adolf Loos, Anton Schroll & Co., Vienna)
- 129. Loos: Steiner House, Vienna, 1910. (Kulka, Adolf Loos, Anton Schroll & Co., Vienna)
- 130. Wagner: Post Office Savings Bank, Vienna, 1905. (Österreichische Nationalbibliothek)
- 131. Schröder: Apartment for A.W. von Heymel, Berlin, 1899. (Franz Stoedtner)
- 132. Behrens: Art Building, Oldenburg Exhibition, 1905
- 133. Behrens: Turbine factory, Huttenstrasse, Berlin, 1909
- 134. Behrens: Factory, Voltastrasse, Berlin, 1911
- 135. Behrens: Electric tea-kettle for the AEG, 1910
- 136. Behrens: Street lamps for the AEG, 1907-8
- 137. Berg: Centenary Hall, Breslau, 1910-12
- 138. Mies van der Rohe: Design for a house for Mrs Kröller-Müller, 1912
- 139. Poelzig: Office building, Breslau, 1911
- 140. Poelzig: Chemical factory, Luban, 1911-12
- 141, 142, 143. Sant'Elia: Sketches, 1912-14 or 1913-14
- 144. Chiattone: Block of flats, 1914
- 145. Gropius and Meyer: Fagus Factory, Alfeld-on-the-Leine, 1911
- 146. Gropius and Meyer: Model Factory, Werkbund Exhibition, Cologne, 1914. North Side
- 147. Gropius and Meyer: Model Factory. Werkbund Exhibition, Cologne, 1914. South Side
- 148. H. B. Cresswell: Queensferry Factory, near Chester, 1901
- 149. Signac: Two Milliners, 1885. (Rübele Collection, Zurich)
- 150. McKim, Mead and White: Lovely Lane Methodist Church, Baltimore, Maryland, 1883–7

Foreword to the First Edition

Most of the preparatory work for this book was done during the years 1930–32. I held a class on the architecture of the nineteenth and twentieth centuries at Göttingen University in 1930, and then published, in the Göttingische Gelehrte Anzeigen of 1931, a short preliminary account of the parts played by the most important architects in the development of the Modern Movement.

However, as far as books on the subject are concerned, this is, if I am not mistaken, the first to be published. I am well aware of its short-comings, and shall be grateful to anybody who may be able to draw my attention to sins of omission or of commission.

I did not know of P. Morton Shand's excellent articles in the Architectural Review of 1933, 1934, 1935 until I had almost finished my research. The fact that our conclusions coincide in so many ways is a gratifying confirmation of the views put forward in this book.

I feel greatly indebted to Geoffrey Baker, Katharine Munro, and Alec Clifton-Taylor, who tried to eliminate from my text the worst clumsiness of a foreign style. Yet I am afraid it is still badly lacking in that supple precision which distinguishes well-written English.

I also want to place on record my gratitude to my mother, Frau Annie Pevsner, who used a time of unwelcome leisure for transforming an illegible into a readable and printable manuscript, and to Mr Richard de la Mare who with great kindness and understanding dealt with all matters of layout, printing, and illustration.

NIKOLAUS PEVSNER

London, May 1936

Foreword to the Second Edition

THE Museum of Modern Art has increased the scope of this book considerably by raising the total number of illustrations from 84 to 137; I have tried to improve the text by corrections, where I had made mistakes, and by additions which vary in length from a line to a virtual rewriting of a whole chapter. For suggestions as to what should be altered and added I wish to thank Philip Johnson, Edgar Kaufman Jr, Henry-Russell Hitchcock, and Alfred H. Barr Jr. But my greatest gratitude is to Herwin Schaefer who has followed the book untiringly through all its stages from manuscript to printed page and never ceased to improve it by queries, checking, and research.

London, December 1948

Foreword to the Pelican Edition

THERE were twelve years between the first and the second editions of this book; there have now been twelve between that second edition and this Pelican edition. Far more research has been devoted during these twelve years to the period with which my book deals than there had been in the preceding twelve. It is gratifying to see that a subject which, when I first tackled it, was shunned by serious scholars has now become the happy hunting ground for American and German and indeed some English students busy on theses, dissertations, or otherwise. Their work, especially that of Madsen, Dr Schmutzler, and Dr Banham, has caused many additions and alterations, none, however, I am happy to say, of such a kind as to rock the structure of my argument. There were, however, places where I felt some slight shaking and had to do a securing job. On the surface it seems as if there were no more than two: Gaudí and Sant'Elia. They had both led a humble existence in the footnotes so far and the necessity was unquestionable of raising them to prominent positions in the body of the text. This resurrection is symptomatic.

When I wrote this book the architecture of reason and functionalism was in full swing in many countries, while it had just started a hopeful course in others. There was no question that Wright, Garnier, Loos, Behrens, Gropius were the initiators of the style of the century and that Gaudí and Sant'Elia were freaks and their inventions fantastical rantings. Now we are surrounded once again by fantasts and freaks, and once again the validity of the style is queried to whose prehistory this book is dedicated. Historical fairness for that very reason made it imperative to show up the line which runs from Gaudí and the Art Nouveau to the present Neo-Art-Nouveau – by way of the Expressionism of the years

immediately after the First World War, which in the previous editions of this book also had been mentioned only in an occasional footnote. But I am as convinced as ever that the style of the Fagus Works and the Cologne model factory is still valid, even if an evolution is unmistakable between the best of c. 1914 and the best of c. 1955. I have argued the case in another place (the last chapter of the Jubilee edition of my Outline of European Architecture, published by Penguin Books in 1960), but shall here also allude sufficiently to the way in which I now see the development between 1914 and 1955.

Apart from the changes made necessary in this context I have made some seventy or eighty others for this Pelican edition, some small and some quite extensive. The most important research which had to be taken into consideration is that of Professor Howarth on Mackintosh, of Dean Bannister and Messrs Skempton and Johnson on early iron structure, and my own on High Victorian Design and Matthew Digby Wyatt. An Italian magazine, L'Architettura, edited by Bruno Zevi, author of the most detailed history of modern architecture (1950), has also devoted much space to architects of my period, to Wright, Horta, Hoffmann, Sant'Elia, and others. However, to say it once again, the main theses of, and the principal accents in, this book did not call for recantation or revision, which is a happy thought for an author looking back over twenty-five years.

London, Summer 1960

For the reprint of 1968 I corrected a few errors and added on pp. 241–44 an annotated bibliography of literature of the last seven or eight years.

For the 1974 reprint, additions to literature and points of view will be found on pp. 245-53. This is all that seemed to me to be necessary.

London, Spring 1974

1 · Theories of Art from Morris to Gropius

'ORNAMENTATION', says Ruskin, 'is the principal part of architecture.' It is that part, he says in another place, which impresses on a building 'certain characters venerable or beautiful, but otherwise unnecessary'. Sir George Gilbert Scott amplified this surprising statement when he recommended to architects the use of the Gothic style, because its 'great principle is to decorate construction'.¹

How this basic doctrine of nineteenth-century architectural theory worked out in practice could not be shown more convincingly than by retelling the story of the new British Government offices in Whitehall, London, as erected by Scott between 1868 and 1873. The following are the facts as told by Sir George. His original plans were in the Gothic style. He writes: 'I did not aim at making my style "Italian Gothic"; my ideas ran much more upon the French, to which for some years I had devoted my chief study. I did, however, aim at gathering a few hints from Italy . . . I mean a certain squareness and horizontality of outline ... I combined this ... with gables, high-pitched roofs and dormers. My details were excellent, and precisely suited to the purpose.' In spite of this, Scott did not win the first prize in the competition, partly because Lord Palmerston thoroughly disliked medieval styles. Scott comments: 'I did not fret myself at the disappointment, but when it was found, a few months later, that Lord Palmerston had coolly set aside the entire results of the competition, and was about to appoint Pennethorne, a non-competitor, I thought myself at liberty to stir.' And stir he did, so that in the end he was appointed architect to the new building. However, he was not able to dissuade the Government from its predilection for the Italian Renaissance. What followed was described by Lord Palmerston as the battle of the Gothic and Palladian styles. He saw no insurmountable difficulty. He sent for Scott and told him 'in a jaunty way that he could have nothing to do with the Gothic style, and that,' continues Scott, 'though he did not want to disturb my appointment, he must insist on my making a design in the Italian style, which he felt sure I could do quite as well as the other'. Lord Palmerston was evidently right, for, after long arguments, Scott promised 'an Italian design'. But he still hoped that Renaissance could be avoided. He altered the front of his building, and now it was 'in the Byzantine of the early Venetian palaces . . . toned into a more modern and usable form'. In vain, for the Prime Minister wanted 'the ordinary Italian', and he would have it. He called the new plans 'neither one thing nor t'other - a regular mongrel affair', and threatened to cancel Scott's appointment. After that, for the sake of his family and his reputation, Sir George 'in sore perplexity' decided to 'swallow the bitter pill'. He 'bought some costly books on Italian architecture and set vigorously to work' to invent an Italian façade 'beautifully got up in outline'.2

The campaign of William Morris's lifetime was directed against the complete lack of feeling for the essential unity of architecture which made this comedy possible. When his impressionable nature began to react on buildings, fine art, and industrial art, almost all contemporary building which surrounded him, as a youth in London and as a student at Oxford, and practically all industrial art was crude, vulgar, and overloaded with ornament. Examples will be given later. Responsible for this state of affairs were the Industrial Revolution and - less known but equally important - the theory of aesthetics created since 1800. The part played by the Industrial Revolution is to be discussed in Chapter 2. It is sufficient here to say that manufacturers were, by means of new machinery, enabled to turn out thousands of cheap articles in the same time and at the same cost as were formerly required for the production of one well-made object. Sham materials and sham techniques were dominant all through industry. Skilled craftsmanship, still so admirable when Chippendale and Wedgwood were at work, was replaced by mechanical routine. Demand was increasing from year to year, but

demand from an uneducated public, a public with either too much money and no time or with no money and no time.

The artist withdrew in disgust from such philistinism or squalor. It was not for him to condescend to the taste of the majority of his fellowmen, to meddle with the 'Arts Not Fine'. During the Renaissance, artists had first learned to consider themselves superior beings, bearers of a great message. Leonardo da Vinci wanted the artist to be a scientist and a humanist, but by no means a craftsman. When Michelangelo was asked why he had portrayed one of the Medicis in the Medici Chapel beardless, though he had worn a beard in life, he answered: 'Who, in a thousand years, will know what he looked like?' However, this attitude of artistic presumption remained exceptional until the end of the eighteenth century. Schiller was the first to form a philosophy of art which made the artist the high priest in a secularized society. Schelling took this up, and Coleridge, Shelley, and Keats followed. Poets, according to Shelley, are 'the unacknowledged legislators of the world'. The artist is no longer a craftsman, no longer a servant, he is now a priest. Humanity may be his gospel, or beauty, a beauty identical with truth (Keats), a beauty that is 'the completest conceivable unity of life and form' (Schiller). In creating, the artist makes conscious 'the essential, the universal, the aspect and expression of the in-dwelling spirit of Nature' (Schelling). Schiller assures him: 'The dignity of Mankind is laid into thy hands', and compares him to a king - 'both living on the summits of mankind'. The inevitable consequence of such adulation became more and more visible as the nineteenth century unfolded. The artist began to despise utility and the public (Keats: 'Oh sweet fancy! let her loose; Everything is spoilt by use'). He shut himself off from the real life of his time, withdrawing into his sacred circle and creating art for art's, art for the artist's, sake. Concurrently the public lost understanding of his personal, outwardly useless utterances. Whether he lived like a priest or lived a vie de Bohème, he was ridiculed by most of his contemporaries, and extolled by only a small set of critics and connoisseurs.

But there had been a time when nothing of all that existed. In the Middle Ages the artist was a craftsman, proud of executing any commission to the best of his ability. Morris was the first artist (not the first

thinker, for Ruskin had preceded him) to realize how precarious and decayed the social foundations of art had become during the centuries since the Renaissance, and especially during the years since the Industrial Revolution. He had been trained as an architect and as a painter, first in the Gothic studio of Street, and then in the circle of the Pre-Raphaelites. But when, in 1857, he had to furnish his first studio in London, the thought struck him that before one can settle down to paint elevating pictures, one must be able to live in congenial surroundings, must have a decent house, and decent chairs and tables. Nothing was obtainable that could possibly satisfy him. This was the situation which all of a sudden awakened his own personal genius: if we cannot buy solid and honest furniture, let us make it ourselves. So he and his friends set out to build chairs 'such as Barbarossa might have sat in' and a table 'as heavy as a rock' (Rossetti). The same experiment was repeated when Morris had a house built for his wife and himself, the famous Red House at Bexleyheath. Ultimately, in 1861, instead of forming a new exclusive brotherhood of artists, such as the Pre-Raphaelite Brotherhood had been, and such as he had wished to found when he was studying at Oxford, Morris made up his mind to open a firm, the firm of Morris, Marshall & Faulkner, Fine Art Workmen in Painting, Carving, Furniture, and the Metals. This event marks the beginning of a new era in Western Art.

The fundamental meaning of Morris's firm and Morris's doctrine is clearly expressed in the thirty-five lectures which he delivered between 1877 and 1894 on artistic and social questions.³ His point of departure is the social condition of art which he saw around him. Art 'has no longer any root'.⁴ The artists, out of touch with everyday life, 'wrap themselves up in dreams of Greece and Italy... which only a very few people even pretend to understand or be moved by'.⁵ This situation must seem exceedingly dangerous to anyone concerned with art. Morris preaches: 'I don't want art for a few, any more than education for a few, or freedom for a few',⁶ and he asks that great question which will decide the fate of art in our century: 'What business have we with art at all unless all can share it?' So far Morris is the true prophet of the twentieth century. We owe it to him that an ordinary

man's dwelling-house has once more become a worthy object of the architect's thought, and a chair, a wallpaper, or a vase a worthy object of the artist's imagination.

However, this is only one half of Morris's doctrine. The other half remained committed to nineteenth-century style and nineteenth-century prejudices. Morris's notion of art derives from his knowledge of medieval conditions of work, and is part and parcel of nineteenth-century 'historicism'. Proceeding from Gothic handicraft, he defined art simply as 'the expression by man of his pleasure in labour'. Real art must be 'made by the people and for the people, as a happiness for the maker and the user'. The pride in artistic genius and some special form of inspiration, which he saw in all the art of his time, was therefore abhorrent to him. 'That talk of inspiration is sheer nonsense' he said; 'there is no such thing: it is a mere matter of craftsmanship.'10

It is obvious that such a definition of art removes the problem from aesthetics into the wider field of social science. In Morris's mind, 'it is not possible to dissociate art from morality, politics and religion'.11 Here, above all, he proves a faithful follower of Ruskin who in his turn owed a debt, just a little too emphatically denied, to Pugin, that brilliant designer and pamphleteer who in the years between 1836 and 1851 had fought violently and relentlessly for Catholicism, for Gothic forms as the only Christian forms, and also for honesty and truthfulness in design and manufacturing. Ruskin took up the latter causes but not the former. Among the Seven Lamps of Architecture, his book of 1849, the first is the lamp of sacrifice, that is the dedication of a man's craft to God, and the second the lamp of truth. Truth in making is to Ruskin making by hand, and making by hand is making with joy. Ruskin also recognized that here lay the two great secrets of the Middle Ages and preached the superiority of the Middle Ages over the Renaissance.

In all this Morris followed him, and both were led to forms of Socialism along this path. If Morris denounced the social structure of his time so eloquently, his main reason was that it is evidently fatal to art. 'Art... will die out of civilization, if the system lasts. That in itself does to me carry with it the condemnation of the whole system.' Thus

Morris's Socialism is far from correct according to the standards established in the later nineteenth century: there is more in it of More than of Marx. His main question is: how can we recover a state of things in which all work would be 'worth doing' and at the same time 'of itself pleasant to do'?¹³ He looked backward, not forward, backward into the times of the Icelandic sagas, of cathedral building, of craft guilds. One cannot, from his lectures, obtain a clear view of what he imagined the future to be. 'The whole basis of Society . . . is incurably vicious,' he wrote.¹⁴ Hence it was sometimes his only hope 'to think of barbarism once more flooding the world . . . that it may once again become beautiful and dramatic withal'.¹⁵ And yet when, partly as a consequence of his own Socialist propaganda, riots began in London and revolution seemed for a moment not unlikely, he recoiled and gradually withdrew back into his world of poetry and beauty.

This is the decisive antagonism in Morris's life and teaching. His work, the revival of handicraft, is constructive; the essence of his teaching is destructive. Pleading for handicraft alone means pleading for conditions of medieval primitiveness, and first of all for the destruction of all the devices of civilization which were introduced during the Renaissance. This he did not want; and since, on the other hand, he was unwilling to use any post-medieval methods of production in his workshops, the consequence was that all his work was expensive work. In an age when practically all objects of everyday use are manufactured with the aid of machinery, the products of the artist-craftsman will be bought by a narrow circle only. While Morris wanted an art 'by the people and for the people', he had to admit that cheap art is impossible because 'all art costs time, trouble and thought'. 16 He thus created art - though now applied art, and no longer the nineteenth-century art of the easel-picture - which was also accessible to a few connoisseurs only, or, as he once expressed it himself, art for 'the swinish luxury of the rich'.17 No doubt Morris's art has in the end beneficially affected commercial production in many trades, but that is precisely what he would have hated, because the diffusion of his style on a large scale involved reintroducing the machine, and thereby expelling once more the 'joy of the maker'. The machine was Morris's arch-enemy: 'As a

condition of life, production by machinery is altogether an evil.' ¹⁸ Looking forward to barbarism, he certainly hoped for machine-breaking, though in his late speeches he was careful (and inconsistent) enough to admit that we ought to try to become 'the masters of our machines' and use them 'as an instrument for forcing on us better conditions of life'. ¹⁹

Morris's attitude of hatred towards modern methods of production remained unchanged with most of his followers. The Arts and Crafts Movement brought a revival of artistic craftsmanship not of industrial art. Walter Crane (1845-1915) and C.R. Ashbee (1863-1942) may be taken as representatives of this. Walter Crane, the most popular of the disciples of Morris, did not go one step beyond the doctrine of his master. To him, as to Morris, 'the true root and basis of all Art lies in the handicrafts'.20 His aim, therefore, just like Morris's, was 'to turn our artists into craftsmen and our craftsmen into artists'.21 Moreover, he agreed with Morris in the conviction that 'genuine and spontaneous art . . . is a pleasurable exercise', 22 and was led by such premises to a romantic Socialism identical with that of Morris. The same conflict which was pointed out in Morris's doctrine is to be found in Crane. He too was compelled to admit that 'cheapness in art and handicraft is wellnigh impossible', because 'cheapness as a rule . . . can only be obtained at the cost of the . . . cheapening of human life and labour'. 23 Crane's attitude towards machine production also corresponds to Morris's. His dislike of 'the monsters of our time clad in plate-glass [and] castiron'24 - Ruskin had been the first to inveigh against railway stations and the Crystal Palace - is tempered only by the consideration that machinery may be necessary and useful as 'the servant and labour-saver of man' for a 'real saving of labour, heavy and exhausting labour'.25

Ashbee was certainly a more original thinker and more energetic reformer than Crane.²⁶ Proceeding also from Ruskin and Morris in his belief that 'the constructive and decorative arts are the real backbone' of any artistic culture, that every object ought to be 'produced under pleasurable conditions',²⁷ and that therefore art for workaday use cannot be cheap, he surpasses Morris in that he links up the problems of workshop-reconstruction and of small-holdings. His Guild and School

of Handicraft, founded in 1888, was removed in 1902 from the East End of London to Chipping Campden in the Cotswolds. While this aspect of his work and doctrine is even more 'medievalist' than the teaching of Morris, there is another side to his doctrine which seems genuinely progressive. At the time of the Guild his attitude towards machine production was still almost that of Morris and Crane. 'We do not reject the machine', he wrote; 'we welcome it. But we desire to see it mastered.' Within the next few years, partly perhaps as a consequence of the hopeless struggle of the Guild against modern methods of manufacturing, he broke away from what he now called Ruskin's and Morris's 'intellectual Ludditism', and the first axiom of his last two books on art, published after 1910, is that 'Modern civilization rests on machinery, and no system for the encouragement or the endowment of the teaching of the arts can be sound that does not recognize this.' 30

In pronouncing this axiom, Ashbee had abandoned the doctrine of the Arts and Crafts and adopted one of the basic premises of the Modern Movement. But with him it was only adopting, and not creating. His foremost title to fame remains the Campden experiment, an attempt to revive handicraft and husbandry far from the centres of modern life. The true pioneers of the Modern Movement are those who from the outset stood for machine art. As forerunners, of a still somewhat transitional character, two contemporaries of Morris may be quoted, Lewis F. Day (1845-1910) and John D. Sedding (1837-91). Day, a well-known industrial designer of his time, wrote as one who prefers a life in the real world to dreams of a medieval and idyllic existence. In discussing the ornament of the future, he said in 1882: 'Whether we like it or no, machinery and steam-power, and electricity for all we know, will have something to say concerning the ornament of the future.' He said it would be useless to resist this fact, for it was 'practically settled by the public that they want machine-work. . . . We may protest that they have chosen unwisely, but they will not pay much heed to us.'31 And Sedding, perhaps the most original church architect of the late Gothic Revivalist school, who became a pupil of Street just two years after Morris had left him, gave the same advice in 1892: 'Let us not suppose that machinery will be discontinued. Manufacture

cannot be organized upon any other basis. We had better clearly recognize this . . . rather than rebel against the actual and the inevitable.'32

However, there is still an immense difference between this hesitating acknowledgement of machinery and the wholehearted welcome which it received in the writings of the leaders of the next generation. Not one of them was English: England's activity in the preparation of the Modern Movement came to an end immediately after Morris's death. The initiative now passed to the Continent and the United States, and, after a short intermediate period, Germany became the centre of progress. English writers have not failed to acknowledge this fact;33 but hardly anybody has tried to explain it. One reason may be this: so long as the new style had been a matter which in practice concerned only the wealthier class, England could foot the bill. As soon as the problem began to embrace the people as a whole, other nations took the lead, nations that lived no longer, or had never lived, in the atmosphere of the ancien régime, nations that did not accept or did not know England's educational and social contrasts between the privileged classes and those in the suburbs and the slums.

The new gospel was first preached by poets and writers. Walt Whitman in his odes and Zola in his novels are carried away by the overwhelming marvels of modern civilization and modern industry. The first architects to admire the machine and to understand its essential character and its consequences in the relation of architecture and design to ornamentation were two Austrians, two Americans, and a Belgian: Otto Wagner (1841–1918), Adolf Loos (1870–1933), Louis Sullivan (1856–1924), Frank Lloyd Wright (1869–1959), and Henri van de Velde (1863–1957). To these five, one Englishman should be added, Oscar Wilde (1854–1900), although his occasional praise of machine beauty may be only one of his many laborious efforts to épater le bourgeois. He said in a lecture of 1882: 'All machinery may be beautiful, when it is undecorated even. Do not seek to decorate it. We cannot but think all good machinery is graceful, also, the line of the strength and the line of the beauty being one.'34

Van de Velde, Wagner, Loos, and Wright were decisively stimulated in their thoughts by England. Wright's manifesto was read at Hull

House in Chicago, a social settlement on the pattern of Toynbee Hall; Wagner expressed his great admiration of the comfort and cleanness of English industrial art;³⁵ Loos said explicitly: 'The centre of European civilization is at present in London',³⁶ and his early criticism was to a large extent passionate support of the exhibitions of modern English objects arranged by the Österreichisches Museum in Vienna; and from van de Velde's writings the following statement may be quoted: 'The seeds that fertilized our spirit, evoked our activities, and originated the complete renewal of ornamentation and form in the decorative arts, were undoubtedly the work and the influence of John Ruskin and William Morris.'³⁷

Only Louis Sullivan, whose *Ornament in Architecture* is the earliest of these manifestoes of a new style, seems to have been independent of England. In his distant Chicago, where metropolitan architecture at that time meant New York and Boston, and, farther afield, Paris, he worked out entirely on his own the theory which found its final form in the *Kindergarten Chats* of 1901–2.³⁸ In *Ornament in Architecture* Sullivan stated already in 1892 that 'ornament is mentally a luxury, not a necessary', and that 'it would be greatly for our aesthetic good, if we should refrain entirely from the use of ornament for a period of years, in order that our thought might concentrate acutely upon the production of buildings well formed and comely in the nude'.³⁹

Whether Sullivan in formulating this thought was expressing directly the message of his own buildings which will be discussed in Chapter 5, or whether he was influenced by more articulate critics who in their turn were influenced by his buildings, is not certain. In any case, Montgomery Schuyler (1843–1914), writer, journalist, and editor, had brought out a book called *American Architecture* in the same year 1892 and says in it just like Sullivan: 'If you were to scrape down to the face of the main wall of the buildings of these streets, you would find that you had simply removed all the architecture, and that you had left the buildings as good as ever.'⁴⁰ Another American architect-writer with similar convictions was Schuyler's friend Russell Sturgis (1836–1909) who wrote in the *Architectural Record*:⁴¹ 'All recognized styles are more or less discredited by the sad misuse which they have undergone at the

hands of our own generation and the preceding one.... The old styles simply do not apply to us, and we have to disregard them.... Things may be better, if architects were allowed to build very plainly for a while.... If the architects were to fall back upon their building, their construction, their handling of materials as their sole source of architectural effect, a new and valuable style might take form.'42

Such approval of the unadorned surface was not entirely new in England either. It had already been said by Crane in 1889 that 'plain materials and surfaces are infinitely preferable to inorganic or inappropriate ornament', and one year after Sullivan, Charles F. Annesley Voysey wrote that 'discarding the mass of useless ornaments' would be healthy and desirable. But just as Voysey, in spite of such suggestions, has been one of the most important representatives of the evolution of ornament between Morris and the twentieth century, so Sullivan was in fact just as much a revolutionary in his ornament as in his use of plain, smooth surfaces. In his same paper of 1892, he stated that 'organic ornament' should be the stage to follow the purge of all ornament which had to come first.

Sullivan's own decorative motifs belong to the species known as Art Nouveau. So do those of van de Velde who, in his lectures between 1893 and 1900,45 pronounced - independently without doubt - the same faith in a type of ornament which would be able to express symbolically 'by means of pure structure . . . joy, lassitude, protection, etc.',46 and in the machine as a stimulus to the achievement of a new beauty. Van de Velde showed his audience that a great deal of the English Arts and Crafts had remained a pastime of highly sensitive artists for highly sensitive connoisseurs, and therefore was not much healthier than the exquisite and decadent writing of Huysmans. He contrasted Morris's art, which never broke away from reminiscences of the Gothic centuries, with his own new doctrine of the beauty inherent in machines. 'The powerful play of their iron arms', he exclaimed, 'will create beauty, as soon as beauty guides them.'47 This statement dates from about 1894. Six years later van de Velde added more explicitly: 'Why should artists who build palaces in stone rank any higher than artists who build them in metal?'48 'The engineers stand

at the entrance to the new style.'49 Engineers are 'the architects of the present day'.50 What we need is 'a logical structure of products, uncompromising logic in the use of materials, proud and frank exhibition of working processes'.51 A great future is prophesied for iron, steel, aluminium, linoleum, celluloid, cement.52 As to the appearance of objects in the house, van de Velde pleads for 'that lost sense of vivid, strong, clear colours, vigorous and strong forms, and reasonable construction',53 and praises the new English furniture for its 'systematic discarding of ornament'.54

Precisely this was to be Adolf Loos's gospel. He had been trained as an architect, first in Dresden and then in the United States.⁵⁵ Coming back to Vienna in 1896, he was shown a small newly published book by Vienna's most progressive architect, Otto Wagner.⁵⁶ The book was based on Wagner's Inaugural Lecture at the Art Academy, in 1894, and its doctrine was in many respects similar to van de Velde's. 'The only possible departure for artistic creation is modern life.'⁵⁷ 'All modern forms must be in harmony with . . . the new requirements of our time.'⁵⁸ 'Nothing that is not practical can be beautiful.'⁵⁹ So Wagner foresaw a 'coming Naissance'⁶⁰ and, what is more astonishing, pointed out as some of the characteristics of that future style 'horizontal lines such as were prevalent in Antiquity, table-like roofs, great simplicity and an energetic exhibition of construction and materials'.⁶¹ Needless to say, he too was passionately in favour of iron.

Adolf Loos wrote his first essays for newspapers and periodicals in 1897 and 1898.⁶² Attacking the Viennese Art Nouveau style, known as the style of the Sezession, which was just then at its height, he pointed out: 'The lower the standard of a people, the more lavish are its ornaments. To find beauty in form instead of making it depend on ornament is the goal towards which humanity is aspiring.'⁶³ For pure beauty in an individual work of art is to Loos 'the degree to which it attains utility and the harmony of all parts in relation to each other'.⁶⁴ The engineers he regards therefore as 'our Hellenes. From them we receive our culture.'⁶⁵ And he is consistent enough to call the plumber (the term being used in the general American sense) 'the quartermaster of culture, i.e. of the kind of culture which is decisive today'.⁶⁶

Only a few years later similar views were expressed with equally strong conviction, though in a more comprehensive and sweeping style, by Sullivan's greatest pupil, Frank Lloyd Wright, who in 1901 read a manifesto on *The Art and Craft of the Machine*.⁶⁷ It begins straight away with a panegyric on our 'age of steel and steam . . . the Machine Age, wherein locomotive engines, engines of industry, engines of light or engines of war or steamships take the place works of Art took in previous history'.⁶⁸ Wright enthusiastically admires the new 'simplified and etherealized' rhythm of future buildings, where – an amazing prophecy – 'space is more spacious, and the sense of it may enter into every building, great or small'.⁶⁹ In such an age the painter or the poet does not count for much. 'Today, we have a Scientist or an Inventor in the place of a Shakespeare or a Dante.'⁷⁰

But if Wright speaks of today, he means the twentieth century as it could be and ought to be, and not as it appeared in 1901. The many disgraceful things perpetrated by machines are, according to Wright, the fault not of the machine but of the designers. For 'the machine has noble possibilities, unwillingly forced to this degradation . . . by the Arts themselves'.71 Hence one can be in no doubt as to the victory in the battle between the artist, in the old sense, and the machine. The machine is a 'relentless force' bound to discomfit the 'handicraftsmen and parasitic artists'.72 It sounds like a deliberate challenge to Morris's 'Art will die out of civilization, if the system lasts. That in itself does to me carry with it the condemnation of the whole system', when Frank Lloyd Wright, looking at Chicago's overwhelming silhouette and lights by night, exclaims: 'If this power must be uprooted that civilization may live, then civilization is already doomed.'73 And Wright's belief in the machine is so strong that he foresees a possible salvation for the craftsman in his humbly learning from the machine. 'Rightly used,' he says, 'the very curse machinery puts upon handicraft should emancipate the artists from temptation to petty structural deceit and end this wearisome struggle to make things seem what they are not and never can be.'74

So Wright's position in 1901 was almost identical with that of the most advanced thinkers on the future of art and architecture today.

However, this theory remained isolated in America for a long time. And it is an indisputable fact that, in most European countries as well, those who pleaded for a new style of the century found very little response before the First World War. This was for instance the case with Anatole de Baudot, Viollet-le-Duc's pupil, who, as early as 1889, said: 'A long time ago the influence of the architect declined and the engineer, *Phomme moderne par excellence*, is beginning to replace him', ⁷⁵ and it was also the case with H.P.Berlage (1856–1934) in Holland who, in two articles in 1895 and 1896, recommended to the architect not to think in terms of style while designing buildings. Only thus, he said, can real architecture comparable to that of the Middle Ages be created, architecture as a 'pure art of utility'. ⁷⁶ Such architecture he visualized as 'the art of the twentieth century', and it should be noted that the century to him was to be one of Socialism. ⁷⁷

To have achieved a wide movement promoting these new ideas is undeniably the merit of German architects and writers. The movement which they fostered proved strong enough to yield a universal style of thinking and building, and not merely some revolutionary sayings and deeds of a few individuals.

The man who acted as a connecting link between the English style of the nineties and Germany was Hermann Muthesius (1861-1927) who, from 1896 till 1903, was attached to the German Embassy in London for research on English housing. Since Art Nouveau had hardly diverted English domestic architecture from the sound and slow course of its evolution, Muthesius came back a convinced supporter of reason and simplicity in building and art. Soon he became the acknowledged leader of a new tendency towards Sachlichkeit, which followed the short blossom-time of Art Nouveau in Germany. The untranslatable word sachlich, meaning at the same time pertinent, matter-of-fact, and objective, became the catchword of the growing Modern Movement.⁷⁸ 'Reasonable Sachlichkeit' is what Muthesius praises in English architecture and crafts,79 'perfect and pure utility' is what he demands from the modern artist. And since today only machine-made objects are 'produced according to the economic nature of the age', they alone can be taken into consideration where the problem is the creation of a new

style, a *Maschinenstil*. 80 If we want to see existing manifestations of this new style, we are once more invited to look at 'railway stations, exhibition halls, bridges, steamships, etc. Here we are faced with a severe and almost scientific *Sachlichkeit*, with abstinence from all outward decoration, and with shapes completely dictated by the purposes which they are meant to serve.' Hence future progress can be imagined only in the direction of strict *Sachlichkeit* and a discarding of all merely 'tacked-on' decoration. Buildings or objects for use that are created on such lines will display 'a neat elegance which arises from suitability and . . . conciseness'.81

By pronouncing such ideas, still unfamiliar in Germany, Muthesius soon became the centre of a group of congenial spirits. Of paramount importance, owing to the echo which he found among the bourgeoisie listening to his lectures and reading his pamphlets, was Alfred Lichtwark (1852-1914), art historian and director of the Hamburg Gallery. He was a teacher by nature, obsessed with the purest passion for education. The rapid development of art education in the widest sense of the word, which has taken place in the German elementary schools and secondary schools since the beginning of the new century, is largely due to Lichtwark's efforts. His campaign in favour of Sachlichkeit started even earlier than Muthesius's. In the lectures which he delivered between 1896 and 1899, and which are full of praise for England, he pleaded for practical, unadorned furniture in 'smooth, polished, light forms' convenient to housewives, for sachliche Schönheit, for wide horizontal windows and 'floods of light', and for fresh flowers in the rooms.82 The campaign thus started was soon taken up by others and diverted into different channels without losing its zest for simplicity and honesty. The architect Paul Schultze-Naumburg (1869-1949) began in 1901 to publish his Kulturarbeiten, a series of books starting with one on the building of houses. In 1903 Ferdinand Avenarius (1856-1923) founded the Dürerbund, and in 1904 the Heimatschutz was created, an association corresponding roughly to our Society for the Protection of Rural England, that is, a preservationist, backward-looking, not a propagandist, forward-looking body, closer indeed to the ideals of Morris than to those of Muthesius. Muthesius on the other hand was

supported by several Germans individually whom one would not expect to find in his camp, for instance to quote only three, by Hermann Obrist, one of the most original artists of the German Art Nouveau, by Wilhelm Schäfer, a well-known writer and poet, and by Friedrich Naumann, a politician of importance in the development of social reforms and democracy in pre- and post-First-World-War Germany. Obrist wrote in 1903 of steamers and 'the beauty in the powerful sweep of their colossal yet quiet contours . . . their wonderful utility, their neatness, smoothness, and shine'. A look into the engine-room makes him feel 'almost intoxicated'.83 Wilhelm Schäfer vividly recommends the sachliche Ausbildung of all forms; this would necessarily lead to a modern style for all products, just as it has done in machines and iron bridges.84 As to Friedrich Naumann, his main interest was in the social aspects of architecture and art. This led him to an early appreciation of the machine. Exactly like Muthesius, and no doubt inspired by him, Naumann speaks of 'ships, bridges, gasometers, railway stations, market halls' as 'our new buildings'. He calls 'building in iron the greatest artistic experience of our time', because 'here there is not the application of art to construction, no stuck-on decoration, no frills. Here is creation for use . . . here are as yet inexpressible possibilities. All our notions of space, of weight and support are changed.'85

Naumann was a personal friend of Karl Schmidt (1873–1948) who, as a trained cabinetmaker, had started a furniture workshop at Dresden in 1898. 86 In this shop he employed from the beginning modern architects and artists as designers. Though Schmidt started under the influence of the English Arts and Crafts (he had travelled in England as a journeyman), his main interest soon became inexpensiveness and production by machinery. As early as 1899–1900 the Deutsche Werkstätten, in an exhibition of industrial art in Dresden, showed an apartment of two living-rooms, bedroom, and kitchen for a mere £40. And in 1905–6, for another exhibition, again in Dresden, they produced their first machine-made furniture, designed by Richard Riemerschmid (1868–1957), Schmidt's brother-in-law. 87 In their catalogue of the same year they prided themselves on 'developing the style of furniture from the spirit of the machine'. This was a feat far more revolutionary than

it seems to us today. At that time there were hardly any instances outside Germany of outstanding artists or architects working not for decorative art, but for industrial design, with the exception perhaps of printing in England which just then took the step from the seclusion of such a private venture as the Doves Press into the market for the common man. The important date is 1912, the year of the introduction, thanks to J.H.Mason, of the Imprint type into the founts of the Monotype Corporation. The Deutsche Werkstätten soon turned to another, even more topical, problem: the standardization of parts. Their first 'Unit' furniture, to call it by the name which has become usual in England, was shown in 1910 as *Typenmöbel*. The idea came from America, where it had been in use for some time for bookcases.⁸⁸

The most important step towards the establishment of a universally recognized style out of individual experiments was the foundation of the Deutscher Werkbund. In 1907, Muthesius, then Superintendent of the Prussian Board of Trade for Schools of Arts and Crafts, had delivered a public lecture in which, in a very outspoken manner, he warned German crafts and industries against continuing with the imitation of the hackneyed forms of bygone times. The speech roused a storm of indignation with the trades' associations. Discussions became more and more excited and, before the end of the year 1907, a number of adventurous manufacturers together with some architects, artists, and writers, had made up their minds to found a new association, called Werkbund, with the aim of 'selecting the best representatives of art, industry, crafts, and trades, of combining all efforts towards high quality in industrial work, and of forming a rallying-point for all those who are able and willing to work for high quality'.89 Qualität, the central idea of the group, was defined as meaning 'not only excellent durable work and the use of flawless, genuine materials, but also the attainment of an organic whole rendered sachlich, noble, and, if you will, artistic by such means'.90 This definition shows clearly that the Werkbund was, from the outset, not opposed to machine production in any respect. In the Inaugural Address at the first Annual Meeting, the architect Theodor Fischer said: 'There is no fixed boundary line

between tool and machine. Work of a high standard can be created with tools or with machines as soon as man has mastered the machine and made it a tool. . . . It is not the machines in themselves that make work inferior, but our inability to use them properly.' And equally it is 'not mass production and subdivision of labour that is fatal, but the fact that industry has lost sight of its aim of producing work of the highest quality and does not feel itself to be a serving member of our community but the ruler of the age'.⁹¹

When, in 1915, the Design and Industries Association was founded in England, avowedly inspired by the example of the Deutscher Werkbund, it declared in one of its first publications that it was 'accepting the machine in its proper place, as a device to be guided and controlled, not merely boycotted'. England, with the foundation of the D.I.A., was not early in taking up the programme developed by the Werkbund. Other Continental countries had followed Germany before the war: the Austrian Werkbund dates from 1910, the Swiss from 1913; and the Swedish Slöjdsforening was gradually reshaped into a Werkbund between 1910 and 1917.

In Germany itself, the existence of this enterprising and uncompromising body did a very great deal to spread the ideals of the Modern Movement. But the Werkbund was not the only centre. Surprisingly quickly, German art schools had deserted the routine of the nineteenth century and adopted the new course. New principals and new teachers were appointed everywhere. In Prussia, Muthesius was responsible for this. He called Peter Behrens to Düsseldorf and Poelzig to Breslau, both as heads of the existing Academies of Art. Even before that time Josef Hoffmann had become Professor of Architecture in the Viennese School of Arts and Crafts, and van de Velde head of the Weimar Art School. In 1907, the Berlin School of Arts and Crafts also secured a progressive principal in the person of Bruno Paul. 93

However, progressive as the spirit in these schools and the Werkbund was, the most essential problem was still unsettled, the very problem with which this chapter is mainly concerned. Though machine art was now accepted as one means of artistic expression besides handicraft, where should the stress lie in the future? This problem was for the first

time clearly put and explicitly discussed at the Annual Meeting of the Werkbund in Cologne in 1914. Muthesius stood up for standardization (Typisierung), van de Velde for individualism. Muthesius said: 'Architecture and the entire sphere of activity of the Werkbund tend towards standardization. It is only by standardization that they can recover that universal importance which they possessed in ages of harmonious civilization. Only by standardization . . . as a salutary concentration of forces, can a generally accepted and reliable taste be introduced.' Van de Velde responded: 'As long as there are artists in the Werkbund . . . they will protest against any proposed canon and any standardization. The artist is essentially and intimately a passionate individualist, a spontaneous creator. Never will he, of his own free will, submit to a discipline forcing upon him a norm, a canon.'94

The first ever to plead the cause of the machine and the new architecture of a machine age with the same fervour with which van de Velde had pleaded that of individualism were the Italian Futurists and especially the brilliant young architect Antonio Sant'Elia (1888-1917) who died without having had a chance of building as he thought, preached, and drew. 95 Sant'Elia's Messaggio is a vision of the casa nuova, 'constructed with loving care for all the resources of science and technics and determined in its new forms, new lines, its new raison d'être, solely by the special conditions of modern life. . . . The calculations of the insistence of materials, the use of reinforced concrete and iron exclude architecture in the traditional sense.' Buildings look grotesque if they try to obtain within the possibilities of the slenderness and thinness of concrete the heavy curves of arches and the massive character of marble. The job of today is not to build cathedrals but big hotels, railway stations, arterial roads, market halls, towers on grid plans in replacement of slums. 'We must build the modern city ex novo'..., a town of 'tumultuous streets' with building below as well as above ground. The house must be beautified not on the small scale of mouldings and capitals but in the grouping of its masses and the arrangement of its plan. It must be 'similar to a gigantic machine', made 'of concrete, of glass, of iron, without painting or sculpture', lifts ought to be exposed outside, cold calculation and the boldest audacity must unite forces, and the result will not be 'an arid combination of the practical and the useful, but remains art, that is expression'.

This message appeared in the catalogue of an exhibition called *Nuove Tendenze* in Milan in May 1914. Two months later Marinetti, the vociferous leader of the Futurists made it the centre of a Manifesto of Modern Architecture issued in July 1914. He added passages with which Sant'Elia did not agree, but it remains highly probable that Marinetti's original Futurist Manifesto of 1909 with its profession of faith in motor-cars ('we laid our hands on their burning breasts') and in 'the great crowd, the modern metropolis, arsenals and shipyards at night, railways, steamers, aeroplanes' had inspired Sant'Elia's thought on the City of the Future, ⁹⁶ and indeed those remarkable visions of buildings to which we have to revert in Chapter 7.

These visions of about 1913-14 appear fantastical when set side by side with the Sachlichkeit of the work of those German architects who agreed with Muthesius, and especially Peter Behrens and Walter Gropius. What they built in 1909-14 will be illustrated at the end of this book, whose chief aim is in fact to prove that the new style, the genuine and legitimate style of our century, was achieved by 1914. Morris had started the movement by reviving handicraft as an art worthy of the best men's efforts, the pioneers about 1900 had gone further by discovering the immense, untried possibilities of machine art. The synthesis, in creation as well as in theory, is the work of Walter Gropius (born in 1883). In 1909, Gropius worked out a memorandum on standardization and mass production of small houses, and on advisable ways of financing such building schemes. 97 At the end of 1914, he began preparing his plans for the reorganization of the Weimar Art School, of which he had been elected principal by the Grand Duke of Saxe-Weimar. 98 The opening of the new school, combining an academy of art and a school of arts and crafts, took place in 1919. Its name was Staatliches Bauhaus, and it was to become, for more than a decade, a paramount centre of creative energy in Europe. It was at the same time a laboratory for handicraft and for standardization; a school and a workshop. It comprised, in an admirable community spirit, architects, master craftsmen, abstract painters, all working for a new spirit in building. Building to Gropius is a term of wide import. All art, as long as it is sound and healthy, serves building. 99 Hence all students of the Bauhaus were trained as apprentices, received at the end of their course the freedom of the trade, and were only after that admitted to the building-site and the studio of experimental design. 100

Gropius regards himself as a follower of Ruskin and Morris, of van de Velde and of the Werkbund. 101 So our circle is complete. The history of artistic theory between 1890 and the First World War proves the assertion on which the present work is based, namely, that the phase between Morris and Gropius is an historical unit. Morris laid the foundation of the modern style; with Gropius its character was ultimately determined. Art historians speak of 'Transitional' preceding the harmonious perfection of 'Early Gothic'. While Romanesque architecture was still lingering on all over France, the master of the east chapels and the ambulatory of St Denis designed in a completely new style, as the pioneer of that style which was to spread over the next sixty or eighty years. What he did for France before the middle of the twelfth century was done for the world at the beginning of this century by Morris and his followers - Voysey, van de Velde, Mackintosh, Wright, Loos, Behrens, Gropius, and the other architects and artists in recognition of whose work the following pages are written.

2 · From Eighteen-fifty-one to Morris and the Arts and Crafts

A STODGY and complacent optimism was the frame of mind prevailing in England about 1850. Here was England, thanks to the enterprise of manufacturers and merchants, wealthier than ever, the workshop of the world and the paradise of a successful *bourgeoisie*, governed by a *bourgeois* queen and an efficient prince consort. Charity, churchgoing, and demonstrative morality might serve to settle your accounts with Heaven and your conscience – on the whole you were lucky to live in this most progressive and practical age.

No generation before this could have conceived the idea of an exhibition of raw materials and technical products from nations all over the world. The scheme, as it was carried to its glorious realization in 1851, was largely due to Prince Albert's energy. In mapping it out and arranging it, he was carried on the same wave of expansive optimism as his contemporaries.

'Nobody who has paid any attention to the particular features of the present era', said Albert in one of the preparatory addresses, 'will doubt for a moment that we are living in a period of most wonderful transition, which tends rapidly to the accomplishment of that great end to which indeed all history points, the realization of the unity of mankind.' In the same speech he extolled 'the great principle of division of labour, which may be called the moving power of civilization', and the introduction to the Official Catalogue of the Exhibition asserts that 'an event like this exhibition could not have taken place at any other period, and perhaps not among any other people than ourselves'. Indeed not; those who wrote these lines knew the reasons and spoke quite frankly about them: 'the perfect security for property' and 'commercial

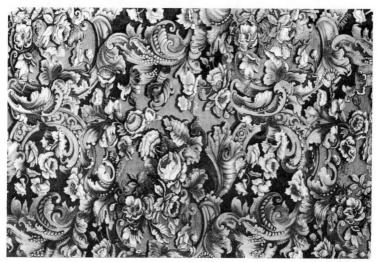

1. Carpet from the Great Exhibition of 1851.

freedom'.³ The thousands of visitors who thronged the Exhibition probably felt the same. The attendance as well as the size of the buildings and the quantity of products shown was colossal. The aesthetic quality of the products was abominable. Sensible visitors realized that, and soon discussions started in England and other countries as to the reasons for such an evident failure. It is easy for us, today, to enumerate various such reasons; but it was hard indeed for a generation that had grown up amid unprecedented discoveries in science and technique. There were the new railways and power-looms, there were the most cunning inventions to facilitate the production of almost any object, formerly made so laboriously by craftsmen – why should these wonderful improvements not help to improve art as well?

Yet this is what resulted: Pardoe, Hoomans & Pardoe's patent velvet pile tapestry carpeting (Pl. I), wrong from any point of view. You see an extremely elaborate pattern, the charm of which, during the Rococo period, would have been based on the craftsman's imagination and unfailing skill. It is now done by machine, and it looks it. Eighteenth-century ornament may have influenced the designer, the coarseness and

2. Shawl from the Great Exhibition of 1851.

overcrowding are his original addition. Moreover, he had neglected all fundamental requirements of decoration in general and of carpet decoration especially; we are forced to step over bulging scrolls and into large, unpleasantly realistic flowers; it seems unbelievable that the teachings of Persian carpets should have been so completely forgotten. And this barbarism was by no means limited to England. The other nations exhibiting were equally rich in atrocities. Take the design for a silk shawl by E. Hartneck, shown in the French section (Pl.2). This is at least as incongruous as the English carpet in its mixture of stylization and realism. It shows the same ignorance of that basic need in creating patterns, the integrity of the surface; and the same vulgarity in detail. It was not only that the machine had stamped out taste in industrial products; by 1850 it seems that it had irremediably poisoned the surviving craftsmen. This is what makes us feel particularly indignant about silverware such as the hand-made decanters, goblets, and jugs in Plate 3. Why could no craftsman during the eighteenth century produce anything so bulging, so overdone? Surely this contrast is real and not

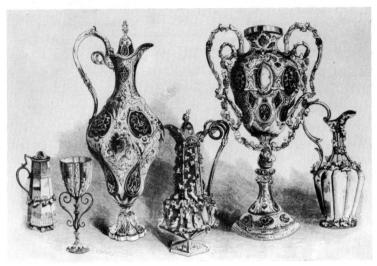

3. Silverware from the Great Exhibition of 1851.

simply a figment of our generation. The insensibility of the artist towards the beauty of pure shape, pure material, pure decorative pattern, is monstrous.

Once more the question has to be asked: Why was this bound to come? The usual answer – because of industrial growth and the invention of machines – is correct, but as a rule taken too superficially. The potter's wheel is a machine, and so are the hand-loom and the printer's press. The development from such simple mechanical devices to modern wonders of machinery was logical and gradual. Why did the machine in the end become so disastrous to art? The transition from the medieval to the modern state of applied art was reached somewhere about the end of the eighteenth century. After 1760, a sudden acceleration in technical improvements set in. This no doubt was due to that profound change of mind which began with the Reformation, gathered strength during the seventeenth century, and was dominant in the eighteenth. Rationalism, inductive philosophy, experimental science, were the determining fields of European activity during the Age of

Reason. Even the religious revival which took place has a strong element of rationalism and marked understanding for worldly tasks and the ethical qualities of workaday life.

The change in European thought was accompanied and followed by a change in social ideals. Thus the newly-roused inventiveness received an equally new practical scope. Applied science as a means of governing the world soon became part of a programme directed against those classes which had governed during the Middle Ages. Industry meant the bourgeoisie as opposed to the Church and the Nobility. The French Revolution accomplished what had been slowly preparing for more than two centuries. The medieval social system was swept out of existence, and with it the class of cultured and leisurely patrons as well as the class of cultured and guild-trained craftsmen. It is more than coincidence that very soon after the dissolution of the guilds in France (1791), the École Polytechnique and the Conservatoire des Arts et des Métiers were founded (1795 and 1798), and the first National Industrial Exhibition was held (1798). Industry instead of handicraft is a conception of the tiers état. This applies likewise to England; but, owing to the temperament of the English, the change was slower here and came about without a sudden revolution. It started early in the eighteenth century and ended only with the Reform Bill in 1832. Guilds had never been so influential in England as on the Continent. From the fourteenth century on, the nobility had already begun to merge with the merchant class. Plutocracy began to replace aristocracy earlier in England than in France. It is only in a figurative sense that the history of English civilization between 1760 and 1830 can be called the Industrial Revolution.

Some dates may illustrate the rapid and impetuous industrial growth which formed a world capable, a century later, of creating the Modern Movement. As England was leading in the Industrial Revolution nearly all these early dates are English. In 1709, Abraham Darby made cast iron with coke (instead of wood); about 1740 Benjamin Huntsman invented the crucible process of melting steel; in 1783 Cort introduced the puddling process; about 1810 the decisive improvements in the use of the blast-furnace took place (Aubertot); in 1839 Nasmyth invented

the steam-hammer; and in 1856 Bessemer his new method of producing steel free from carbon. To these innovations in metallurgy, we must add the invention of the steam-engine with separate condenser (J. Watt, 1765), of the steam-boiler (1781), the screw steamer (1821), and the railway engine (1825). The principal dates in the spinning and weaving industries are the following: 1733 fly-shuttle (J. Kay), 1760 shuttle drop box (R. Kay), 1764–7 spinning jenny (Hargreaves), 1769–75 water-frame for spinning (Arkwright), 1774–9 spinning mule (Crompton), 1785 power-loom (Cartwright), 1799 Jacquard loom.

The immediate consequence of this precipitous development was a sudden increase in production, demanding more and more hands, and so leading to an equally fast increase in population. Towns grew up with horrifying rapidity, new markets had to be satisfied, an ever bigger production was demanded, and inventiveness was stimulated anew. A few more figures may illustrate this rank growth which made our modern world out of a world less similar to ours than to that of the thirteenth and fourteenth centuries. The production of iron in England amounted to about 17,000 tons in 1740, 68,000 in 1788, 170,000 in 1802, 678,000 in 1830. The production of coal in 1810 was 6,000,000 tons, in 1830 25,000,000, in 1857 115,000,000. The export of cotton in 1701 was valued at £23,500, in 1764 at £200,000, in 1790 at £1,500,000, in 1833 at £18,000,000, in 1840 at £26,500,000. The English population grew before 1750 by about 3% per decade, between 1751 and 1781 by 6% per decade, 1781–91 9%, 1791–1801 11%, 1801–11 14%, 1811–21 18%. Manchester had 8000 inhabitants in 1720, 41,000 in 1744, 102,000 in 1801, 353,000 in 1841; Birmingham, 15,000 in 1700, 73,000 1801, 183,000 in 1841.

In the midst of this breathless race, no time was left to refine all those innumerable innovations which swamped producer and consumer. With the extinction of the medieval craftsman, the shape and appearance of all products were left to the uneducated manufacturer. Designers of some standing had not penetrated into industry, artists kept aloof, and the workman had no say in artistic matters. Work was bleaker than ever before in European history. Working hours were between twelve and fourteen, doors and windows in factories were kept locked. Children

were employed from their fifth or sixth year on. Their hours of work were reduced in 1802, after long struggles, to twelve hours a day. In 1833, 61,000 men, 65,000 women, and 84,000 children under eighteen years of age worked in cotton mills. In mines, no inquiries into accidents were held before 1814.

Economists and philosophers were blind enough to provide an ideological foundation for the criminal attitude of the employer. Philosophy taught that unthwarted development of everybody's energy was the only natural and healthy way of progress. Liberalism ruled unchecked in philosophy as in industry, and implied complete freedom for the manufacturer to produce anything shoddy and hideous, if he could get away with it. And he easily could, because the consumer had no tradition, no education, and no leisure, and was, like the producer, a victim of this vicious circle.

All these facts and considerations have to be taken into account if we are to understand the exhibits of 1851. They were indeed taken into account by the very organizers of the exhibition which, in the eyes of this group of energetic men, was, on the aesthetic side, to be an attempt at reform. These men were Henry Cole (1808-82), civil servant and reformer by constitution, his architect friends Owen Jones (1809-74) and Matthew Digby Wyatt (1820-77), and his painter friend Richard Redgrave (1804-88).5 Cole began in 1847 to issue what he called art manufactures, i.e. things of everyday use, better designed, he thought, than was current at the time, and two years later he started a magazine called the Journal of Design and Manufactures. This journal developed a programme of remarkably sound aesthetics.6 'Ornament . . . must be secondary to the thing decorated', there must be 'fitness in the ornament to the thing ornamented', wallpapers and carpets must have no patterns 'suggestive of anything but a level or plain', and so on. Certain designs by Owen Jones illustrate these principles to perfection although Cole's own and those made by his friends for his short-lived firm do not. The commentary in the Journal of Design to Owen Jones's chintz here illustrated (Pl.4) runs as follows: 'The design is, as it ought to be, of a perfectly flat unshadowed character. Secondly, the quantities and lines are equally distributed, so as to produce at a distance the appearance of

 Owen Jones: Pattern design, from the Journal of Design and Manufactures, 1852.

levelness. Thirdly, the colours [they are black and dark purple on white] produce a neutral tint. And lastly . . . it is quite unobtrusive, which a covering of handsomer stuffs [the material was presumably for loose covers of chairs] ought to be. The lines and forms are graceful too, when examined closely.'7

The principles put forward in such a commentary and throughout the writings, occasional or permanent, of the Cole circle were based – as they all freely admitted – on the tenets formulated a few years before by Augustus Welby Northmore Pugin, to whom reference has already been made as an inspirer of Ruskin's theory of honesty in architecture and design. Pugin had started his *True Principles* with 'the two great rules for design . . . that there should be no features about a building which are not necessary for convenience, construction, or propriety', and 'that all ornament should consist of enrichment of the essential construction of the building', yet the title of the book is *The True Principles of Pointed or Christian Architecture*, and Pugin was indeed unable to isolate his principles from the use which, in his view, Gothic builders had made of them. So he remained firmly within a faithful

 Pugin: Ornamental design, from Foliated Ornament, 1849.

imitation of the past, even if some of his own ornamented patterns herald and certainly surpass the designs of Owen Jones and even herald those of William Morris (Pl. 5).

What raises Morris as a reformer of design high above the Cole circle and Pugin is not only that he had the true designer's genius and they had not, but also that he recognized the indissoluble unity of an age and its social system, which they had not done. Cole, Jones, and Wyatt had accepted production by machine unquestioningly, they had not seen that it posed any unprecedented problems and so had simply attempted to improve design without ever pioneering to its roots. Pugin's panacea was Catholic faith and Gothic forms. He thundered against 'those inexhaustible mines of bad taste, Birmingham and Sheffield', against 'Sheffield Eternal' and 'Brummagem Gothic' and succeeded in getting better work by employing 'a devout and skilful goldsmith of Birmingham'- in fact Hardman, a manufacturer – and by supervising him closely. That alone clearly could not be enough, nor could Cole's attempts at a reform in the teaching principles of art schools be enough.

Morris alone felt that what was needed was the personal example, the artist turning craftsman-designer himself. While he followed his inborn passion for making things with his own hands, he knew also that to do this instead of painting pictures was his social duty. Before he was twenty-two, he had experimented with carving in stone and wood, moulding in clay, and illuminating. This helped him to acquire a respect for the nature of materials and working processes. Wherever he looked in contemporary industrial art, he saw manufacturers blatantly violating this. So his first furniture for his own rooms was nothing but a protest. The chairs and tables, 'intensely medieval, like incubi and succubi' (Rossetti), tell of a deliberate return to the most primitive attitude in shaping domestic objects.

At the time, and also in the years when Red House was furnished and the firm founded, Morris's mode of expression was still somewhat different from that of his later, more famous, and more established years. His early designs are crisper, lighter, and more daintily stylized, under some influence no doubt from the teachings of Cole's Journal and of Owen Jones whose Grammar of Ornament he possessed. In the Daisy, the second of any wallpapers he designed, 1861 (Pl.6), the colours are light though restrained, the pattern is pleasantly balanced, without recession, and wholly ornamental without ever losing that intense feeling for nature which is so characteristic of Morris and so different from the imitation of nature as the designers of the Exhibition practised it.

Later on, Morris's style becomes broader and statelier and thereby loses some of its youthful and adventurous charm. Not that his creative vein was less abundant now. His very simplicity of approach led him to forms more traditional. When, for example, in 1878, he decided to make carpets, he saw that certain Oriental patterns were almost exactly what he wanted. Hence his Hammersmith carpets (Pl. 7) are very much like Oriental designs, though he emphasized that he wanted them 'obviously to be the outcome of modern and Western ideas'. This is remarkable. Morris was so far from inventing decorative forms for invention's sake, that if he found models however remote in space or time which met his purpose, he made use of them or at least came under their spell, even if this happened against his own will.

6. Morris: The Daisy wallpaper, 1861.

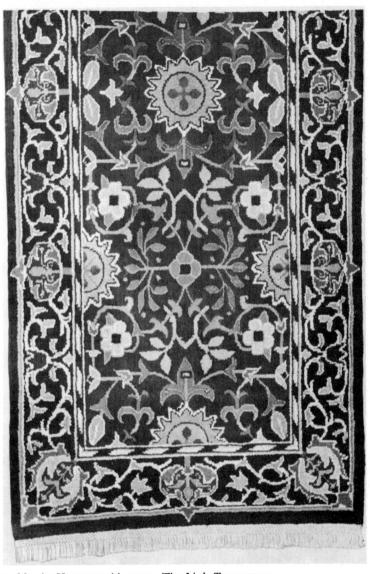

7. Morris: Hammersmith carpet. The Little Tree pattern.

8. Morris: The Honeysuckle chintz, 1883.

Herein lies the explanation of the dependence of most of Morris's later chintzes and wallpapers on models of the sixteenth and seventeenth centuries. We are inclined today to over-rate the importance of this. It is sufficient to compare one of his most famous chintzes, the Honeysuckle of 1883 (Pl. 8), with a specimen of pre-Morris design in textiles such as the shawl from the Great Exhibition (Pl. 2), in order to recognize at once the fundamental novelty of Morris's designs. The contrast between the two is not only one between inspiration and imitation; between valuable imitation inspired by fifteenth-century delicacy, and bad imitation vulgarizing eighteenth-century licence; it is more. Morris's design is clear and sober, the shawl of 1851 is a messy entwinement of motifs. Its thoughtless concoction of stylization and realism is opposed to Morris's logical unity of composition and close study of growth in nature. The designer of the shawl neglects the decorative law of the coherence of surfaces, while Morris without any loss of vitality spreads out a flat pattern.

We get exactly the same result if we place Morris's carpet side by side with the carpet of the Exhibition. Again we find live understanding of decorative requirements as opposed to utter neglect of them, and again simplicity and economy as opposed to wasteful confusion. And although it must certainly be admitted that in stained glass designed by Morris's firm there is more detail-realism than we would now approve of for ornamental purposes, it must not be forgotten that when Morris began, stained-glass windows were just illustrations with plenty of figures, buildings, and spatial recession, and with a large quantity of colours and shades. His is the merit of having gone back to simple figures, simple attitudes, simple colours, ornamental backgrounds. His Pre-Raphaelite friends and masters helped him in that. Their style in painting differed in the same way from mid-Victorian genre-painting as his from the style of 1851. And if Morris windows do not go further in decorative economy, that is due less to Morris than to Burne-Jones, who could not help remaining a painter, whereas Morris wanted him to be nothing but a decorator. 10

The revival of decorative honesty in Morris's designs counts for more in the history of the Modern Movement than their connexion

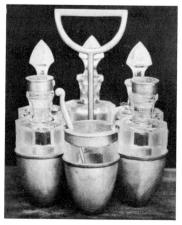

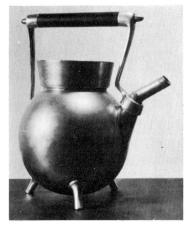

9. Dresser: Cruet set and tea-kettle, 1877-8.

with bygone styles. Morris the artist may in the end not have been able to reach beyond the limitations of his century; Morris the man and thinker did. This is the reason why his writings and lectures had to be discussed in this book before his artistic achievements.

The first effect of Morris's teaching was that several young artists, architects, and amateurs decided to devote their lives to the crafts. What had been an inferior occupation for more than half a century, became once more a recognized task. There is no need to enumerate them all. Crane and Ashbee have already been mentioned. De Morgan was the great English potter of his age; in glass Powell was foremost; in metalwork Benson; in the arts of the book, Emery Walker and Cobden-Sanderson, the founders of the Doves Press. It is extremely significant that between 1880 and 1890 five societies for the promotion of artistic craftsmanship were started: in 1882 Arthur H. Mackmurdo's Century Guild (the term 'Guild' should be noticed), in 1884 the Art Workers' Guild, in the same year the Home Arts and Industries Association, particularly interested in rural crafts, in 1888 Ashbee's Guild and School of Handicraft, and also in 1888 the Arts and Crafts Exhibition Society.

Most of the members of these guilds and associations were a generation younger than Morris, but not all. De Morgan, for instance, was born in

1839, L.F. Day in 1845, Arthur H. Mackmurdo in 1851. The work of these artists, if re-examined today, has remarkable surprises in store. Take for instance a cruet set and a tea-kettle (Pl.9), produced in 1877 and 1878 by Hukin & Heath's of Birmingham to the designs of Christopher Dresser (1834-1904).11 Dresser, like Lewis Day, was a professional designer for industrial production. His inspiration was no doubt the Cole circle. He lectured at South Kensington, travelled in Japan, and brought much Eastern art back to his London home. He also designed for Clutha glass and Linthorpe pottery¹² and wrote several books on the principles of design, sensible but not especially original. This makes the two works illustrated all the more astonishing. In comparison with the silver of the 1851 Exhibition, and actually with most designs for silver and plate done before 1900 or 1905, Dresser's simplicity and creative daring are likewise significant. Both cruet set and tea-kettle are in every detail reduced to fundamentals, as were Morris's own early designs. The base of the cruet set consists of six plain eggshaped holders, lids and stoppers are unadorned, there are hardly any mouldings, and the handle is composed of straight lines and an exact

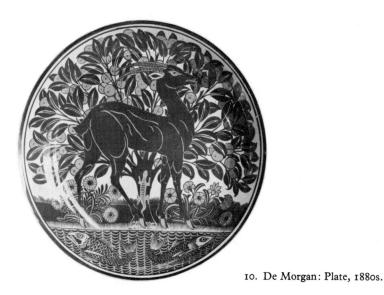

semicircle. The tea-kettle is globular, legs and spout come out with an almost offensive directness, and the handle is again reduced to the simplest of forms.

If we now look at a plate with a gazelle (Pl. 10), made by De Morgan at his Merton Works between 1882 and 1888 and now at the Victoria and Albert Museum in London, the same understanding of decorative fundamentals appears, only this time in terms of two instead of three dimensions. There is of course inspiration from Morris and dependence on Persia, but the bold and ornamental draughtsmanship of the tree behind the sharply outlined animal and the symbol of water behind the fishes are remarkably original.

The same blend of originality and tradition which has proved to secure life beyond its own period for Morris's designs characterizes the best in English domestic architecture during the same period. Comparable also was the attitude of opposition among the leading architects against the accepted standards of design.

All through the development of secular architecture in the principal European countries from 1850 to the end of the century, the same direction can be noticed. The high tide of the Gothic Revival (Houses of Parliament: Barry and Pugin, 1835-52) was passing about 1865, though later and yet pure neo-medieval buildings are of course to be found in many places (Town Hall, Manchester: Waterhouse, 1868-77; Glasgow University: G.G. Scott, 1870; Natural History Museum, London: Waterhouse, 1873-80). Simple Neo-Renaissance was also coming to an end (Reform Club: Barry, designed 1837; Dresden Opera: Semper, first building 1838-41; Dresden Gallery: Semper, 1847-54). The next phase was the revival everywhere of an overdecorated type of Nordic Renaissance (in Paris the extensions to the Hôtel de Ville, already begun in 1837, in England Neo-Elizabethan from the 1830s onwards, in Germany Neudeutsche Renaissance, after 1870). Immediately after the introduction of this style of decoration, an equally overdecorated but more colossal Neo-Baroque set in (Paris Opéra: Garnier, 1861-74; Brussels Palais de Justice: Poelaert, 1866-83). This style remained the official architectural taste in most Continental countries until after 1900.

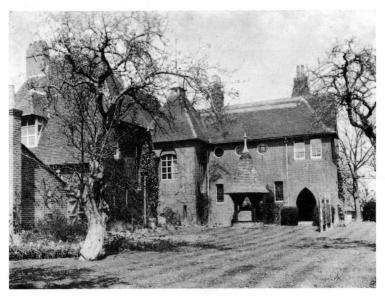

11. Webb: Red House, Bexleyheath, Kent, 1859.

In England the evolution followed precisely the same course; but, since English architecture had been so different from Continental during the centuries imitated, the result was likewise different. The background in England was something like this. The overcrowded Elizabethan and Jacobean Mannerism was superseded in the seventeenth century by Inigo Jones's, and then by Christopher Wren's stately and dignified Baroque classicism, and then by a cooler, more restrained Palladian classicism. This grand yet reserved style remained dominant throughout the eighteenth century as far as churches and large houses were concerned. It was otherwise with domestic architecture of a more intimate character. In this, since the Middle Ages, England had developed an unobtrusive, dignified, and comfortable style of her own. After the accession of William of Orange, even royal palaces (Kensington Palace) began to exhibit these qualities. They are the keynote in the style of London's squares and streets; they give London her distinctive character.

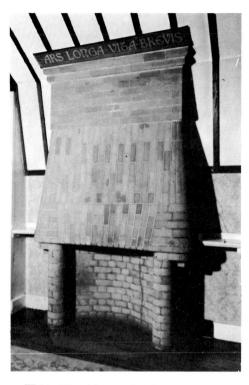

12. Webb: The chimney-piece in Red House, 1859.

In 1859, Morris asked Philip Webb (1831–1915), his friend and colleague in Street's studio, to design a house for him and his wife. It was built in a spirit contrary to that of the past century. As in his decorative designs, Morris refused any connexion with Italy and the Baroque and aimed at something akin to the style of the Late Middle Ages. Webb applied certain Gothic details such as pointed arches and high-pitched roofs; he also adopted the irregularity of the fourteenth-and fifteenth-century domestic and especially monastic architecture, but he never copied. He even admitted the sash-windows of William and Mary and Queen Anne without ever being afraid of clashes between the various styles to which he went for inspiration. Red House as a

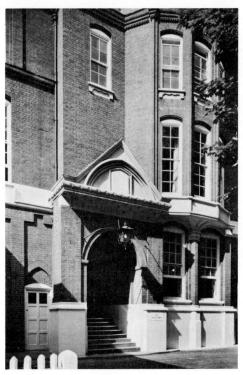

13. Webb: No. 1 Palace Green, Kensington, London, 1868.

whole is a building of a surprisingly independent character, solid and spacious looking and yet not in the least pretentious (Pl. 11). This is perhaps its most important feature. The architect does not imitate palaces. In designing he thinks of a middle class comfortably off but not rich. He shows the red brick of the façades without covering it with plaster as Neo-Classical rules prescribed, and takes the outside appearance of the house as an expression of inside requirements without attempting a grand and useless symmetry. And in his interiors he appears even bolder and more independent (Pl. 12). Detail is deliberately rough and rustic. Individual pieces may be highly ornamented, for instance by paintings done by Morris's and Webb's Pre-Raphaelite

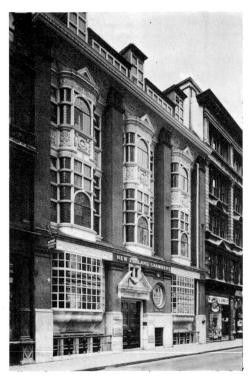

14. Shaw: New Zealand Chambers, Leadenhail Street, London, 1872–3.

friends, but other pieces are left fearlessly sheer, telling their tale without any borrowed phrases.

In town architecture the counterpart of Red House is the house at No. I Palace Green in Kensington, London, which Webb designed in 1868 (Pl.13). It exhibits fearlessly two Queen Anne windows and between them a brick pier of obvious Gothic derivation supporting an oriel window on a curious ribbed corbel. Of the Domestic Revival, as the movement in English town and country architecture between 1860 and 1900 is often called, Webb remained the strongest and soundest, if not the most brilliant exponent. If one looks for brilliance, fecundity of invention, and sheer joy in novelty, one has to go to Richard Norman

 Shaw: The architect's house, Ellerdale Road, Hampstead, London, 1875.

Shaw (1831–1912)¹³ and not to Webb. Shaw's large country houses (or rather the country houses of the Shaw-Eden Nesfield partnership) start in a theatrical, undisciplined, flamboyant imitation-Tudor, still entirely pre-Morris in spirit. The most characteristic examples are Leys Wood in Sussex (1869), and Grims Dyke near London (1872). Then, immediately after Grims Dyke, Shaw changed to something much more original. The seventeenth century caught his fancy, and in his first city building, the New Zealand Chambers in Leadenhall Street, London (Pl. 14), now unfortunately destroyed, he dared to combine bay-windows of a lively English provincial appearance on the second and third floors with a ground floor exhibiting hardly anything but two

large office windows of many panes separated by wooden glazing bars. That was in 1872–3. In 1875 his own house in Ellerdale Road, Hampstead, London, is of equal boldness (Pl. 15). The key motifs now comprise, besides Dutch curved gables of the shape popular in England between 1630 and 1660, the tall slim sash-windows of William and Mary and Queen Anne architecture. The composition is deliberately picturesque, but very sensitively balanced and by no means haphazard.

However successful this so-called Oueen Anne Revival was, Norman Shaw did not in the long run remain satisfied with it. There was yet another change in his style - or rather the source of his style; for he remained to the end faithful to historicism as such, even if his was a very cavalier treatment of historical precedent. It was in the late eighties that he remembered what his former partner Eden Nesfield (1835-88) had done as far back as 1870, and studied in earnest the style of the smaller country and town house of the later seventeenth and early eighteenth centuries in England, not only for window motifs but for the whole of their plain, sensible, well-proportioned, unadorned brick frontages. Nesfield's Lodge at Kew Gardens was indeed built in 1866 and has the short brick pilasters usual in England about 1660 or 1670, a steep pyramid roof and dormer-windows with segmental pediments. Nesfield's Kinmel Park (Pl. 16) was begun only in 1871 but probably designed earlier. Its slender segment-headed sash-windows and pedimented dormer-windows stand on their own. Shaw turned to Kinmel Park for belated inspiration, when he designed No. 170 Queen's Gate, London in 1888 (Pl. 17). This house, exceptional in Shaw's œuvre, started a fashion which reached its climax only in the twentieth century. It comes indeed as near to the spirit of the new century as one could come without actually breaking with the past, and in this respect it was more progressive than the work of any of Shaw's contemporaries at home and abroad.

Apart from Shaw and Webb only one other English architect must here be recorded, Edward Godwin (1833–86), more a designer than an architect. He was a friend of William Burges, architect of Neo-Gothic churches and secular buildings, and inventor of some fantastic decoration to which we shall have to revert later. Godwin started with

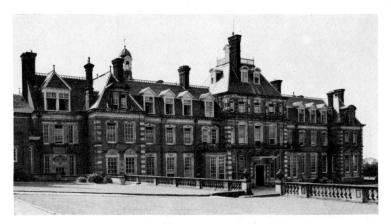

16. Nesfield: Kinmel Park, Abergele, Wales, 1871 or earlier.

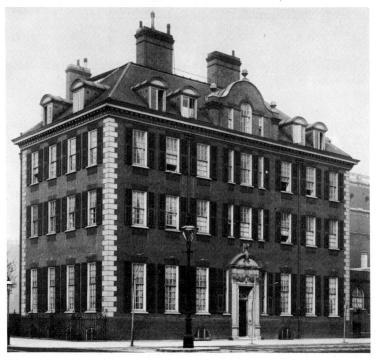

17. Shaw: No. 170 Queen's Gate, London, 1888.

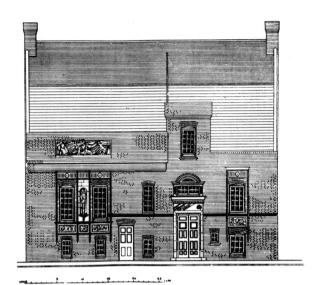

18. Godwin: White House, Tite Street, Chelsea. Built for Whistler (with alterations) in 1878.

successful essays in the civic Gothic (Northampton Town Hall, 1861), but very soon turned domestic and original. In his own house in Bristol, as early as 1862, he had bare floors, plainly coloured walls, a few Persian rugs, a few Japanese prints, a few pieces of antique furniture. If Whistler some years later went in for bare walls, plain-coloured, Godwin's influence may well be assumed. In 1878 Godwin designed for Whistler the White House in Tite Street, Chelsea (Pl. 18), the most interesting house in England between Shaw's in Ellerdale Road and Shaw's in Queen's Gate, original, challenging, witty, if architecture can be witty, and certainly highly capricious in its fenestration.

Only one other country, besides England, took part in this domestic revolution of the late nineteenth century: the United States. These were the first decades in which the New World staked a claim to leadership in architecture, even if still, at least in the domestic field, a joint leadership. The earliest architect to advance from provincialism to a

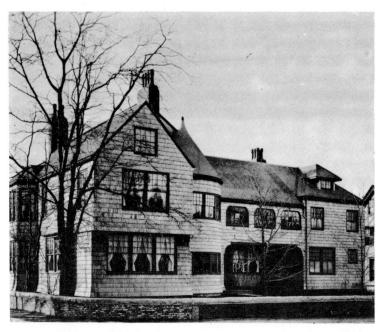

19. Richardson: Stoughton house, Cambridge, Massachusetts, 1882-3.

place in the vanguard was Henry Hobson Richardson (1838–86). ¹⁴ His F. L. Ames gate lodge in North Easton, Mass., 1880–81, and his Stoughton house in Cambridge, Mass., of 1882–3 (Pl. 19) are even less derivative than Shaw's contemporary houses. Richardson's use of shingling and of large-scale random rubble, of boulders, one is tempted to say, and of picturesque asymmetry shows as much originality as Shaw possessed, and more vigour. His even more impressive power in the designing of commercial structures will be mentioned later. Both his town and his country styles were at once widely imitated by good, bad, and indifferent architects. Amongst his best followers was Stanford White (1853–1906) whose Newport Casino was built as early as 1881 (Pl. 20). The same qualities are here clearly visible as in the Stoughton house though perhaps handled a little more elegantly.

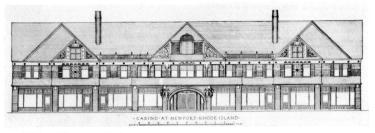

20. White: Newport Casino, 1881.

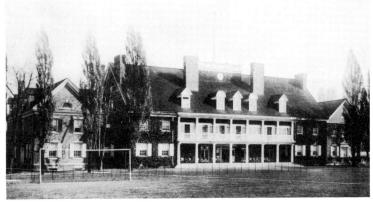

21. White: Germantown Cricket Club, Philadelphia, 1891.

Stanford White, less elementary and less hard than Richardson, could indeed take the same step which Shaw had taken between the houses of 1875 and of 1888. Only in the case of White the new ideal of simplicity was not expressed in terms of English Queen Anne but first in terms of the Central Italian High Renaissance and then of American Colonial. The examples are well enough known: The Villard houses on Madison Avenue, New York, of 1885 and the H. A. C. Taylor house in Newport, R. I., of 1886 or the Germantown Cricket Club, Philadelphia, of 1891¹⁵ (Pl. 21).

However stimulating and original these American developments

were, they did not have any immediate repercussions on architecture in Europe. In England occasional similarities with Richardson occur (and will be referred to in a later chapter), but the Continent remained unaware of American innovations for a surprisingly long time. When Continental architects had grown weary of the boastful spirit of Neo-Baroque, and had freed themselves from all period forms by a short plunge into Art Nouveau, they looked to England for help, to English building and English crafts, and not yet to America.

3 · Eighteen-ninety in Painting

WHEREAS the way for a future style in architecture and design was cleared by English artists, the new ideals in painting were conceived and developed on the Continent. The part played by England in the growing movement was to maintain and revive wholesome traditions in order to secure a solid foundation upon which the structure could be built; the task which Continental artists had set themselves was to force a new faith upon the world of art.

Morris had declined to follow the ways of the generation preceding him; the leading Continental artists with whom we shall have to deal in this chapter did the same, or, as it would be better to say, outwardly the same. For Morris turned against the horrors of 1851, the reformers of 1890 against Manet, Renoir, and the other Impressionists, artists of brilliant skill. Morris loathed the superficiality of his immediate predecessors and that Liberalism which was responsible for the social and artistic conditions in England; the rebels of 1890 also accused their predecessors of superficiality (though in the changed sense of exclusive regard for surface qualities) and of more concern with personal than with community interests, which is the philosophical corollary of Liberalism.

That far, the Morris Movement and the movement in painting which took shape about 1890 advanced on comparable lines and towards comparable aims. But there is one chief difference of means and ends. Morris dreamed of a revival of medieval society, medieval craft, and medieval forms; the leaders of European painting in 1890 fought for something that had never existed before. On the whole, their style was free from period revival, unencumbered and uncompromising. This

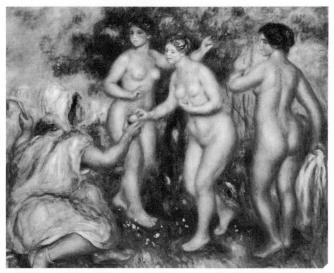

22. Renoir: The Judgement of Paris, 1908.

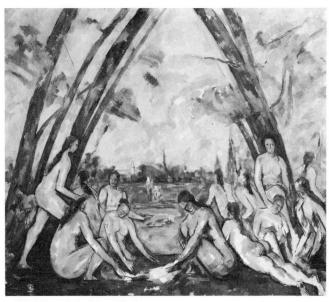

23. Cézanne: Bathers, 1895-1905.

would also apply to the architecture and decoration of Art Nouveau; but the break was achieved by the painters earlier than by the architects. Therefore an account of the revolution in painting has to be given before we can continue the discussion of architectural and decorative evolution, which is the main task of this book.

Many artists took part in this destructive and constructive movement. The most powerful characters were two Frenchmen, Cézanne and Gauguin, a Dutchman, van Gogh, and a Norwegian, Munch. Five more, besides these, shall be mentioned here: Seurat, Rousseau, Ensor, Toorop, Hodler.

A comparison between the Judgement of Paris of 1908 by Renoir (Pl.22) and the large Bathers by Cézanne, of 1895–1905 (Pl.23), may serve to illustrate the violent change which characterizes European painting about 1890. Renoir's painting, in spite of its late date, is the work of a classic Impressionist; Cézanne (1839–1906), though born during the same decade as Manet, Renoir, and Monet, was an Impressionist only for a short time. His early style was derived from Delacroix, Courbet, and the Baroque, and while even in his most mature works he keeps that beauty of the surface which was the sole ideal of Impressionism, his own ideal was in other ways wholly opposed to theirs. The surface of a landscape by Monet is a glittering veil, Cézanne's hills and trees and houses are still and monumental planes, reposing in the three-dimensional space of the picture.

The charm of Renoir's Judgement of Paris lies in the play of rosy bodies, in a landscape of loosely sketched-in green and bluish and pinkish tones. It is a highly sensuous charm. Renoir said frankly that in front of a masterpiece he thought of only one thing: to enjoy it. He once praised a picture by saying that he wanted to kiss it, and he blamed a great painter because 'he had never caressed the canvas'. To catch all the bliss of a passing instant, all the joy in what the eye can drink in of light and colour any day and any moment, to make a round, harmonious composition of it and to paint it with all its atmospheric glamour: that is Renoir's aim.

Cézanne despised such a superficial approach. The women in his Bathers are without any sensuous appeal. They act not on their own

but on behalf of an abstract scheme of construction which is the real subject of the picture. His aim is to express the lasting qualities of objects; no transitory beauty occupies his mind. The striding woman on the left is a diagonal to be continued in the unnaturally slanting trees. The powerful curve of the back and thigh of the figure sitting on the left serves to join these diagonals with the four main horizontals. The faces are hardly detailed, no personal expression is allowed. Cézanne does not care for the individual, he speculates on the idea of the Universe. 'That gang of Impressionists', he once exclaimed, 'lack a master as well as an idea.' By constructing his pictures with 'cylinder, sphere, and cone', 3 Cézanne strove to paraphrase the eternal laws of Nature. Hence he was almost bound to take endless pains over his works, altering and restarting them over and over again. Up to fifty sittings were necessary for a portrait, and many of them retain evidence of this passionate exertion.

For the intensity and passion of Vincent van Gogh (1853-90), this exertion proved too much. His mind gave way as soon as he had achieved his task. The course of van Gogh's life is extremely significant of the changed attitude which inspired the creative artists about 1890. He went as a lay-preacher to the poor and destitute, before he had found in painting an adequate means of expression, and he had to work hard to acquire the craft of the brush. His mature style is to be found in the works of only two years, pictures that he painted in a frantic hurry, 'like the harvester who works silently in the blazing sun, concentrating on his work'.4 A picture may represent an empty chair only, but it means the chair which is empty, now that the friend has tragically departed – and all the overwhelming violence of his feeling is in its colours and the infuriated strokes of broad brushes. He may paint a café, but he paints it as 'a place where one can run mad, or commit a crime'.5 His colour above all is never accidental, never just the rendering of shades observed in nature. The introduction of a new colour always suggests an 'emotion of an ardent temperament',6 maybe 'the thought of a brow', or 'the love of two lovers'.7

So not one of his mature portraits is only a portrait, only the representation of the features of some indifferent person. In a mysterious

way, much more is embedded in the lines of such a face, the rude shape of such a body, the hard strokes of such a background (Pl.24). Again we feel of a sudden confronted with Nature as a creative force, magnificent and terrifying, and not with the changing surface of nature as skilfully portrayed by the Impressionist. Manet, in his Jeanne (Springtime) of 1882 (Pl.25), hardly differentiates between the consistence of the human being and that of the surroundings. This refusal to distinguish between the changing and the lasting, the absolute and the accidental, had emerged in philosophy since the seventeenth century; it created the art of the Dutch landscape, and culminated in Impressionism. Jeanne is of importance to the artist only in so far as she is part of nature, reflects colour and light.

But to van Gogh the peasant woman, as he knew her so well, is the vessel of an idea. She is sacred and indestructible as a symbol. He was longing to paint 'pictures of saints and holy women from life which would seem to belong to another age, and they would be middle-class

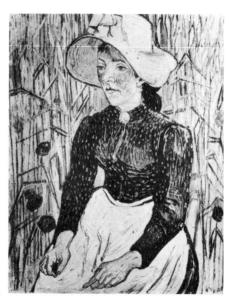

24. Van Gogh: Portrait, 1890.

women of the present day'.8 He wanted to address the people, he believed that they, in buying cheap and coarse colour prints, were on the right path, rather than those city dwellers who went to the art exhibitions.9 He preferred the simplicity of the popular colour print to the refinement of contemporary painting, and strove towards a similar simplicity of subject and technique. Only diffidence and underestimation of his own powers prevented him from venturing upon religious subjects. He actually began to paint a *Garden of Gethsemane* but destroyed it afterwards. By painting all day long, he hoped to drown this 'terrible need of religion'. But he failed; the 'terrible need' appears in whatever he did, and lends that convulsive intensity to any man, or flower, or cloud that he chooses as an object for his devotion.

It is true, this need for religion was felt so violently by van Gogh alone. But would Gauguin (1848–1903) have left Europe and started a new life amongst the savages of Pacific islands, if he too had not despised the shallowness of nineteenth-century life? Before he went, he turned

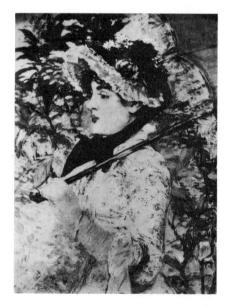

25. Manet: Jeanne (Springtime), 1882.

for a short time to religious painting. There is, in the Edinburgh Gallery, the picture of Jacob wrestling with the Angel, with the foreground of Breton women, and there is the Yellow Christ, illustrated in Plate 26. An Impressionist painter could never have been satisfied with these wooden forms, so harsh and unpleasing, with these thick black outlines - cloisonnism it was called in the Press - and with these heavy, solid, intense colours, nor would an Impressionist have chosen this subject. The Impressionist is interested only in what he can see with his own eyes, and nothing behind the surface is important. He is as materialistic as any Victorian philosopher. To Gauguin the surface is immaterial, the casual arrangement of objects in nature is no more than a stimulus for the conception of a picture. The essential process is to condense from the impression received something which contains all the factors of lasting significance. In the Yellow Christ the background is not one particular piece of French scenery, it is a general symbol of Brittany, and of the spirit of peasant life, close to the soil and pious in an elementary, unreasoning way. There is no thought in the faces of these Breton women. Tiredness after hard work, resignation, and dumb submission are all they express. The Christ in the centre of the picture also has all the deliberate primitiveness with which the Expressionists of 1920 endowed their figures - an idol, not an image of Christ crucified, as the five centuries before Gauguin had evolved it. Gauguin had in fact copied it from a rustic piece of late medieval Breton wood carving.

Gauguin had worked in Bretagne, at Pont Aven, in 1886 and the following years. ¹¹ A group of young artists had gathered around him, especially Émile Bernard and Paul Sérusier. In the middle of the Breton years Gauguin went to Martinique, and in 1891 he left Europe again, to get away from Western sophistication. He went to Tahiti, stayed there till 1893, went back to France, and returned to Tahiti for good in 1895. What kept him was that there he found men and women naïve and untouched by the twisted reasoning of Paris, trusting instinct and their passions; and he found nature fertile and untrimmed.

Nature – that is, the spirit of nature versus the imitation of the surface appearance of nature, and also, in a much broader sense, nature as a universal power versus human independence – is one of the mottoes of

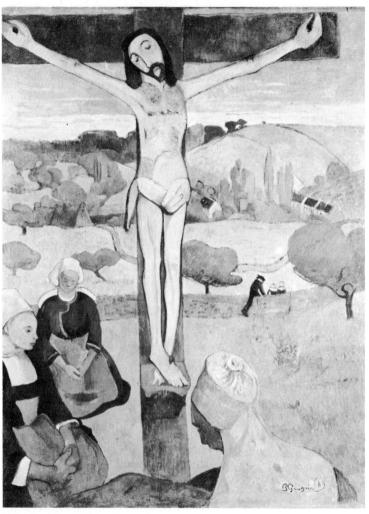

26. Gauguin: Yellow Christ, 1889.

the new movement in European painting about 1890. It may mean, as in Gauguin and van Gogh, back to instinct and self-abandon, or it may mean, as in Cézanne, back to the fundamentals of geometry. It may lead to Expressionism or to Cubism. It may go for inspiration to

cylinder, sphere, and cone, or to Polynesian and medieval carving; the essential attitude of opposition to the mentality of the nineteenth century remains the same.

One typical outcome of the rediscovery of early art at its most forceful was a change of style in the graphic arts, initiated by Gauguin in his zincographs of 1889. The effect of these prints is confined to violent contrasts of flat surfaces. All delicate shades and atmospheric transitions are abandoned. No wonder that after a few years Gauguin resorted to another even more suitable medium for expressing in black and white those visions which occupied his mind. The woodcut relying entirely on the process of carving with a knife should not seek after effects that are not simple and strong (Pl.27). Only by a perverse *tour de force* could nineteenth-century wood engravers produce superficially something like the subtle charm of etchings.

Gauguin's first woodcuts date from the time immediately after he had settled down on Tahiti. At exactly the same time, his Swiss follower, the painter Félix Vallotton (1865–1925)¹² had discovered the possibilities of the woodcut for expressing the new feelings of 1890. In his woodcuts of 1892 and 1893, *The Anarchist* or *Young Girls*, he goes so far in reducing nuances and stressing a few main features and gestures as to

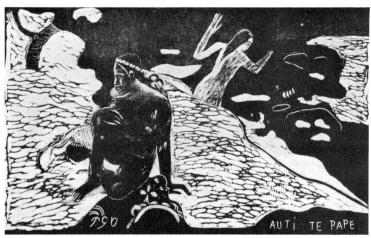

27. Gauguin: Women at the River (Auti Te Pape), c. 1891-3.

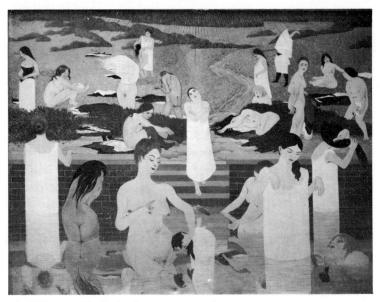

28. Vallotton: The Bath, 1890.

approach caricature. And his principal picture of this period, *The Bath* (Pl. 28), is perhaps the most astonishing example of deliberate infantilism that was produced by that generation. In a highly scandalizing manner, Vallotton has combined a few stylized figures in grotesque chemises with ten or twelve obtrusively drawn nudes. No wonder that he became one of the leaders in the conversion of posters into works of art. His posters begin in 1892.

From the same years date the first French posters whose value is based on the opposition of simple and brightly-coloured surfaces and the abolition of space (Toulouse-Lautrec, Steinlen). English artists, above all the Beggarstaffs (J. Pryde and W. Nicholson), joined this movement almost at once and produced some of the most striking posters (*Cinderella*, Drury Lane Theatre, 1894).¹³

Paintings of the same years by Maurice Denis (1870–1945) such as the *April* at the Kröller-Müller Museum at Otterlo (Pl.29) have a marked affinity to posters too. The common source is Gauguin by whom

Denis had been much impressed and of whom he knew through their mutual friend Sérusier. 14 The young ladies are all clothed in white, the path winds in a curve answering the undulations of their garments, and the hooped branches in the foreground sum up the theme, a theme at the same time decorative and of a meaning which remains concealed. One thing one feels certain about is that these maidens are not just out for a walk to pick flowers. In fact the picture is one of a series of the Four Seasons, and Denis did other decorative and meaningful schemes as well, both in painting and in stained glass. He also illustrated books and designed carpets and wallpaper. This turn to craft in the Gauguin circle - a curious and ineffective parallel to the emerging English Arts and Crafts - is significant too of the abandoning of art for the sake of the most skilful imitation of nature exclusively. Gauguin worked in pottery as early as 1886 and very boldly and crudely in 1888-90, and he carved some reliefs in wood in 1890 - one of them being called Soyez mystérieuses. And Émile Bernard (1868-1941), friend of Gauguin and of Cézanne and of van Gogh and a painter of medievalizing religious pictures which may well have turned Gauguin's attention to Christian themes, carved in wood and designed for textiles and stained glass, all as early as 1888, and in 1890 even tried to earn money as a designer in a textile firm at Lille. 15 We do not know what his designs looked like; those for the crafts are again flat, hieratic, summary, and as reminiscent of the old broadsheet as of the new poster. Here is the principal point of comparison with the paintings of Seurat and Rousseau. The Grande Jatte (Pl.30) by Georges Seurat (1859-91) appeared as a joke when it was shown in 1886. The figures are wooden like children's toys, they move as awkwardly as if they were driven by clockwork inside, along invisible rails running parallel to the frame of the picture. We seem to hear the tic-tac of their movements. The dogs and the ridiculous little monkey have no life either. This deliberate elimination of atmosphere is all the more remarkable, as Seurat had started from Impressionism and had developed his strange mosaic-like technique while endeavouring to push to its extreme the scientific principle which underlies the Impressionist dissolution of the surface. The Impressionists had painted in loose touches and commas of unmixed colour so as to leave to the eye of the

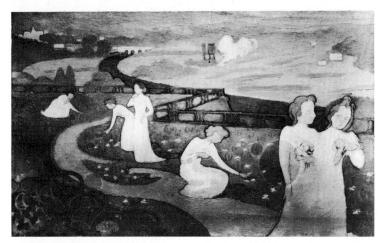

29. Denis: April, 1892.

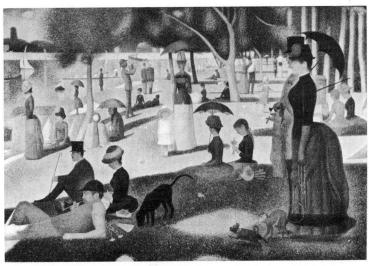

30. Seurat: A Sunday Afternoon on the Island of the Grande Jatte, 1884-6.

beholder the task of gathering up the separate dots. This helped to create that effect of blurred atmosphere which, to the convinced Impressionist, equals the world. Seurat, in condensing these flaky spots into small solid units, destroyed the effect aimed at by Renoir and Monet and replaced it by an unreal effect of hieratic stiffness.

Seurat must have enjoyed the shock which this apparently childish stiffness gave the public. Otherwise, he would not have painted those circus scenes, like the *Chahut* (1890) and the *Circus Parade* (1888), with the grotesque acrobats and dancers, petrified, it seems, in the most distorted attitudes. Here again, we are confronted with revolt – as much as in Cézanne's *Bathers*, or van Gogh's landscapes, or Gauguin's Tahiti women – a sudden revelation of the futility of modern civilization.

Only one painter among those most characteristic of 1890 had nothing of that feeling: Rousseau, *le douanier* (1844–1910), to whom destiny had given such a child-like mind that he could paint primitively without any conscious revulsion. This art has none of the aesthetic subtleties of Manet or Degas. But this loss in aesthetic value is counterbalanced by an increase in live value, and that is in our context tantamount to historical value.

In his life-size self portrait of 1890 (Pl.31), the colours are crude as in an old-fashioned calendar illustration, the forms are as if drawn by a child. This pretty array of flags, those prim clouds with the balloon floating about, and the black silhouette of the painter himself looking rather cross, might have appeared the aberration of an untalented amateur. Today we can see that all this corresponds to Seurat's and Vallotton's tendencies, and marks a milestone in the development of Western art.

Like Gauguin, Rousseau felt attracted by the primitive life of the tropics. He had once seen them, and, years later, he began to paint primeval forests, lions, tigers, monkeys, and lion-hunters. It is not easy to appreciate his attitude in doing this. His pictures lack that sacred quality which Gauguin, and later on Nolde, embedded in their simple tales. But they are strikingly sincere in their childish treatment, with trees and wild animals such as infants would enjoy and fear in their picture-books. It may well be that, by such an apparently helpless

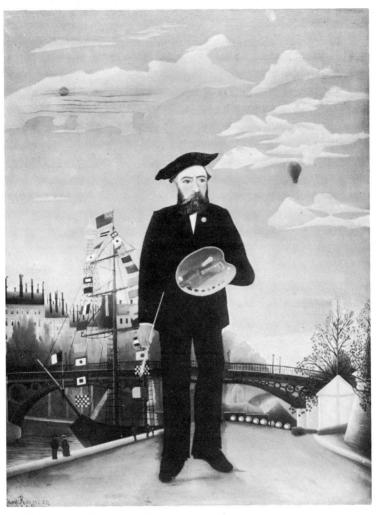

31. Rousseau: Self Portrait, 1890.

technique, Rousseau has come nearer to the world of the savages than Gauguin with his superior knowledge of art.

At first sight one may also take as mere fun the many paintings by James Ensor (1860–1949) which represent masked revellers. But their

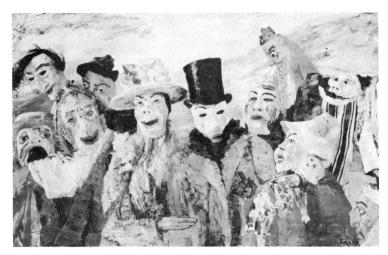

32. Ensor: Intrigue, 1890.

true meaning is entirely opposed to that of Seurat's or Rousseau's works. Ensor too had been an Impressionist for some time. He began to paint masks even before he broke away from the tenets of Impressionism. In his mature works, those painted since about 1886 (Pl. 32), there is nothing of Impressionist naturalism, nothing either of Rousseau's simple-heartedness or Seurat's directness of approach. He painted those groups of people with their grinning masks not because he enjoyed festive confusion, but because the mask allows the artist to fix a lasting expression of demoniac villainy on a face. This is again a denial of the nuance, a 'back to fundamentals', though to Ensor the ultimate fundamental to be reached is the baseness of human nature. The truth of this interpretation of his attitude can be proved by looking at other subjects which Ensor painted or etched during those decisive years. His principal paintings are the Tribulations of St Anthony of 1887 and The Entry of Christ into Brussels of 1888. Here again the Saint or the God is surrounded by hideous demons made even more terrifying by the softness and sometimes sugariness of Ensor's colours. But where such fleshy pinks and silky blues and sweet rich greens serve to add to the sheer surface joy of an Impressionist painting, they intensify in

33. Khnopff: Poster, 1891.

Ensor the grim contrast with the anxieties of the scenes he depicts. Wherever one looks, a new conception of the 'subject-picture' is an integral part of the movement of 1890. Thinking of Impressionism we think of landscapes, portraits, still lifes, not of religion and philosophy. There were, it is true, many outside Impressionism who painted patriotic or allegorical subjects and anecdote and genre, but amongst the spiritual leaders few between the English Pre-Raphaelites, that is the last descendants of early-nineteenth-century Romanticism, and the pioneers of 1890 took an interest in subject-matter as such. And when the movement of 1890 turned once more to symbolism, inspiration

came more often than is usually realized through the manifold, if not very deep, channels of the English Arts and Crafts which were still fed from the Pre-Raphaelite fountain-head. Such is the case with the two French painters who stood out between 1860 and 1890 as exponents of an art expressive of thoughts more profound than what everyday life could offer: Gustave Moreau (1826–98), Huysmans's friend, and Odilon Redon (1840–1916).

The connecting link between Moreau, the Pre-Raphaelites, and the new style of 1890 is the work of the Belgian Fernand Khnopff (1858–1921). He had English blood, a British wife, and spent several years in England. His first symbolistic picture, *Sphinx*, was painted in 1884.

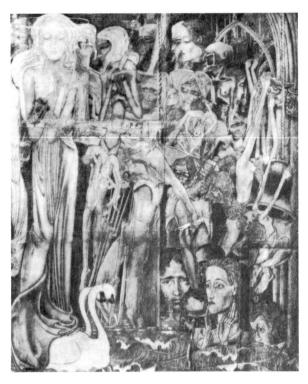

34. Toorop: Faith Giving Way, 1894

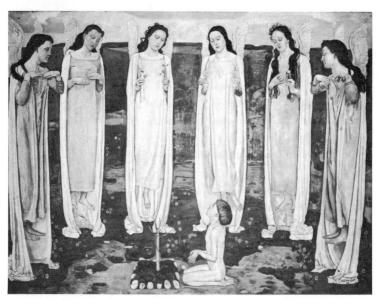

35. Hodler: The Chosen One, 1893-4.

His principal works date from about 1891–6 (*The Offering*, 1891). The poster shown in Plate 33 is of 1891 and advertised an exhibition of Les Vingt, a group of artists at Brussels to which we shall have to revert later. The typography is still wholly Victorian, undisciplined and licentious without being truly original, but the figure on the right, four years later repeated in the painting *Arum Lily*, stands erect, in a hieratic pose as if she were in some kind of ritual procession. ¹⁶

To the position of Khnopff in Belgium corresponds that of Jan Toorop (1858–1928) in Holland.¹⁷ He too started under the influence of French nineteenth-century tendencies, he too acquired a personal knowledge of England (about 1885), he too had a British wife (that is one born in Ireland of English and Scottish parents), and he too arrived at symbolism about 1890. The cartoon which is called *Faith Giving Way* (Pl. 34) was drawn in 1894 and is Toorop's first work showing the new style fully developed: an odd entwinement of gaunt limbs, understandable only by reading an elaborate programme. Both this obscurity

and the intricacy of the pattern of human bodies bear witness to two more sources of Toorop's style, one doubtful, the other certain; namely Blake's linear art and hermetic symbolism, and the arts of Java, brought close to Toorop by Holland's Eastern possessions. It is indeed illuminating in this connexion to remember that Toorop was born in Java, that his father had some Javanese blood, and that in the mid-eighties T.A.C. Colenbrander had started a Dutch vogue for the imitation of Indonesian Batik-printing, just as Gauguin in his rare wooden statuettes of the nineties¹⁸ was to imitate the idols of the West Indies and the Pacific.

More successful than Toorop's and purer than Gauguin's was the style of the Swiss Ferdinand Hodler (1853-1918) which was developed to express sacred truth in terms of line and cool precise colour. Hodler's first portrait, showing a marked tendency towards hieratic simplification, dates from 1888; his first allegorical picture, The Night, from 1890. The painting called The Chosen One, which is illustrated in Plate 35, was conceived in 1893 and carried out in 1893-4. A tapestry, not a picture: that is what we feel. No spatial, and above all no atmospheric values are admitted. The six guardian angels do not stand on the ground; they are supposed to be flying, but do not give any such impression. Neither is there any air between their feet and the grass, or between their bodies and the background. As six long and slender candle-like shapes, they surround in a shallow ellipse the small and sparse figure of the boy praying. His arms and hands are again as delicate as those drawn by Toorop or Khnopff. Sensuous charm of flesh and skin would detract from the main content. An icy air of clear abstraction rests upon Hodler's work. No wonder that, in his old age, he turned towards Alpine landscapes. Artists who struggled for such purity of style and precision of rendering were bound to look down scornfully on the surface realism and loose composition of the Impressionist school.

But the greatest Germanic painter of his generation, much greater in power than Hodler and Toorop, is Edvard Munch (1863–1944). Like so many of the leaders of that generation, he had gone through a phase of Impressionism. But while working in Paris under the influence of Pissarro, he imbibed, first perhaps unconsciously, the style of Gauguin,

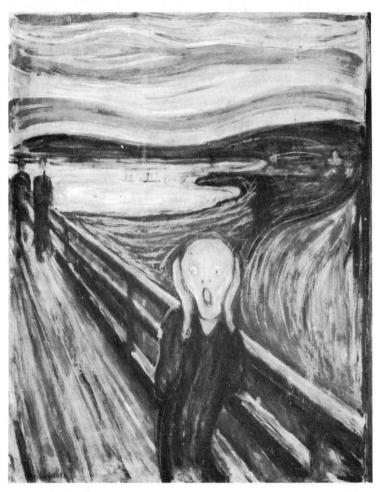

36. Munch: The Cry, 1893.

and thus gained strength to overcome the dangerous charm of superficial beauty. Soon he started, in a surprisingly original manner, simplifying and leaving out all non-essential features. By the beginning of the nineties, the phase of transition was at an end. His paintings, woodcuts, and lithographs of 1893, 1894, 1895 are a synthesis of the new movement's Germanic aspect, as strong and as serious as van Gogh's paintings

and drawings of 1889 and 1890, and yet utterly different in appearance.

In the picture *The Cry* (Pl. 36), natural data are reduced to the minimum: sea, hill, beach, and pier. More than that would be unnecessary. The face of the shrieking creature – we do not even recognize its sex – is defined only so far as the intense expression demands. The cry shapes this face, and it pervades the whole picture, carried by visible waves of sound. So Munch achieves his symbolical expression of the oneness and the Strindbergian horror of the Universe. The subject matters as much to him as to Toorop and Hodler. He painted *Jealousy* and *Puberty*, and even such critical subjects as *The Kiss* and *The Day After*. But he is never sophisticated, or verbose, or melodramatic, though, during these years of open revolt, he seems at times to work under morbid obsessions.

But the quality, above all, which raises Munch to the level of van Gogh is that he does not depend on the symbolic subject. He is just as strong in his landscapes and portraits. Whatever he paints, he makes us feel the inexhaustible power of Nature parturient.

How far, that is the most essential question in our context, do the new tendencies of the painters discussed here coincide with or bear upon those of the architectural style of the Modern Movement? In summing up the qualities which distinguish the artists of 1890 from their predecessors, an attempt will be made to emphasize those which find an echo in contemporary architecture and decoration.

Instead of a variety of charming surface effects, Cézanne, Gauguin, Rousseau believe in the unbroken flat surface; Hodler, Munch, Toorop in the rhythmically drawn outline, as a more intense means of artistic expression. Strong colours and primitive shapes replace the abundance of delicate nuances; hard schemes of composition, the liberty of apparently casual picturesqueness. Not closeness to reality but expressiveness of pattern is what matters; not quick observation of natural facts but their perfect translation on to a plane of abstract significance. Carried over into the artist's personal outlook, this means seriousness, religious conscience, fervent passion, and no longer spirited play or skilful craftsmanship. It means, instead of art for art's sake, art serving something higher than art itself can be.

Exactly the same qualities appear at the same time in literature. The movement away from naturalism and surface interest in the widest sense of these words was universal. ¹⁹ It can be seen in the Belgian Maeterlinck (born in 1862) and his *Pelléas et Mélisande* of 1892, ²⁰ in the Englishman Oscar Wilde's (born 1854) *Salomé* of 1893, in the German Hauptmann's (born 1862) sudden change from his *Weavers* of 1892 to his *Hannele* of 1893, and in France even earlier in Verlaine, Mallarmé, and Rimbaud (born in 1844, 1842, and 1854 respectively).

But, just as in painting, there are two aspects to this literary movement. Symbolism may be a strength and a weakness – an endeavour towards sanctity or an affectation. Cézanne and van Gogh stand on the one side, Toorop and Khnopff on the other, the former strong, self-disciplined, and exacting, the latter weak, self-indulgent, and relaxing. So the one led into a future of fulfilment, that is the establishment of the Modern Movement of the twentieth century, the other into the blind alley of Art Nouveau. It is with Art Nouveau that we must now first concern ourselves.

Nouveau

If the long, sensitive curve, reminiscent of the lily's stem, an insect's feeler, the filament of a blossom, or occasionally a slender flame, the curve undulating, flowing, and interplaying with others, sprouting from corners and covering asymmetrically all available surfaces, can be regarded as the leitmotif of Art Nouveau, then the first work of Art Nouveau which can be traced is Arthur H. Mackmurdo's cover of his book on Wren's City Churches published in 1883 (Pl. 37). We have come across Mackmurdo once before, as the founder of the Century Guild in 1882, the earliest group of artists to follow Morris's teachings, and we shall have to go back to him later for his architectural work. He was a true pioneer in everything he tackled in these early years of his long life. He was born in 1851 and died in 1942. Much recent research has been devoted to the sources of so amazing a design as this title-page and, in connexion with it, to the sources of Art Nouveau. 1 Mackmurdo's immediate source no doubt was certain designs of the Pre-Raphaelites, either whole paintings or cartoons, e.g. by Burne-Jones (Pl. 38), or details, e.g. by Rossetti. Equally unquestionable is the dependence of Rossetti on Blake. Here the most original compositions of the early and the late nineteenth century are firmly linked. But there were also potentialities of Art Nouveau, which one is tempted to label proto-Art Nouveau, within the Gothic Revival in English architecture and design, just as the theories of the Gothicists had stimulated the theories of the reformers of the mid and later nineteenth century. A case in point is for instance an overmantel in the highly medieval house which William Burges built for himself in Melbury Road, Kensington in 1875-80 (Pl. 39).

Mackmurdo's daring was first imitated by other designers for books and magazines, notably Charles Ricketts and Charles Shannon whose *Dial* began to appear in 1889. A few designer-decorators also followed at once, Heywood Sumner² being the most interesting of them. The Morrisite style of the Arts and Crafts Movement could indeed easily be given an Art Nouveau twist.³ In fact, while the various trends must here be presented in separation, they were not seen so at the time, and it should never be forgotten that Gilbert and Sullivan's 'sentimental passion of a vegetable fashion' and their 'poppy or a lily in his medieval hand' do not refer to full-grown Art Nouveau, but come out of *Patience* produced in 1882 – one year before the Mackmurdo book on the Wren churches.

Abroad the effect of all this started after 1890. Generally speaking the designers were listened to less than the typographers and book illustrators, and none of them was received with more fascination than Aubrey Beardsley,⁴ who had only eight years to show his questionable genius before he died in 1898 at the age of twenty-six. He had begun as a belated follower of the Pre-Raphaelites, and broken away from them

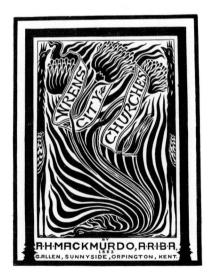

37. Mackmurdo: Title-page, 1883.

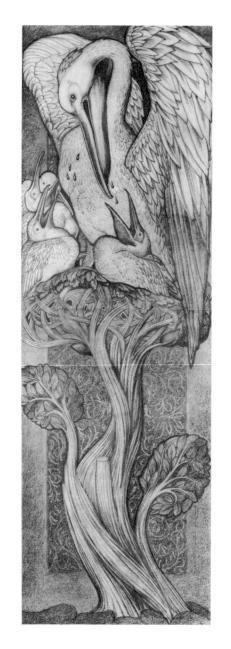

38. Burne-Jones: Pelican, 1881.

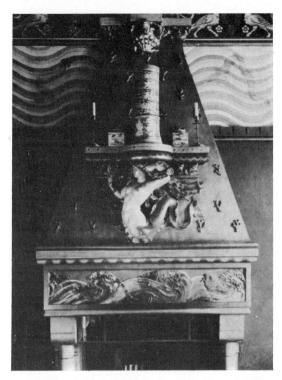

39. Burges: Chimney-piece in his own house, Melbury Road, Kensington, c. 1880.

in 1892 while he was working on the illustrations to the *Morte d'Arthur*. A particularly complete example of his exceedingly personal and *outré* handwriting is the drawing *Siegfried* (Pl.40), published in 1893 in the first issue of the *Studio*. The arrangement of short C-curves, little flowers, lines of minute dots, is different from the manner of any other artist. The way in which Beardsley covers tree trunks and flower stalks and the body of the monster with dainty ornament, shows how regardless he is of the meaning of the scene represented. His concern is with decoration, an elegant display of intricate draughtsmanship, highly artificial and sophisticated. All this has nothing to do with Siegfried, or

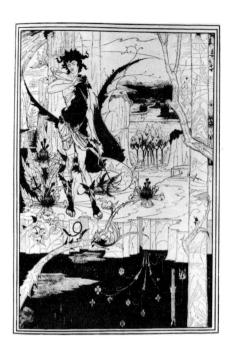

40. Beardsley: Siegfried, 1893.

with Wagner, and only very little with the seriousmindedness of the Pre-Raphelites, Morris, and the Arts and Crafts.⁵

A similarity of approach and graphic style between Beardsley and the Toorop of the same years will be evident to anybody who remembers the Faith Giving Way illustrated in the previous chapter (Pl. 34). The Three Brides, a painting done two years later, that is in 1893 (Pl. 41), shows perhaps even more clearly the characteristics of Art Nouveau in terms of a figure composition. Disregarding for the moment the mystic content of the canvas, we need only look at its long curves, the slenderness of the proportions, the flower-like delicacy of bodies and limbs, the strangely slanting profiles, in order to recognize the same English sources as in Beardsley, and the same conscious effort towards a complicated, sinuous, intertwined, all-over pattern.

Again, looking back at Hodler's The Chosen One (Pl. 35) purely from

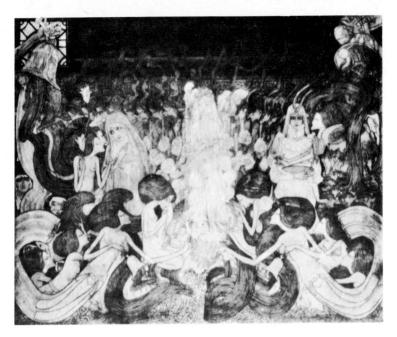

41. Toorop: The Three Brides, 1893.

the point of view of the forms he favours, the long-drawn-out lines of the garments will be recognized as Art Nouveau, and the hair of the angels, the slender stem of the young tree in the middle, some of the flowers held by long delicate hands, and the tortuous movements of these hands. The same is evident in Denis's *April* (Pl.29), with its sinuous lines of composition and the interlocked curves of the branches in the foreground.

Or take Munch's *The Cry* (Pl.36). The importance in it of sweeping curves as carriers of expression has already been emphasized. It is even more important in his lithograph *Madonna* (Pl.42) which was done in 1895 after a painting of 1894. The long wavy hair and the sinuous movement of the figure, the swaying lines in the background, and above all the odd frame with the embryo and the floating spermatozoa, make this work one of the most remarkable instances of Art Nouveau in painting,

original and striking in appearance, independent of tradition, but questionable as to its sanity and vital value. In Munch, a strong, sane, and unsophisticated painter, this was a passing phase. He soon cast off the mannerisms of Art Nouveau and retained only its genuinely decorative qualities for the development of his monumental style. Incidentally, the same is true of Hodler, to whom, in a similar way, Art Nouveau – if we can call his style during the nineties Art Nouveau – was only a means of attaining the ornamental clarity of his later wall paintings and land-scapes.

But Art Nouveau as a movement does not originally belong to painting, nor, indeed, is the term as a rule applied to painting at all. It means usually a short but very significant fashion in decoration, and if the works of painters and draughtsmen have here been given precedence over those of architects and designers, the reason is that the new ornamental fashion in the first works of its two creators appeared later than in pictures, book illustration, and the like.

The two creators referred to were Louis Sullivan in Chicago and Victor Horta in Brussels. Sullivan (1856–1924) was probably essentially

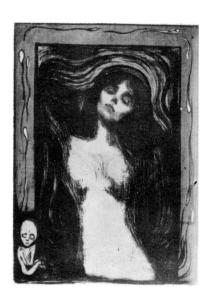

42. Munch: Madonna, 1895.

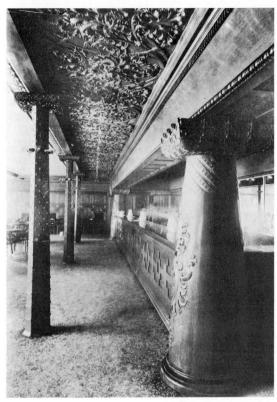

43. Sullivan: Auditorium Building, Chicago, 1888. Bar.

original, Horta (1861–1947), no doubt familiar with recent English and Continental developments. Sullivan's ornament remained solitary, Horta's created a craze which for a few years swept most countries on the Continent. How Sullivan came to evolve these curious tangles of tendrils, cabbagey, scalloped leaves, and coral reef growths remains a mystery. Can they really rest on no more promising ground than Gray's *Botany*? Or can one dimly recognize behind them the cabbagey forms of Gothic Revival foliage? Another look at Burges's fireplace might be advisable. By the time Sullivan designed the interiors of the Auditorium Building in Chicago, that is by 1888, his ornamental style was complete

(Pl. 43). It appears again in the Anshe Ma'ariv Synagogue of 1890–91 and at its wildest in the Carson Pirie Scott Store of 1903–4, of which, for very different reasons, more will be said later. Sullivan's ornamental ideal was an 'organic decoration befitting a structure composed on broad and massive lines',⁷ and so his theory of severe functionalism discussed in a foregoing chapter cannot be understood without a careful look at his flowing ornament, nor his ornament without a vivid memory of the austerity of the main lines and blocks of his buildings.

This is what distinguishes him from Horta who remains, if not wholly, at least primarily, a decorator. Horta's magnum opus is his first building, the house No. 6 rue Paul-Émile Janson, formerly 12 rue de Turin, in Brussels (Pl. 44). It was begun in 1892, and the decoration of its interior, especially the memorable staircase, is wholly dependent on that leitmotif of Art Nouveau which has been analysed apropos Mackmurdo's and Beardsley's and Toorop's designs. The same tendrils are painted on the walls, laid in mosaic on the floor, and bent in iron up the brackets at the top of the supporting shafts and all along the handrail. It seems almost unbelievable that Horta should have created this decoration without knowing of the Century Guild, the Dial, and other English decoration, although he would not admit dependence on England.8 This is different from Henri van de Velde, Horta's most important fellow-fighter for the new ornamental style, who told the author that he had seen Toorop's first mature works with the keenest delight.

As for the relations of the young Belgians with England, van de Velde writes⁹ that the discovery of the English revival of craft was made by A. W. Finch (born in 1854), a painter of half-English descent who later became a potter, that he bought a few things which strongly impressed his friends, but that, even earlier (in 1884), Gustave Serrurier-Bovy of Liège had been in England, and that his furniture thereafter showed influence from the Arts and Crafts. However, Serrurier-Bovy himself said proudly that by 1894 he was 'entirely free of any reminiscences from past or English styles'. ¹⁰ By that time much progress had been made. A shop called Compagnie Japonaise had shown English modern wallpapers and metalwork at Brussels in 1891, and in 1892 Les Vingt

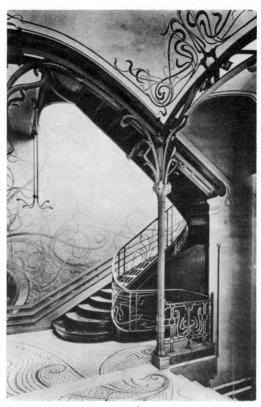

44. Horta: No. 6 rue Paul-Émile Janson, Brussels, 1893. Staircase.

appeared, a society of young artists to which we shall have to refer once more later on, which exhibited work by Crane and by Selwyn Image, Mackmurdo's friend and collaborator in the Century Guild; and van de Velde, so he tells us, had begun to collect samples of English decorative art privately. Very soon after that, van de Velde says, the translation of the English style into something Belgian began. In writing this, he is evidently alluding to himself. For he is completely silent about the part played by Horta and also Paul Hankar (1861–1901), the first to pick up the style of the rue Paul-Émile Janson. 11 While this omission

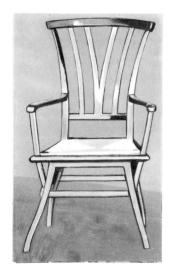

 Van de Velde: Chairs for his own house at Uccle, near Brussels, 1894-5.

no doubt detracts from the historical value of van de Velde's account, the fact remains true that his was the most comprehensive and philosophical mind amongst the young architects and designers of Belgium.

We have already met him as a theorist. As an artist he began by painting in the style of Barbizon and then of the Neo-Impressionists. It was, when he was twenty-nine, in 1892, that under the influence of William Morris's teaching and the art of Pont Aven he gave up painting and devoted himself to applied art. He designed wallpapers, brocades, decoration for books, furniture. The chairs shown in Plate 45 were made for his own house at Uccle near Brussels in 1894 or 1895. They are Art Nouveau in the swing of their curves, but at the same time these curves are filled with a tense energy that is quite unlike the luxurious grace of Horta's lines. Behind Horta one can always feel nature, vegetable and animal nature. Van de Velde's design is rigidly abstract and – theoretically at least – meant to illustrate the function of the object or part of the object to which it is attached. 'Dynamographique' is what he called it later, and he defined his intent as 'structurizing'. He postulates an ornamental

art based on almost scientific laws of attraction and repulsion, and hence as far from arbitrariness as the creation of the engineer. Here the connexion between his admiration for the machine and his own artistic style becomes visible, 12 a connexion which most of his over-decorated works of about 1900 would hardly lead one to expect. 13 And yet, at the time when his fantastic interior of Haby's barber shop in Berlin was new (1901), the public was greatly scandalized by the frank exposure of water pipes, gas pipes, and pipes for electric wiring. 'You don't wear your guts like a watch-chain across your waistcoat,' was the comment of Berliners upon this odd mixture of functionalism and Art Nouveau.

In the chairs for Uccle, the functional side of van de Velde's activities is predominant. The unity of grace and energy in such objects inspired E. de Goncourt to his excellent and prophetic term 'Yachting Style' which he coined when van de Velde's works were first made known to the Paris public. Van de Velde's recognition was due to Samuel Bing (born 1838), an art dealer from Hamburg who had moved to Paris in 1871, gone to visit the Far East in 1875, started a shop for Oriental art in Paris with a branch in New York, travelled in the United States for the French Government in 1893, reported to it on architecture and design with a remarkable appreciation of Richardson and Sullivan and of the powers of the machine to 'vulgariser à l'infini la joie des formes pures', and opened a shop for modern art in the rue de Provence on 26 December 1895 which he called L'Art Nouveau. 14 Bing, together with the German art critic Julius Meier-Graefe, had discovered van de Velde's house at Uccle, and he invited the artist to design four rooms for his shop. The effect of this on France was immediate: enthusiasm on the one side, furious criticism on the other, led by Octave Mirbeau in Figaro who wrote of 'l'Anglais vicieux, la Juive morphinomane ou le Belge roublard, ou une agréable salade de ces trois poisons'. More serious adversaries warned designers against succumbing to the spell, and pointed to the excellent commercial position which French industrial art had attained by remaining faithful to eighteenth-century traditions. Convinced friends of the new style emphasized the fact that several French artists had already for some time worked independently on similar lines. Émile Gallé (1846-1904) in the art of glassmaking, and Auguste Delaherche (1857-?) in the art of pottery, are the most noteworthy names. Gallé had in fact begun to exhibit glass of an utterly un-Victorian delicacy and fantastic colours as early as 1884. ¹⁵ Its shapes (Pl. 46) were based on Gallé's deep belief in nature as the sole legitimate source of inspiration for the craftsman – something of the faith in the organic which we have met with in Sullivan and van de Velde.

The influence of Gallé's glass was certainly wide even before Bing opened his shop in 1895 and exhibited it consistently. For in New York Louis Comfort Tiffany (1848–1933) had started to produce his Favrile Glass as early as 1893 (Pl.47). Tiffany in his turn impressed Bing considerably on the latter's visit to America. And in Germany Karl Koepping (1848–1914) produced glass vessels of exquisite fragility and slenderness in 1895 at the latest. 17

Between 1895 and the early years of the twentieth century, Art Nouveau had as great a vogue in France as in Belgium. In 1895 some young architects and craftsmen had founded a group which they called Les Cinq. One of them was the architect Tony Selmersheim (born 1871). In 1896 Charles Plumet (1861–1925) joined, and the group became Les Six. The group exhibited and called its exhibitions *L'art dans tout*. Their work is Art Nouveau without question, but neither as original nor as genuine as that of the Belgians or of the furniture-designer Eugène Gaillard in Paris or of the designers of Nancy such as Louis Majorelle (1859–1926) and Augustin Daum (1854–1909).

In architecture the most interesting of the French is Hector Guimard (1867–1942), whose best-known buildings are the highly Art Nouveau stations of the Paris Métro. These date from 1900.¹⁸ Earlier is his remarkable block of flats called Castel Béranger which is No. 16 rue La Fontaine, Passy. This was built in 1894–8 and, while architecturally less rewarding than Horta's houses, exhibits much uninhibited ornamental detail, especially in the ironwork of its gates (Pl. 48).

There is indeed a curious relationship between Art Nouveau and iron. The use of iron in façades was nothing new; its functional aspects will be discussed in the next chapter. Nor were the ornamental advantages of iron for façades a discovery of the late nineteenth century. A line can be drawn from the cast-iron tracery of the earliest bridge ever

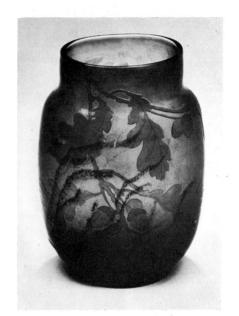

46. Gallé: Glass vase.

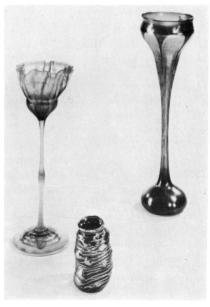

47. Tiffany: Glass vases.

 Guimard: Castel Béranger, No. 16 rue La Fontaine, Passy, Paris, 1894–8.

built of that material, the Coalbrookdale Bridge of 1777, and the castiron window tracery in early Gothic Revival churches, to the rich ornamentation of the Coal Exchange by Bunning in London (1847–9)¹⁹ and the Oxford Museum (1857–60) and so to the plates and text of Viollet-le-Duc's *Entretiens* where in the second volume published in 1872 iron trails and leaves appear side by side with iron vaulting-ribs, the one for reasons of the tensile strength of iron, the other for reasons of its ductile nature (Pl.72). Viollet's suggested ornamentation in iron must have been Horta's principal source in the rue Paul-Émile Janson and led him on to the triumphs of Art Nouveau ironwork at the Maison du Peuple in Brussels of 1896–9, which in its turn was followed by Paul Saintenoy's Old England Store of 1899, also in Brussels, and Frantz Jourdain's Samaritaine Store in Paris of 1905.

Whereas the dependence of France on Belgium in this respect as well as in all others regarding Art Nouveau seems now on the whole established, 20 the interesting fact about Germany is that while she also joined the movement later than Belgium she kept surprisingly intransigent in the works of her best artists. In 1895, that is two years before an exhibition, held at Dresden in 1897, made van de Velde known in Germany, a group of young German artists had started with aims similar to his.²¹ Only a few names can be given here.²² Otto Eckmann and Hermann Obrist are the two most interesting personalities during the years 1895 to 1898. After this date, the Viennese Sezession took the lead. Eckmann²³ (1865–1902) had been a painter until 1894. Now he became converted, just like Morris and van de Velde. He burnt all his pictures and started as a designer. When, in 1895, Meier-Graefe succeeded in starting Pan, a magazine of modern art and literature in Germany, Eckmann designed the decoration of several pages (Pl.49). His ornament is completely different from Horta's and van de Velde's, and yet equally original, impressive, and representative of Art Nouveau:

49. Eckmann: Decoration of two pages in the magazine Pan, 1895.

a flat pattern again, with long curves gracefully entwined, and again full of the joy of tracing many consonant lines.

But Eckmann stood on the side of Gallé and against van de Velde in his faith in nature. He does with leaves and stalks what van de Velde did by means of abstract form. This contrast between van de Velde and Eckmann and between Veldians and Eckmannites was already noticed in 1903. ²⁴ It is not quite clear where Eckmann got his initial ideas from. He did not know van de Velde when he began, though he must of course have known the English book art of Ricketts and Beardsley. Of connexions with Gallé we have no information. But it may be worth recording that Toorop exhibited in Munich in 1893, and that the famous Munch Exhibition in Berlin, which caused so much controversy, took place in 1892.

In 1892 Obrist (1863–1927), whose later enthusiasm for machine art has already been mentioned, was in Florence starting an embroidery workshop, which was transferred to Munich in 1894. The ornament on his cushions and hangings (Pl. 50) is again less abstract than that of the Belgians and the French. But his favourite forms are only vaguely reminiscent of particular forms in nature. They recall stalks as well as shells, and indented carapaces of reptiles as well as froth and foam. ²⁵ His influence on Endell is evident and of historic importance. Any picture of Art Nouveau would certainly be incomplete without a discussion of Endell. However, his contribution to the Modern Movement proper is much more essential than to Art Nouveau. He – and for the same reasons two more of the most fascinating Art Nouveau designers, Olbrich in Vienna and Mackintosh in Britain – must be left to a later chapter. ²⁶

As far as Britain is concerned, it will have been noticed that, after she had created the style in the eighties she disappeared out of this survey. The reason is that she kept away from Art Nouveau as soon as it became the fashion. When in 1900 some objects of Continental Art Nouveau were presented to the Victoria and Albert Museum, a letter of protest was sent to *The Times* signed by three architects of the Norman Shaw school and with Arts and Crafts sympathies. In it these objects are called wrong in principle and lacking in 'regard for the

50. Obrist: Embroidery, 1893.

materials employed'.²⁷ Moreover, Lewis F. Day said that Art Nouveau 'shows symptoms... of pronounced disease'²⁸ and Walter Crane speaks of 'that strange decorative disease known as *L'Art Nouveau*'.²⁹ This is indeed noteworthy (and no doubt due to reasons of national character); for the functions of the Arts and Crafts in England and of Art Nouveau on the Continent were to a large degree the same. They are both the 'Transitional' between Historicism and the Modern Movement and they both were bent upon reviving handicraft and the decorative arts. Hence, on the Continent, they were nowhere seen as opposing each other, but they appeared as a rule together, those who advocated the one also advocating the other. This can best be seen in examining what exhibitions of decorative art were held on the Continent and what magazines of decorative art were started.

The very fact that so many magazines suddenly appeared and so many exhibitions suddenly took place and were well attended shows the vigour of the revival on the Continent. The first of the new magazines was of course English, the *Studio*, founded in 1893, just before England's influence on the Continent set in. Amongst the artists discussed in 1893 and 1894, the following may be noted: Beardsley, Crane, Voysey,

Toorop, Khnopff. Other articles dealt with new furniture at Liberty's, the renaissance of pottery in France, the Munich Sezession, the New English Art Club. The first of the Continental magazines, Pan, came out in Germany in 1895. One of its two editors was Meier-Graefe who, as we have seen, was one of the discoverers of van de Velde and who, in 1897, started a shop, La Maison Moderne, in Paris in competition with Bing's.³⁰ Among the chief supporters and contributors were Lichtwark and Karl Koepping. Jugend and Simplizissimus, both mainly satirical papers, followed Pan in 1896. In 1897, Art et décoration, and L'Art décoratif were started in France, Deutsche Kunst und Dekoration and Dekorative Kunst in Germany. Again in 1897, the Revue des arts décoratifs in Paris was reformed, and in Vienna one year later Kunst und Kunsthandwerk and Ver Sacrum, the magazine of the Vienna Sezession, began to appear.31 One year later again Russia appeared on the scene with Mir Isskustva. Some examples of what these periodicals discussed may help to give an impression of the manifold interests at that moment. In its first years Pan printed poetry by Verlaine and Mallarmé, by Dehmel, Liliencron, Schlaf, illustrations by Klinger, von Hofmann, Stuck, decoration by Eckmann, Th. Th. Heine, articles on Munthe, Obrist, Tiffany, designs by Crane, Townsend, Voysey. In Dekorative Kunst and Deutsche Kunst und Dekoration we find articles on English lamps, Copenhagen porcelain, Voysey, essays by Endell and Bing, illustrations of works by van de Velde, Hankar, Lemmen, Serrurier, Plumet, by Brangwyn, Ashbee, Cobden-Sanderson, and by Melchior Lechter, the illustrator of the Stefan George group. In Art et décoration, Horta and van de Velde are discussed, as are La Libre Esthétique in Brussels, the English Arts and Crafts, Lalique's early glass, and furniture by Plumet and Selmersheim. At the same time the Studio also illustrated the work of Tiffany, Plumet, Aubert, Selmersheim, and some German representatives of Art Nouveau. Mir Isskustva in its first year showed reproductions or discussed the work of Beardsley, Brangwyn, Burne-Jones, Delaherche, Koepping, Vallotton, and Whistler.32

In the matter of exhibitions, England was again first in the field. The Arts and Crafts Exhibition Society showed works of artistic handicrafts

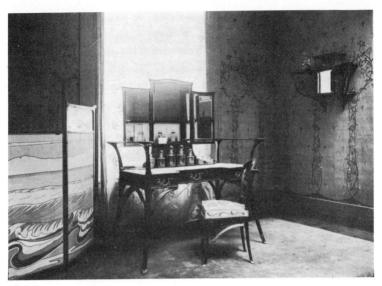

51. Plumet: Interior.

in 1888, 1889, 1890, 1893, 1896. In Paris the Salon du Champs de Mars of 1891 was the first where works of the decorative arts appeared side by side with paintings. 33 In the same year the Salon des Indépendants showed three of Gauguin's ceramic pieces and one carved relief in wood.34 However, the most adventurous art exhibitions on the Continent were those brought together by the group Les Vingt in Brussels, called La Libre Esthétique since 1894.35 They had pictures by Khnopff, Ensor, Whistler, Liebermann as early as 1884, Raffaelli, Uhde, Manzini, Kröyer in 1885, Monet, Renoir, Israels, Monticelli, Redon in 1886. The concurrent appearance of men like Renoir and Whistler on the one hand, and Ensor and Redon on the other, shows how strangely intermixed Impressionism and Post-Impressionism were in their action on foreign countries. In 1887 Les Vingt had asked Sickert and Seurat to exhibit, in 1888 Toulouse-Lautrec and Signac, in 1889 Gauguin, Steer, and Klinger, in 1890 Cézanne, van Gogh, Segantini, Sisley, and Minne, in 1891 Crane and Larsson. In 1892 they included for the first time stained glass, embroidery, ceramics (Delaherche), and illustrated books

(Horne, Image). After this, the exhibition of 1894 contained, besides works of Beardsley and Toorop, wallpapers and fabrics by Morris, silver by Ashbee, books of the Kelmscott Press, posters by Lautrec, and a complete studio interior furnished by Serrurier, and in 1895 Voysey was represented. Finally in 1896 van de Velde did a whole 'salle de five o'clock'. Meanwhile L'Œuvre artistique had asked the Glasgow School of Art under its remarkable head Francis Newbery to show at an exhibition in Liège. There was at the same exhibition also work by Ashbee, Burne-Jones, Crane, Morris, Sumner, and Townsend. Two years later the first exhibition on similar lines was held in Germany. Munich, in the Glaspalast Exhibition in 1897, reserved two small rooms for applied art. Amongst the artists represented were Eckmann, Endell, Obrist, Th. Fischer, Dülfer, and Riemerschmid. On a larger scale was the Dresden Exhibition, held also in 1897, to which the organizers had brought whole sections of Bing's L'Art Nouveau.

This shop, which has been mentioned more than once, gave the whole movement its name, at least in England and France. The German term Jugendstil was taken from the Jugend which, as has been said, was started in the same year, 1896; and the Italian term Stile Liberty comes, curiously enough, from Liberty's, the furnisher's and draper's shop then in the Strand in London, which during the nineties went in for materials and colours suitable for Art Nouveau schemes. So by sheer chance liberty, youth, and novelty appear together in the names given to this remarkable if brief and transitory movement.

With novelty it must most certainly be connected, and liberty at least in the sense of licence is applicable too. But whether, looked at at a distance of more than two generations, Art Nouveau has a youthful appearance must remain doubtful. For a revolution it is suspiciously sophisticated and refined, and – an even more portentous doubt – it was entirely lacking in a social conscience. A little while ago it was called a Transitional style between the Victorian style and the Modern Movement, and it was, in this respect, compared with the Arts and Crafts in England. But the Arts and Crafts were firmly based on the teachings of William Morris and thus fought for a sounder status for the artist and a saner attitude to design. Art Nouveau is *outré* and directs its appeal to

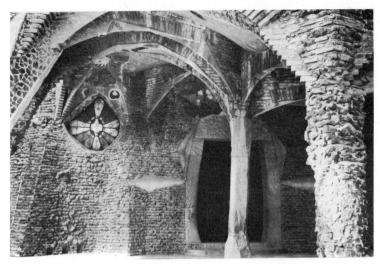

52. Gaudí: Crypt of Santa Coloma de Cervelló. Begun in 1898.

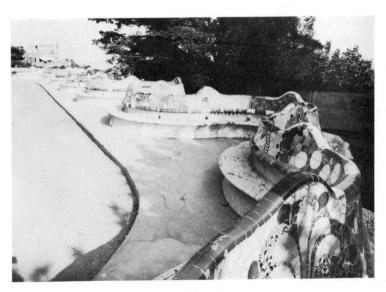

53. Gaudí: Parque Güell, Barcelona. Begun in 1900.

the aesthete, the one who is ready to accept the dangerous tenet of art for art's sake. In this it is still emphatically nineteenth century, even if the frenzy of its insistence on unprecedented form places it beyond that century of historicism. A universally acceptable style could not issue from its endeavours. Such a style was in the same years more humbly and more securely prepared in England.

Thus it cannot be unexpected that Art Nouveau reached its highest achievement in a country marginal to later nineteenth-century developments in art and architecture, and a country in which social conditions had remained wholly unchallenged. Antoni Gaudí (1852–1926) worked almost exclusively in and around Barcelona. The started as a late and highly personal Gothic Revivalist. Viollet-le-Duc's *Entretiens* were no doubt known to him, but the nightmarish quality of such Gothicist palaces as that of the bishop of Astorga (1887–95) is already entirely Gaudi's, and in decorative details such as the fearfully spiky gates of the Casa Vicens at Barcelona of 1878–80 he is as original as Burges in the contemporary details in his house in Melbury Road (Pl. 39). Then – an exact parallel to Mackmurdo and to no-one else in Europe – he turned to bold and wilful curves in the entrance to the town house of his great patron Eusebio Güell, a manufacturer and a man aware of recent English developments.

Gaudí achieved full liberation in 1898, and his first completely mature masterpieces were begun in that year and in 1900, both for Güell. It is in the Colonia Güell and its amazing, fascinating, horrible, and inimitable church, Santa Coloma de Cervelló (Pl. 52) that walls are first set in motion, windows appear in the seemingly most arbitrary positions and the seemingly most arbitrary forms, that columns bend or stand out of plumb, and that the craftsman is encouraged to leave work rough. The Parque Güell (Pl. 53) as a conception was based on those new English ideas of garden suburbs and garden cities which will engage our attention in another more normal context. Gaudí's details of the lodges with their minaret and their wildly heightened Orientalism everywhere, of the parapets snaking up and down, the covered promenades of stonework as rough as in eighteenth-century sham ruins and of the Doric columns placed out of true like wooden posts shoring up a wall, all

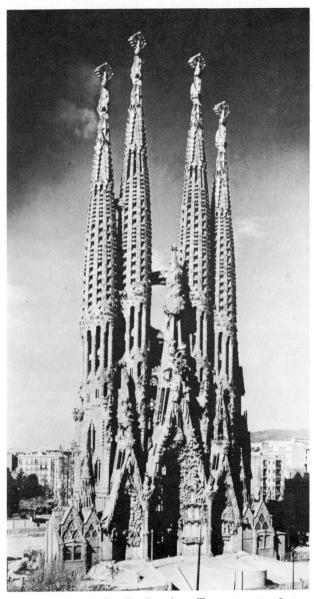

54. Gaudí: Sagrada Familia, Barcelona. Transept, 1903–26.

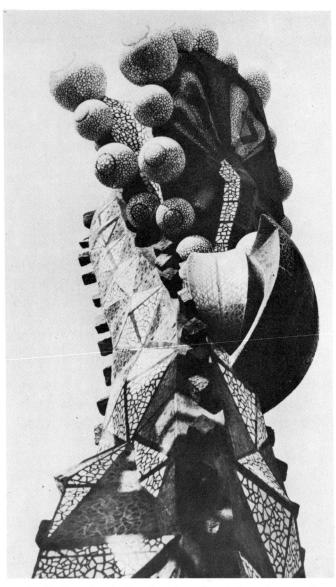

55. Gaudí: Sagrada Familia, Barcelona. Detail from the top of one of the transept towers.

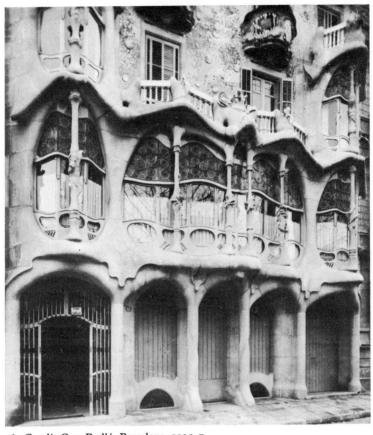

56. Gaudí: Casa Batlló, Barcelona, 1905-7.

this goes in many ways beyond Western Art Nouveau, and yet can only be understood within the terms of that short-lived style. Here is the frantic desire for the unprecedented, here the faith in the creative individual, here the delight in the arbitrary curve, and here the keen interest in the possibilities of materials. Gaudí to avoid at all costs any convention in the use of materials uses broken tiles and old cups and saucers to face his parapet, and later on the same improbable materials for the pinnacles of the Sagrada Familia.

The church of the Sagrada Familia had been begun in 1882. The plans were in the accepted Gothic Revival. In 1884 Gaudí was put in charge, and he first adhered and developed the conventional designs. On the east façade of the transept (Pl. 54) one can follow from storey to storey how his Gothic turned more and more original – in a way which can be paralleled in some Arts and Crafts Gothic in England during the same years (J. D. Sedding for instance and Caröe) – and how after 1900 he abandoned Gothic altogether in favour of his own Art Nouveau. The four sugar-loaf spires, Tunisian more than anything else, with their amazing pattern of voids and solids and their even more amazing crustaceous pinnacles are the lasting monument to Gaudí's intrepid daring (Pl. 55).

That the faithful of Barcelona with whose money the church was being built were ready to support so fantastic a design and so fantastic a method of construction – for Gaudí was on the site all the time and settled all details in personal talk with the workmen – is a reminder of how remote from the conditions of London, Paris, or Brussels the conditions were in which Gaudí could develop this intransigent brand of Art Nouveau. Even more surprising is the fact that the same uncompromising style was accepted for blocks of flats (Pls. 56 and 57). Who would be ready to live in rooms of such curvy shapes, under roofs like the backs of dinosaurs, behind walls bending and bulging so precariously and on balconies whose ironwork might stab at you any moment? Who but an out-and-out aesthete or a compatriot of Gaudí and Picasso?

Gaudi's art indeed – a flowering of Art Nouveau long after saner architects and designers had discarded it – is a link between that revolt of the nineties and the Expressionism of the early *collages*, the Expressionism of Picasso's pottery, and some of the more outrageous innovations of the architecture of 1950. Ronchamp has more in common with the Sagrada Familia than with the style whose early development is the theme of this book.

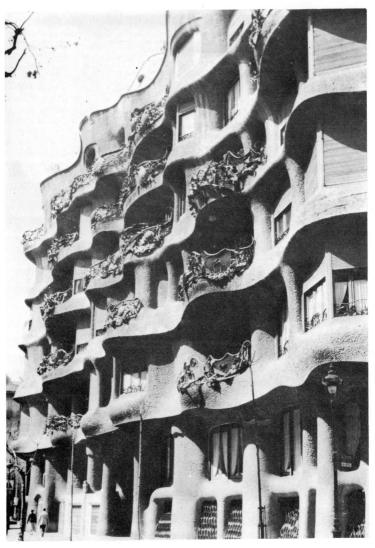

57. Gaudí: Casa Milá, Barcelona, 1905-7.

5 · Engineering and Architecture in the Nineteenth Century

THE Modern Movement has not grown from one root. One of its essential sources, it has been shown, is William Morris and the Arts and Crafts; another was Art Nouveau. The works of the nineteenth-century engineers are the third source of our present style, a source as potent as the other two.¹

Engineering architecture in the nineteenth century was largely based on the development of iron, first as cast iron, then as wrought iron, later as steel. Towards the end of the century reinforced concrete appears as an alternative.

The history of iron as a material of more than auxiliary usefulness in architecture begins when the inventiveness of the Industrial Revolution had found out how iron could be produced industrially, that is after 1750.2 Attempts were soon made to replace timber or stone by iron. The first case so far recorded is a freak; cast-iron columns supporting a chimney at Alcobaça in Portugal. Their date is 1752. More structural uses were developed in France in the 1770s and 1780s by Soufflot for the staircase of the Louvre in 1779-81 and by Victor Louis in the theatre at the Palais Royal in 1785-90. If Rinaldi in his Orlov Palace at St Petersburg indeed used iron beams, that would point to precedents in Italy or France not yet traced. Some early comparable cases in England are the iron lantern over Soane's Stock Office in the Bank of England (1792), the iron beams of James Wyatt's Palace at Kew (1801), Nash's iron and glass coving of the picture gallery at Attingham Park in Shropshire (1810), and Foulston's Theatre Royal at Plymouth (1811–14), where wood was practically replaced by cast and wrought iron. On the Continent Ludwig Catel had suggested as early as 1802 an iron roof

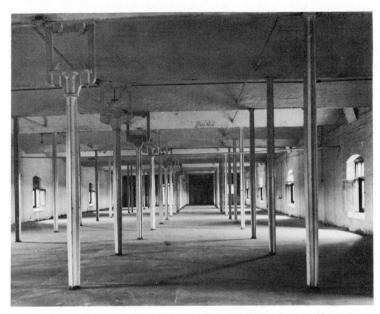

58. Benyon, Bage, & Marshall's flax-spinning mill, Ditherington, Shrewsbury, 1796.

for the projected National Theatre in Berlin, and in 1806 Napoleon had wanted his Temple to the glory of the grande armée to be erected without any wood, entirely of stone and iron. After 1820 there are more cases than can be enumerated. In London Smirke's British Museum has in its earliest part, the King's Library, iron roof beams dated 1824. The iron beams in Wilkins's University College, also in London, are of 1827–8. And as for churches, an iron roof went in above the stone vaults of Southwark Cathedral, again in London, probably between 1822 and 1825, and at Chartres Cathedral in 1836–41.

In all these cases iron was chosen instead of wood for purely practical, not for aesthetic reasons. The same is true of the architecturally much more important development of iron framing in factories. The creative brain here was William Strutt of Derby, cotton-spinner and partner for a while with Richard Arkwright whose invention of the water-frame for

59. Lorillard: Building in Gold Street, New York, 1837.

spinning has been mentioned in Chapter 2. They built a six-storeyed factory at Derby in 1792-3 which had exposed iron columns. This building does not exist any longer; but inside a warehouse of Strutt's at Milford in Derbyshire, the so-called Cruciform Building, erected in 1793, cast-iron columns are present, supporting timber beams. The same is true of Strutt and Arkwright's West Mill at Belper, built in 1793-5. This is again of six storeys. The next and decisive step was

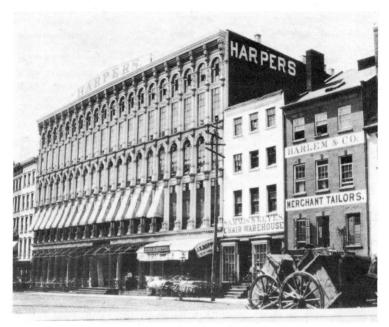

60. Bogardus: Building for Harper Bros, New York, 1854.

taken by another manufacturer. Messrs Benyon, Bage, & Marshall built their flax-spinning mill at Ditherington just outside Shrewsbury in 1796 (Pl. 58). This also is happily still in existence. It is five storeys high, with brick walls, and has inside cast-iron supports throughout, that is not only cast-iron columns but also cast-iron beams. Timber is entirely avoided – obviously a tremendous advantage in a factory. The new idea caught on at once. Boulton and Watt designed a seven-storeyed cotton mill for Philips & Lee at Salford near Manchester in 1799, Benyon & Bage built another flax-spinning mill at Leeds in 1803, and Strutt built more mills at Belper and Milford in 1803 and thereafter. When P. C. W. von Beuth, the Prussian Minister of Commerce travelled in England in 1823, he saw plenty of factories of eight and nine storeys, with paper-thin walls, iron columns, and iron beams; and when Schinkel travelled in England in 1826 he drew them.

However, as long as these members of iron remained inside they could make little difference to the consciousness of so façade-minded a generation of architects as that of the mid nineteenth century. The admission of iron to the front of utilitarian buildings was due to America. At Pottsville, Pennsylvania, the Farmers' and Miners' Bank of 1829-30 has a cast-iron façade in imitation of marble. The architect was John Haviland.⁵ A warehouse in Gold Street, downtown in New York, which was built in 1837 (Pl. 59), has cast-iron piers and cast-iron lintels. The style here is also still classical. There is then a gap in our evidence, but a passage in Gottfried Semper's Wissenschaft, Industrie und Kunst⁶ written late in 1851 refers to the report of a German engineer on building in New York and mentions as a usual thing 'a whole front of richly ornamented cast iron' stuccoed all over. So such buildings must have existed in 1850. They cannot have been very prominent, however, for otherwise James Bogardus could not have got away with his attitude of the inventor or at least the innovator, when he brought out his pamphlet on Cast Iron Buildings in 1856. He had erected a building with an exposed cast-iron frame already in 1854 for Harper Bros in New York⁷ (Pl.60). By the mid fifties Britain was certainly as fully aware as New York of the architectural possibilities of cast iron for commercial purposes. An example is the Jamaica Street warehouse in Glasgow of 1855-6 (Pl.61); another and far more spectacular one is Oriel Chambers at Liverpool, which was designed by Peter Ellis and built in 1864-5.8 The delicacy of the ironwork in the plate-glass oriel windows and the curtain walling at the back with the vertical supports retracted yet visible from outside is almost unbelievably ahead of its time. Of London, George Aitchison, an architect, himself busy designing commercial buildings, could say in 1864 that 'one rarely sees a large building being erected without iron columns and iron girders'.9

What still remained of decorative details in the façades kept in touch with the Italianate or Gothic fashion of the day. But at the back, where nothing needed to be done for show, an absence of all 'motifs' occurs sometimes which is surprisingly akin to twentieth-century detailing (Pl. 62). The same is true to an even more astounding degree in a large, purely utilitarian building recently discovered by Mr Eric de Maré. 10

61. Jamaica Street warehouse, Glasgow, 1855-6.

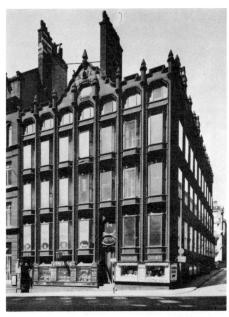

62. Ellis: Oriel Chambers, Liverpool, 1864-5.

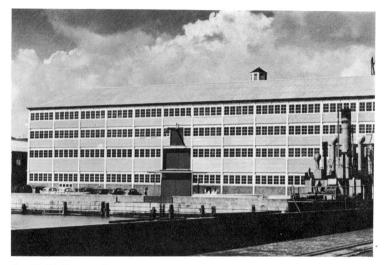

63. G. T. Greene: Boat store at Sheerness Naval Dockyard, 1858-61.

It is a boat store at the Sheerness Naval Dockyard (Pl.63) and was designed in 1858 by Col G. T. Greene, Director of Engineering and Architectural Works to the Admiralty. It was built in 1859-61. It is 210 feet long and 135 feet wide and exhibits an entirely uncompromising four-storeyed iron framework with bands of low windows and sillpanels of corrugated iron. While technically the novelty of all these buildings was their extensive use of iron, aesthetically their most notable quality is their equally extensive and completely even use of glass. Much glass was useful for high town buildings anyway; the designers of the timber-framed town houses of the sixteenth and seventeenth centuries had known that. Many of these houses have façades in which, except for wooden mullions, wooden bressummers, and sill-panels, all is glass. The effect could be obtained with stone as well as iron, and there are indeed in America all-glass façades with stone mullions before they appeared with iron. The most amazing of them is the Jayne Building, Philadelphia, of 1849-50. This was designed by W. J. Johnston and Thomas U. Walter, the architect of Gerard College and the iron dome of the Capitol, and a man with engineering interests and experience. The building

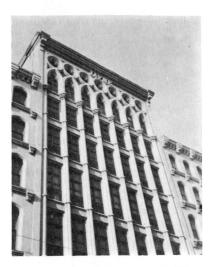

64. Johnston and Walter: Jayne Building, Philadelphia, 1849–50.

is eight storeys high and the Gothic stonework is of granite (Pl.64).11

There was indeed no basic difference between the stone and glass front and the iron and glass front as long as the technique was not evolved which became that of the twentieth century, namely the carrying of the masonry or brick panels of the walls on the members of the iron skeleton. This may be the case at Oriel Chambers. In any case it was exactly contemporarily done in a shot tower in New York built about 1860–65, and a grain elevator in Brooklyn. These were, we are told, 'constructed as a cast-iron framework filled in with a light wall of brick, the iron showing on the outside'. ¹² In France the warehouses of the St Ouen Docks in Paris by Préfontaine and Fontaine, discussed in the *Builder* in 1865, were also apparently iron frame with brick used only to fill in, ¹³ and so was the Chocolat Menier Factory of 1871–2 at Noisiel-sur-Marne by Saulnier. ¹⁴ The source in this case was Viollet-le-Duc, and to his *Entretiens* we must refer again in a later context.

The buildings so far presented are interesting enough, but it can hardly be maintained that iron in them was regarded as an aesthetic asset. It is hard to decide when this positive attitude first appeared, that

is, when designers began to like the look of iron structures. One is inclined to say in iron bridges, because to us their resilience and elegance, made possible only by the use of iron, are aesthetically so irresistible. This applies, to a certain degree, even to the earliest all-iron bridge ever designed, the one built by the great iron-master Abraham Darby in 1779 across the river Severn at Coalbrookdale (Pl. 65). Who designed the bridge cannot be said with certainty. The idea seems to have been partly John Wilkinson's, the other great iron-master of the same district, and partly an architect's: Thomas Farnoll Pritchard (1723-77). Pritchard's design of 1775 (Pl. 66), is indeed bolder than that finally adopted after his death in 1777. The executed design is probably Abraham Darby's, but the credit for the bold idea seems more likely to be Pritchard's and Wilkinson's. 15 Bolder in design and even more sparing of materials was the successor of the Coalbrookdale Bridge, the bridge at Sunderland, built between 1793 and 1796, designed, it seems, by Rowland Burdon, though Tom Paine may also have had something to do with it. Paine, while in America, had taken out a patent for iron bridges in England in 1788. The Sunderland Bridge was carried out by Walker's of Rotherham and Burdon. It has unfortunately been taken down. It had a span of 206 feet as against the 100 feet of Coalbrookdale. Five years after its completion, Thomas Telford suggested replacing London Bridge with a cast-iron structure to be thrown across the river in one sleek sweep of 600 feet (Pl. 67).

Parallel with this development of the arched bridge runs that of the suspension bridge. The Chinese had known bridges suspended from iron chains, and they were illustrated in Europe as early as in Kircher's China . . . illustrata of 1667 and in Fischer von Erlach's Historical Architecture of 1726. This book was translated into English in 1730, and about ten or twelve years later a bridge which made use of this Chinese principle was built across the river Tees in North England, two miles above Middleton. It was 70 feet long, but little more than 2 feet wide and chiefly crossed by miners on their way to work. The gangway was, we are told in 1794, unpleasantly restless and 'few strangers dare trust themselves' on it. After this the problem of the suspension bridge seems to have been left in abeyance for sixty years, until James Finley

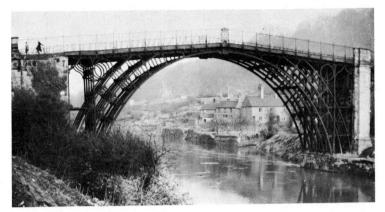

65. Coalbrookdale Bridge, 1777-81.

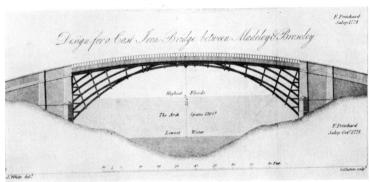

66. Pritchard: Design for the Coalbrookdale Bridge, 1 775.

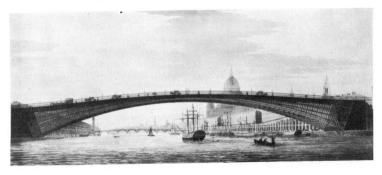

67. Telford: Design for a cast-iron bridge to replace London Bridge, 1801.

(who died in 1828) made a fresh start in America. His bridge across Jacob's Creek between Uniontown and Greenburgh had about the same length as its English predecessor and dates from 1801. Finley took out a patent for suspension bridges in the same year and built eight more between that year and 1811. The longest of them crossed the cataracts of the Schuylkill and had a span of 306 feet.¹⁷

When England reappeared in the story of the suspension bridge, with Telford's design of 1815 for the Menai Bridge, he no doubt knew of these American developments. The Menai Bridge has a main span of 579 feet and two side spans of 260 feet each and is admirably clean in appearance. Telford was followed by Captain Samuel Brown who had taken a patent for chain bridges as early as 1817. His Union Bridge at Berwick-on-Tweed was built in 1819–20 with a main span of 449 feet. The Brighton Chain Pier followed in 1822–3 and then many others in England and on the Continent.

The most impressive of all is probably the Clifton Suspension Bridge at Bristol (Pl.68), designed in 1829-31 by Isambard Kingdom Brunel (1806-59) and begun in 1836.19 It seems hardly admissible that the beauty of such a structure should be purely accidental, that is the outcome of nothing but intelligent engineering. Surely, a man like Brunel must have been susceptible to the unprecedented aesthetic qualities of his design - an architecture without weight, the age-old contrast of passive resistance and active will neutralized, pure functional energy swinging out in a glorious curve to conquer the 700 feet between the two banks of the deep valley. Not one word too much is said, not one compromising form introduced. Even the pylons are entirely unadorned, admittedly against Brunel's original wish which was for Neo-Egyptian decoration. As they happen to be, they form a superb counterpoise to the transparency of the iron construction. Only once before had such daring spirit ruled European architecture, at the time when Amiens, Beauvais, and Cologne were built.

Brunel may not have thought of his designs in such terms, or in terms of art at all, and at that stage that was perhaps all to the good. The iron-masters certainly had ambitions of an artistic kind, and as soon as this aiming at art became a conscious effort, the results were less convincing.

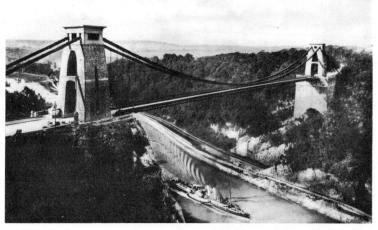

68. Brunel: Clifton Suspension Bridge, Bristol. Designed 1829-31. Begun in 1836.

This is true of John Wilkinson's cast-iron pulpit of about 1790 at Bradley in Staffordshire and also of the obelisk which is his own proud funeral monument at Lindale near Grange-over-Sands (1808),²⁰ and of that cast-iron tracery of the later eighteenth and the early nineteenth century which appears in the churches of Shropshire and the surrounding counties, not too far from the Severn Valley iron-works (Pl.69).

Where iron columns occur in churches and public buildings, on the other hand, it can as a rule be said that the material was chosen for practical and not for visual reasons. Here once more England was leading. At St Anne in Liverpool, a church built in 1770–72 and no longer extant, the galleries were carried on cast-iron columns. The same is true of Lightcliffe in the West Riding of Yorkshire, where the date is 1774–5 and the style comes close to John Carr's. ²¹ At St Chad in Shrewsbury by George Steuart, on the other hand, the two orders of slim columns are still encased in timber. The church is dated 1790–92. ²² Unconcealed iron appeared on a smaller scale to support galleries of theatres as well as churches. The earliest theatre recorded is Smirke's Covent Garden Theatre in London of 1808–9. The earliest churches

69. St Alkmund, Shrewsbury, 1795. Cast-iron tracery.

seem to be connected with yet another fanatical iron-master, John Cragg of Liverpool, who induced young Thomas Rickman to make extensive use of iron at Everton Parish Church near Liverpool in 1813–14 and at St Michael Toxteth in 1814. ²³

A few years later as distinguished an architect as Sir John Soane recommended it in his Memorandum to the Church Commissioners of 1818,²⁴ but it was to be used without disguise only for smaller churches. John Nash has it quite often, but as a rule also in such a way that the public should take it for stone. Thus the Doric columns of Carlton House Terrace (begun in 1827) facing St James's Park in London are of cast iron, and so were those of the Regent Street Quadrant (begun in 1818).

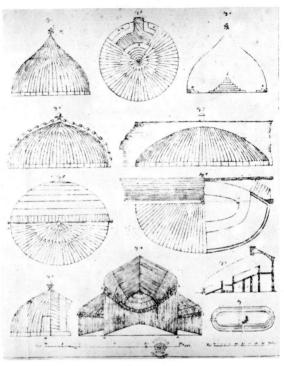

70. Loudon: Designs for conservatories, 1817.

However, there is at least one case in which Nash seems to have treated iron deliberately as iron and enjoyed the elegance which it can give to a support. This was in his famous extravaganza, the Pavilion at Brighton, where the main staircase is entirely of iron, and in the kitchen thin iron shafts support the ceiling. At the top copper palm leaves sprout out of them. That was in 1815 and 1818–21, respectively, important dates, since so far as we can see, they mark the first appearance of unmasked iron in connexion with royalty.

The bulbous dome of the Pavilion also has a framework of bent iron girders. The earliest example of metal with glass in a dome, however, was the Halles au Blé in Paris, designed in 1809 and built in 1811. This achieved an even daylight inside the building, which could not otherwise

be obtained. At the same time the designers of conservatories began to realize the advantages of glass vaults. Here glass roofs had already been made use of since the beginning of the eighteenth century. The idea of 'curvilinear' roofs appears for the first time in a paper read to the Horticultural Society in London by Sir G.S. Mackenzie in 1815. It was at once taken up by the horticulturist T.A. Knight of Downton Castle in Shropshire, brother of the more famous Richard Payne Knight, and by the gardener and journalist Loudon. It was Loudon who in 1817 and 1818 suggested the shapes which then became usual (Pl.70). By 1830 there existed in England quite a number of large hothouses with curved roofs or domes, such as the circular conservatory at Bretton Hall in Yorkshire, which was 100 feet in diameter and 60 feet high.²⁵ So the importance of the Paris Jardin des Plantes has been rather overestimated. This was followed by the Chatsworth Conservatory which Joseph Paxton (1801-65) built for the Duke of Devonshire in 1837-40 and which was 277 feet long, 132 feet wide, and 67 feet high.

With it the stage was set for the Crystal Palace of 1851, home of the first international exhibition ever held, and as assertive a profession of faith in iron as the largest of the suspension bridges. But before it is reached, a few other developments must for a moment be taken into consideration. Iron and glass have obvious advantages also for market halls and railway stations, two types of building which the fabulous growth of populations in the cities of the early nineteenth century and the fast-growing interchange of materials and products between factories and cities brought to the fore. The Market Hall by the Madeleine in Paris was of an elementary iron and glass construction as early as 1824. It was not vaulted, but in 1845 Hector Horeau suggested, for the rebuilding of the Central Market Hall in Paris, a glass vault of 300 foot span. 26 That would have reached the span of the widest railway shed ever built, the shed of the Broad Street Station at Philadelphia of 1893,27 and surpassed any which the English railway companies, leading in iron construction up to the eighties, had actually built, namely that of New Street, Birmingham, in 1854 by Cowper, which was 212 feet and then that of St Pancras, London, by W. H. Barlow, of 1863-5, which was 234 feet. The Market Hall in Paris as carried out by Baltard &

Callet in 1852-9 is also of glass and iron but not vaulted and of no special merit.

In the Crystal Palace the vaults are not the determining factor either. What makes Paxton's building the outstanding example of midnineteenth-century iron and glass architecture was rather its enormous size - 1851 feet long, that is, much longer than the palace of Versailles - the absence of any other materials, and the use of an ingenious system of prefabrication for the iron and glass parts, based on a twenty-fourfoot grid adopted throughout. Only by means of prefabrication could a building of such size be erected in the miraculously short time of sixteen weeks. It is likely that even Paxton, the outsider, would not have dared such an unprecedented procedure and such an unprecedented design, if he had not worked for a temporary building. However, the fact that the Crystal Palace was re-erected in 1854 at Sydenham near London for a more permanent purpose proves that the new beauty of metal and glass had caught the fancy of progressive Victorians and of the public at large. In architectural literature there raged a fierce controversy. Pugin, Gothicist and fanatical Catholic that he was, of course hated it. He called it the 'Crystal Humbug' and the 'Glass Monster', 'a bad vile construction' and 'the most monstrous thing ever imagined'.28 Ruskin, following Pugin here as in so many other things, called it 'a greenhouse larger than greenhouse was ever built before' and the final proof that higher beauty was 'eternally impossible' in iron. 29 In fact he had already in 1849 placed at the very start of his Seven Lamps of Architecture a definition which 'separates architecture from a wasp's nest, a rat hole, or a railway station'. The opposition against this negative and reactionary attitude came from the circle of Henry Cole who as reformers of design were in some other ways so close to Ruskin. The voice of the circle in matters of iron architecture was Matthew Digby Wyatt, an inferior architect when compared with Pugin, an inferior writer when compared with Ruskin, but a highly intelligent critic. He wrote in the Journal of Design in 1851:30 'It has become difficult to decide where civil engineering ends and architecture begins.' The new iron bridges are amongst the 'wonders of the world'. 'From such beginnings,' he continued, 'what glories may be in reserve, when England

has systematized a scale of form and proportion . . . we may trust ourselves to dream, but we dare not predict. Whatever the result may be, it is impossible to disregard the fact that the building for the Exhibition of 1851 is likely to accelerate the "consummation devoutly to be wished" and that the novelty of its form and details will be likely to exercise a powerful influence upon national taste.'

Here more than anywhere one may feel inclined to allow the Cole circle a seat among the pioneers of twentieth-century design, and one must make oneself remember how distressingly Wyatt's performance differs from his theory, to send him back to the mid nineteenth century to which he belongs. Another somewhat similar case is that of Thomas Harris who built in the wildest, most nightmarish High Victorian style, yet wrote in 1862 that in the Crystal Palace 'a new style of architecture, as remarkable as any of its predecessors, may be considered to have been inaugurated' and that 'iron and glass have succeeded in giving a distinct and marked character to the future practice of architecture'.31 Even Ruskin, before he had seen the Crystal Palace, had in 1849 suggested that the time may be near 'when a new system of architectural laws will be developed, adapted entirely to metallic construction', 32 The most successful of High Victorian architects, Sir George Gilbert Scott, was also too intelligent to overlook the potentialities of iron in architecture, even if he was far too conventional to explore them himself. This is what he wrote of bridges in 1858: 'It is self-evident that this triumph of modern metallic construction opens out a perfectly new field for architectural development' and 'it would puzzle the most ingenious bungler to render [suspension-bridges] unpleasing'. But as soon as it came to building, he was ready to grant iron only 'as an exceptional expedient' in such cases as the Crystal Palace.33

The railway station was the field where architecture and engineering met. Nothing could characterize the situation more poignantly than Scott's towering and towered Gothic brick and granite palace in front of Barlow's splendid train shed at St Pancras. The exact parallel to this is James Fergusson writing in his *History of the Modern Styles of Architecture* in 1862 that the Gare de l'Est in Paris was superior to King's Cross Station in London, because 'from its higher degree of

ornamentation . . . it becomes really an object of Architectural Art'.34 There one is back where this book started, at the definition of architecture as decoration of construction. All the more remarkable are those who wholeheartedly hailed railway architecture, 'Stations are the cathedrals of our century' said an anonymous author in the Building News in 1875,35 and a full twenty-five years earlier, that is before the Crystal Palace, Théophile Gautier of all people wrote this: 'Mankind will produce a completely new kind of architecture . . . at the moment when the new methods created by . . . industry are made use of. The application of iron allows and enforces the use of many new forms, as can be seen in railway stations, suspension bridges, and the arches of conservatories.'36 A strange remark to come from the poet of l'art pour l'art. It shows the complete confusion between social and aesthetic considerations which characterizes art criticism about the middle of the nineteenth century. Was Gautier perhaps less moved by faith in the industrial age than by delight in the forms of engineering structures and machinery, a delight such as is found also in Turner's Rain, Steam and Speed, Monet's Gare St Lazare, or Menzel's Rolling Mill?

So far all our testimonies on iron have been stimulated by structures which were not architecture with a capital A: When it comes to civic buildings or churches, the field of those ready to use iron frankly and with aesthetic conviction narrows at once considerably. The two most noteworthy buildings of the 1840s, that is of the decade before the Crystal Palace, are Labrouste's Bibliothèque Ste Geneviève in Paris of 1843-50 and Bunning's Coal Exchange in London of 1847-9. Labrouste's Library has a restrained Neo-Renaissance exterior and a two-naved, arched, and tunnel-vaulted interior where the extremely slender shafts separating the two naves are of exposed iron and the two vaults rest on traceried iron arches connecting the shafts with the outer stone walls. The London Coal Exchange is equally free in the exposure of iron, though very much freer in the display of busy ornament. In the fifties, the Oxford Museum built by Deane & Woodward under the immediate supervision of Ruskin and with his full blessing, has tall iron columns and much iron decoration in Gothic and naturalistic forms. In the same fifties, in Paris Louis-Auguste Boileau had the temerity to introduce at

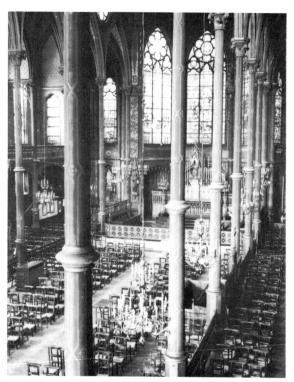

71. Boileau: St Eugène, Paris, 1854-5.

St Eugène not only iron columns but also iron vaulting-ribs (Pl.71; 1854–5). He and his son Louis-Charles did the same in the sixties in other churches³⁷ and Louis-Auguste wrote several books on the advantages of iron in architecture. Baltard, the architect of the Market Hall, joined the Boileaus at St Augustin in Paris in 1860–61 and used iron piers, iron arches, and an iron dome.

This is when Viollet-le-Duc appeared on the scene, a character as ambiguous and as influential as Pugin had been. He was the successful and ruthless restorer of more cathedrals than can be counted, of Carcassonne and of Pierrefonds. He was a radical politician and a learned architectural historian. His *Dictionnaire* has remained a source

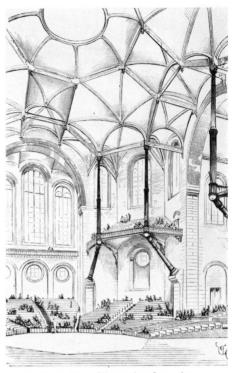

72. Viollet-le-Duc: Illustration from the *Entretiens*, 1872.

of information and an object of study to the present day. He was the expounder of the principle of Gothic construction with as much conviction as and far better scholarship than Pugin. He was the defender of the Gothic thirteenth century as a century of the people, and on top of all this a passionate defender of iron in architecture, iron for supports, and iron for vaults. The book to go to for Viollet-le-Duc's views on iron is his *Entretiens*. In the first volume (1863) there is in Lecture IX a general reminder that 'in the present day we have immense resources furnished by manufacturing skill', and a plea for 'making use of these means with a view to the adoption of architectural forms adapted to our times', instead of disguising 'these novel appliances by an architecture

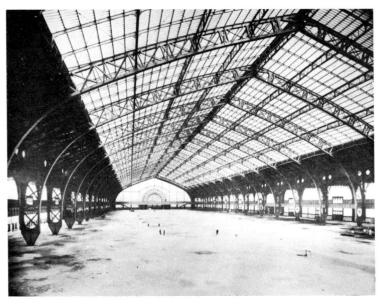

 Dutert and Contamin: Halle des Machines, Paris International Exhibition, 1889.

borrowed from other ages', and in Lecture X one reference to the use of iron for the building of an assembly hall for 2000 people.³⁸ In Volume II (1872), there is far more: a consistent proposal for 'the simultaneous employment of metal and masonry' with masonry walls and undisguised supports of iron and vaulting-ribs of iron, an appraisal of the 'feats of construction which iron would allow and of the innovations of the engineers',³⁹ and illustrations showing precisely what Viollet had in his mind, heavy Victorian structures with heavy and floridly decorated iron members (Pl.72).

More than this could indeed not be expected from any architect of the sixties and seventies. The complete abandonment of borrowed architectural elements and ideals could not come from the architects. It came from the engineers. The next decades were their years of ultimate triumph. Bridges achieved unprecedented spans, the Brooklyn Bridge of 187c–83 with its main span of 1596 feet and the Firth of Forth

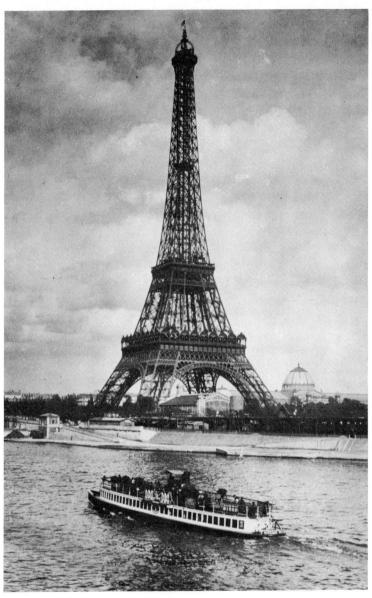

74. Eiffel: Eiffel Tower, Paris, 1889.

Bridge of 1883-9 with its 1735-foot span. Vaulting achieved the miraculous span of 385 feet in the Halle des Machines at the Paris International Exhibition of 1889, by the engineer Contamin and the architect Dutert (Pl. 73). It had a height of 150 feet and must have conveyed an unprecedented feeling of space and weightlessness. The illustration shows the fascinating ease with which the steel arms spring from the supporting shafts. The pairs of arms are not joined together at the top of the vault; they just touch each other by means of the same narrow bolts used at the bottom of the shafts. For the same exhibition where the widest span ever was thus accomplished, Gustave Eiffel built the highest structure ever erected, the Eiffel Tower (Pl.74), Eiffel (1832-1923)40 had already tried out the construction of those sickle-shaped girders that form the base of the tower, in several bridges which are among the boldest of the century, for instance the Douro Bridge (1875) and the Garabit Viaduct (1879). The overwhelming effect of the Eiffel Tower is due to the height of 1000 feet - unsurpassed until after the First World War - and also the elegance of its curved outline, and the powerful yet controlled energy of its élan.

The Eiffel Tower was still constructed of wrought iron but by 1885–90 steel had begun to take the place of iron. Hence it ought to be realized that, from 1890 onwards, the most advanced architectural thought and the visual qualities of progressive buildings can no longer be fully understood without taking steel into consideration, and steel at this moment meant more than anything the skyscraper. Not every tall building is a skyscraper. We use the term only for buildings where load-bearing walls are replaced by skeleton construction. Recent research has established with great precision the various stages which led from the one to the other.⁴¹ They do not concern us here in detail.

All that need be said of the prehistory of the skyscraper is that tall office buildings were not possible before the advent of the lift (1852) and more particularly the electric lift (invented by W. von Siemens in 1880). A height of 349 feet was reached, in spite of solid masonry walls, by the Pulitzer Building in New York in 1888–9. Meanwhile, however, the Home Insurance Building in Chicago by William Le Baron Jenney (1832–1907) had been erected in 1884–5 with a genuine skeleton

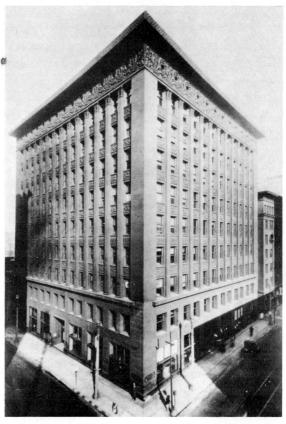

75. Sullivan: Wainwright Building, St Louis, 1890-91.

construction, and other Chicago office blocks such as the Tacoma Building of 1887–8 by Holabird and Roche improved Jenney's innovation at once. 42 But in their appearance neither the Home Insurance nor the Tacoma Building nor the other earliest Chicago skyscrapers show features in advance of the customary masonry towers put up before. It was left to Sullivan to pay attention to the voice of steel. The result is the Wainwright Building in St Louis (Pl. 75), a milestone in the evolution of the Modern Movement. It was designed in

1890. Mr Morrison has pointed out rightly that its façades do not by any means show its construction in its entirety. The masonry strips at the corners are still wider than the other uprights, which are of the same width, although only every second of them corresponds to a steel stanchion. The top storey with its bull's-eyes, and the far projecting top cornice with its lush Sullivanian Art Nouveau decoration, also are reminiscent of stone traditions. Yet Sullivan had understood that the grid of steel calls for an exterior essentially based on one and the same unit, or, as he puts it, that we must 'take our cue from the individual cell, which requires a window with its separating pier, its sill and lintel, and without more ado, make them all look alike, because they all are alike'. Hence the splendid simplicity of rhythm and the unfaltering directness of effect. In contrast to van de Velde, Sullivan thus translated into the reality of big buildings those revolutionary theories of his which we have discussed at the beginning of this book.

Nor was he the only architect in Chicago to have such a strong feeling for the character of the coming century. It appeared in Richardson when he was faced with the job of designing the Marshall Field Wholesale Building in 1885, a massive block, not a skyscraper at all, but a monument to commerce and industry erected regardless of all the paraphernalia traditionally connected with monumentality. Its round arches are the only allusion to the architect's Neo-Romanesque past. The spirit is wholly original, and must have impressed enormously not only Sullivan but also Burnham and Root, when they built the Monadnock Block in 1890-91 (Pl.76). This building has neither any Richardsonian forms nor does it make use of a steel skeleton. It is the last of the big masonry towers, yet in its uncompromising refusal to mitigate its sheer lines by any mouldings and any ornament, it is entirely of the new age. To that extent can technique and aesthetics be at variance at any one moment even in so consistent a development as that of the Chicago school.44

In the cellars of the Monadnock Block and other American office buildings ferro-concrete was used, and although it was not used in any but a utilitarian and hidden way, it must at this juncture be introduced formally, as it was to become one of the most significant materials of

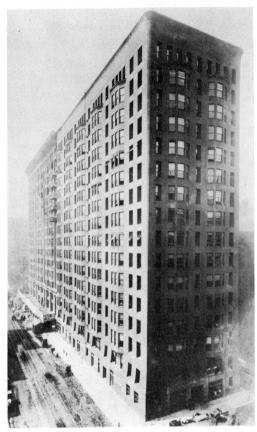

76. Burnham and Root: Monadnock Block, Chicago, 1890-91.

the twentieth century. Its prehistory has recently been elucidated very fully, 45 and so the story can be summarized easily. There are first of all the differences between cement and concrete – concrete being an aggregate – and between mass concrete and reinforced concrete – the iron or steel reinforcements adding to the compression strength of concrete the tensile strength of iron.

Concrete had been widely used by the Romans and was indeed their distinguishing building technique from the first century A.D. onwards.

The material was then lost and appears again only in the French building manuals of about 1800, such as Rondelet's *Art de bâtir*. Propaganda for cisterns, grain elevators, and whole houses to be made of mass concrete started soon, and in both France and England concrete houses can be traced back to the 1830s. The first concrete fanatic in history, a type to multiply rapidly, was François Coignet who wrote at the time of the International Exhibition of 1855: 'Cement, concrete, and iron are destined to replace stone,'46 and built the shell of the church of Le Vésinet of concrete. Its interior was of iron.⁴⁷

The beginnings of the iron reinforcement of cement go back to a note in Loudon's Encyclopaedia of Cottage, Farm, and Villa Architecture of 1832,48 where cement floors with an embedded lattice work of iron ribs are mentioned, and to a patent of 1844 for cement floors with embedded cast-iron joists. In the 1850s more patents followed, an English one of 1854 referring explicitly to the iron or wire-rope inside the concrete as being in a state of tension 49 and a French one of Coignet's of 1856 speaking equally explicitly of the iron members as 'tirants'.50 The next name after Coignet's which must be remembered is that of Joseph Monier who perfected flower-pots of reinforced concrete in 1867 and columns and beams of reinforced concrete in 1877. Concurrently progress was made in England in shuttering for the pouring of concrete. Norman Shaw's name comes into the history of concrete too, although only very marginally; for the designs for partly concrete cottages which lie brought out in 1878 are of mass concrete not of reinforced concrete.

Reinforced concrete emerged to maturity in the same seventies, when William E. Ward and Thaddeus Hyatt began to analyse and calculate the properties of concrete and iron in their combination. A few years later the Germans, impressed by Monier's experiments, followed suit, and the names of G.A. Wayss and Koenen, as manufacturer and engineer respectively, mark the start of concrete making and concrete scholarship in the modern sense. They take us to the mid eighties.

Finally their scientific endeavours were paralleled and reinforced by the ingenuity and the showmanship of a great French enthusiast, François Hennebique. It was Hennebique who replaced iron by steel

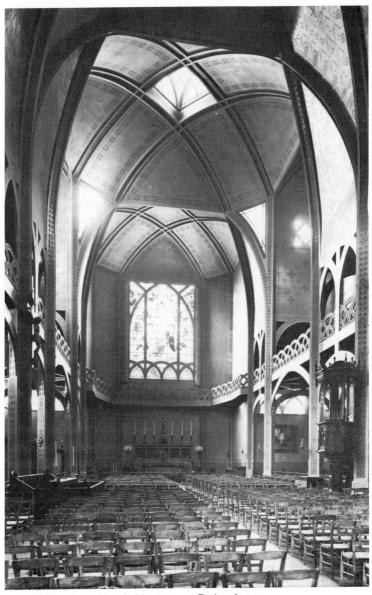

77. De Baudot: St Jean de Montmartre, Paris, 1894-9.

and introduced the bending of the steel reinforcements near the supports. His first patents date from 1892 and 1893, and his firm soon became extremely prosperous. A spinning mill at Tourcoing by Hennebique which was built in 1895 has as uncompromisingly functional a façade of exposed concrete framing with large glass surfaces between as any of the buildings of the Chicago architects.

Two years later concrete graduated. The date is that of Anatole de Baudot's church of St Jean de Montmartre (Pl. 77). Baudot was a pupil of Viollet-le-Duc. He shared his master's faith in new materials and their applicability to monumental tasks. If Viollet-le-Duc had suggested the use of iron for reinterpreting Gothic principles, Baudot used concrete for the same purpose. The bareness and sheerness of the supports, the unmitigated scaffolding effect of the concrete beams passing forward and backward and across, and the glazing of pendentives and lantern achieve an austere directness which Baudot considered fundamentally Gothic, but which at the same time heralds the spatial intricacies of Mackintosh and Le Corbusier. Between the completion of this building and the First World War, France remained the leader of the development of concrete architecture.

One more remark is necessary before this account of engineering architecture can be closed. Ruskin, Morris, and their followers hated the machine and consequently the new steel and glass architecture, which, according to Ruskin, is 'eternally separated from all good and great things by a gulf which not all the tubular bridges nor engineering of ten thousand nineteenth centuries cast into one great bronze-foreheaded century, will ever over-pass one inch of'.⁵¹

Ruskin's reasons for this frantic scorn were of a primarily aesthetic nature, those of Morris were entirely social. Morris was unable to appreciate the positive possibilities of the new materials, because he was too intensely concerned with the negative consequences of the Industrial Revolution. He saw only what had been destroyed: craftsmanship and pleasurable work. But no new period in human civilization has ever arisen without an initial phase in which a complete upheaval of values took place; and such phases are not specially pleasant for contemporaries.

The engineers, on the other hand, were too absorbed in their thrilling discoveries to notice the social discontent accumulating around them, and to listen to Morris's warning voice. Owing to this antagonism, the two most important tendencies in nineteenth-century art and architecture could not join forces. The Arts and Crafts kept their retrospective attitude, the engineers their indifference to art as such.

The precipitate turned out to be Art Nouveau. So fascinated were the designers of Art Nouveau by any novelty, any demonstration against the traditional and conventional that they could take the innovations of the engineers in their stride. They were as much convinced of the necessity for devoted work in the crafts as Morris and his disciples, but they were also capable of achieving an occasional synthesis between the new sensitivity and the new material.

So it is essential ultimately to understand the style of the twentieth century as a synthesis of the Morris Movement, the development of steel building, and Art Nouveau. The account of these three principal lines of progress, which has been given in this and the preceding chapters, will now enable us to devote the remaining pages of this book to the Modern Movement itself, as it grew in England, the United States, and on the Continent.

6 · England, Eighteen-ninety to Nineteen-fourteen

WE must first return to English architecture and design. At the end of the eighties, as was shown, Morris was the leader in design, Norman Shaw in architecture. The deliberate break with tradition, which characterized the style of Europe's greatest painters about 1890 and the style of the initiators of Art Nouveau, was not made and not desired in England. So it seemed appropriate to leave until now the discussion of the English development from 1890 onwards, though at least one English architect had ventured on a new style of an original and highly stimulating nature, before Art Nouveau had begun. This was C.F. Annesley Voysey (1857–1941). It has already been said that his designs were a source of inspiration of Art Nouveau. Van de Velde told the author of the revolutionizing effect of Voysey's wallpapers on him and his friends.2 His words were: 'It was as if Spring had come all of a sudden.' And indeed we have only to look at one of Voyscy's wallpapers printed in the nineties (Pl. 78) and one of his somewhat later printed linens (Pl. 79), to see the great difference between him and Morris. Not that he aimed at novelty; his modifications and progressiveness, it would seem, were almost unconscious. Doctrines and hard-and-fast rules were not his way. In the controversy between supporters of stylized and of naturalistic ornament, he did not take sides. For although, in an interview in 1893, he declared realism to be unsuitable for decoration, he was inclined to admit plants and beasts in patterns on condition that they be 'reduced to mere symbols'. This may seem in accord with Morris, but there is a distinctly new note in Voysey's urgent desire to 'live and work in the present'.3

So he arrives at patterns which are happily near to nature, and at the

78. Voysey: Design for a wallpaper, c. 1895.

79. Voysey: Stags and Trees, printed linen, 1908.

same time full of decorative charm. The graceful shapes of birds flying, drifting, or resting, and of tree-tops, with or without leaves, are favourite motifs of Voysey's, and there is an unmistakable kindliness in his child-like stylized trees and affectionately portrayed birds and beasts. A comparison between these wallpapers or linens and Morris's *Honeysuckle* (Pl. 8) shows what a decisive step has been taken away from nineteenth-century Historicism into a new world of light and youth.

It is known that everywhere in English cultural life a longing for fresh air and gaiety expressed itself at the end of Queen Victoria's reign. The success of Liberty's about 1890 depended largely on their Eastern silks in delicate shades and their other Chinese imports. The history of the part played by China and Japan in European art since 1860 has not yet been written. It would be very interesting to show the influence of the East appearing here in a loose technique of painting, there in the greatest finesse of line and contours, there again in clear, soft, and pure colour, and in yet other works in flat pattern effects. Owing to the unique synthesis of ornamental and 'Impressionist' qualities in Eastern art, both the Impressionists and, at the opposite pole, the originators of Art Nouveau, could use what Japanese woodcuts and Chinese pottery had to teach them. The Impressionist went to Japan for a lightness that he took for plein air, for a sketchy handling of the brush, and a flatness of surfaces, which he wrongly interpreted as meaning the shadelessness of strong sunlight. His adversary, more justly, stressed the high degree of stylization in every line drawn and every surface decorated by an Eastern artist. That is why Japanese woodcuts can appear in the backgrounds of Manet's Zola and Degas's Tissot as well as van Gogh's Père Tanguy and Ensor's Skeleton Studying Eastern Paintings. 4 The case of Whistler is especially instructive; for it proves that in the same painter at the same time both aspects of the Eastern style might be reflected. The influence of Eastern colour, Eastern delicacy, and Eastern composition on his yet so clearly Impressionist portraits is evident and has no need of the Chinese costume in the Princesse du Pays de la Porcelaine to stress it. At the same time, however, Whistler could make this same picture the chief accent of a room decorated in a style which, although not free from traces of Historicism obviously pointed forward to Art

Nouveau.5 Moreover Whistler pleaded for rooms with completely plain walls in light colours. In this he followed a lead given by his friend Edward Godwin whose house at Bristol has been mentioned in a previous chapter because of the plain walls and bare floors of its rooms and because of its Japanese prints. The date of these interiors, 1862, is remarkably early. Whistler's house in Tite Street, Chelsea, built for him by Godwin, had white and rich yellow walls, Japanese matting on the floors, plain curtains in straight folds, some pieces of Chinese porcelain, and a few simply framed pictures and etchings.⁶ In trying to imagine such rooms, we feel ourselves at once in the early years of the twentieth century, no longer in the days of Morris and Ruskin. And yet, in theory (if that is not too heavy an expression for his casual aperçus) and in technique, Whistler was as complete an Impressionist as anybody, and therefore an object of passionate hatred to those who worked for a new outlook on life and art.7 There is no need to go again into that unpleasant case, Whistler versus Ruskin. Morris was bound to follow Ruskin.8 This was a matter of principle primarily, but also a matter of taste. The man who regarded Burne-Jones as the great living painter of the Late Victorian era could certainly not appreciate Whistler's superficial (truly superficial) pictorial impressions.

One would expect to find the same contrast between the disciples of the Arts and Crafts and the Impressionists as between Morris and Whistler. However, it is a fact which has already been mentioned in connexion with the exhibitions of Les Vingt, that on the Continent the introduction of Impressionism, and of the new decorative style in both its forms, as Art and Crafts and as Art Nouveau, took place concurrently and were both due to the same persons. Meier-Graefe, who was one of the first to discover van de Velde, wrote books on Renoir and Degas, and also on van Gogh and Gauguin. And even today most people interested in art are unaware of the irreconcilable difference between Impressionism as a doctrine and the doctrine of Morris and all his followers. Yet, it is obvious that the antithesis, Impressionism versus Arts and Crafts, is but the artistic expression of a far more comprehensive cultural antithesis between two generations. On the one side there is a conception of art as a rapid rendering of momentary surface

effects, on the other as an expression of what is final and essential; on the one side there is the philosophy of Art for Art's sake, on the other a renewed faith in a social message of art. The Impressionists stand for the exquisite luxuries of late-nineteenth-century Paris, the Arts and Crafts for 'roughing it' in the spirit of that Youth Movement which is so significant of the years around 1900 and after, and can be traced in Bergson as much as in the foundation of the first 'modern' public schools in England: Abbotsholme (1889) and Bedales (1892).

In design, Voysey is the outstanding but by no means the only representative of this new *joie de vivre*. Some of Crane's late wallpapers also depart from Morris's heaviness. Frank Brangwyn's designs for textiles are another example. As long as Continental architects believed in Art Nouveau, it was chiefly English designs for wallpapers, printed linens, chintzes, and so on which appealed to them. As soon as the new desire for *Sachlichkeit* spread, all the pioneer work done by the English architects and artists in the shaping (not the decoration) of objects became topical. It must have been a delightful surprise to those who—like Muthesius—came to England, weary not only of Victorian stuffiness but also of the licence of Art Nouveau, to see a toast rack or a cruet set designed by Voysey (Pl. 80). The refreehing simplicity of his wallpapers is also the keynote of these small things of everyday use. Their charm lies solely in the cleanness and gracefulness of their shapes.

Of particular importance for the coming Modern Movement was the expression of this new spirit in furnishing. The entrance hall of Voysey's house, The Orchard, Chorleywood, Hertfordshire, of 1900 can serve as an example (Pl. 81), with its lightness; the woodwork painted white, a pure intense blue for the tiles, unmitigated contrasts of uprights and horizontals, especially in the screen to the staircase (a motif which was for a time to become eminently popular), and furniture of bold, direct, if a little *outré* forms.

There is one more thing which must be said about Voysey and which places him further from Morris and close to us. He was a designer, not a craftsman. He could not in fact, so he told the author, work in any craft. Ernest Gimson (1864–1920),⁹ the greatest of the English artist-craftsmen, was, as a matter of fact, in not too different a position,

80. Voysey: Toast rack and cruet set.

81. Voysey: The Orchard, Chorleywood, Hertfordshire, 1900.

although not many people realize it. He had been trained, it is true, in craftsmanship, but his famous works of cabinetmaking, metal-work, and so on are only designed and not made by him. The chairs shown here (Pl. 82) give an impression of his honesty, his feeling for the nature of wood, and his unrevolutionary spirit. Few of his works have this superb simplicity. As a rule, Gimson was more responsive to English tradition and did not despise the use of forms invented in the past.

On a really commercial basis good progressive furniture was at the same time made by Sir Ambrose Heal (1872–1959). The firm of Heal & Son had been producing Victorian furniture, until Ambrose Heal changed its course. A wardrobe which Heal's showed at the Paris Exhibition of 1900 (Pl.83) has the same brightness which we found in Voysey's wallpapers. Plain surfaces of slightly fumed and waxed oak contrast with small panels decorated in pewter and ebony. There are no long curves; the patterns are composed of rectangles and gracefully-drawn little flowers. The close atmosphere of medievalism has vanished. Living amongst such objects, we breathe a fresher air.

Even more important historically than such exhibition pieces of Heal's was their production for the ordinary market. In 1898, the first catalogue of Heal's Plain Oak Furniture came out and started the revival of the simple wooden bedstead in England. For more than twenty years these pleasant bedsteads were popular in the English furniture trade, until they were swept away by misguided supporters of modernistic forms.

Exactly the same contrast between 1890 and 1900 as in cabinet-making is to be found in English printing. Morris's Kelmscott Press – founded in 1890 – produced pages the effect of which depends largely on their exquisite medievalist decoration. Cobden-Sanderson's and Emery Walker's Doves Press – founded in 1900 and mentioned in this book on page 35 – secured for the plain unadorned type face its place in modern book production.

As far as English architecture is concerned, the historical position is not quite so simple as in applied art. It has been pointed out that, by 1890, Norman Shaw had attained a style which, based on Queen Anne, was so 'modern' in character and so perfectly suited to English needs

82. Gimson: Chairs, 1901.

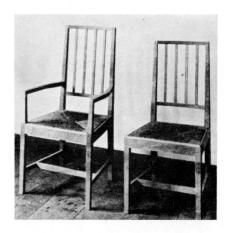

83. Heal: Wardrobe, 1900.

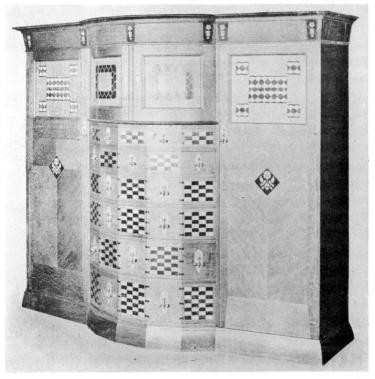

84. Mackmurdo: 8 Private Road, Enfield, c. 1883.

and taste that it could hardly be improved on, as long as no open break with tradition was attempted. The earliest and most remarkable cases of independence - earlier in fact than that of Horta - are afforded by some of the early architectural works of Mackmurdo and Voysey. Mackmurdo's house, 8 Private Road, Enfield (Pl. 84) built about 1883 is of a surprisingly free carriage. The flat roof and the few horizontal windows of the upper floor are particularly noteworthy. Although much more orderly it forms in its independence of approach a parallel, the only European parallel, to Godwin's house of 1878 for Whistler. In 1882 Mackmurdo founded the Century Guild, the first of all those groups of artist-craftsmen-designers who followed the teaching of William Morris. Of 1883 was his amazing title page which started Art Nouveau on its way. In 1886 Mackmurdo put up the stand, for the products of his guild at an exhibition at Liverpool, which is illustrated in Plate 85. The attenuated shafts with their excessive top cornices instead of capitals and the repetition of these odd forms on top of the

85. Mackmurdo: Exhibition stand, Liverpool, 1886.

fascia board are even more original, and started a fashion, when Voysey and then several others took them up. Of Mackmurdo's strong influence on Voysey there can be no doubt. He himself said to the author that when he was very young Mackmurdo had impressed him even more than Morris. Yet the first house which Voysey built, the one in The Parade at Norman Shaw's garden suburb, Bedford Park near London (Pl. 86), is amazingly independent, considering the date, 1891. The arrangement of the windows is particularly striking. But whereas this kind of free grouping also prevails in the works of Norman Shaw and his school, the whiteness of the walls was an open protest against the surrounding red brick of Shaw's garden suburb. The tower-like tallness of the house also and the skipping rhythm of bare walls and horizontal window openings were innovations introduced deliberately and not without a youthful sense of mischief.

However, Voysey did not go on in that direction, or else he would have developed into an architect of Art Nouveau. Already in the tiny studio

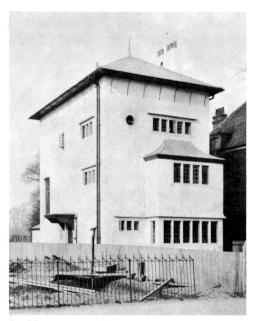

 Voysey: House in Bedford Park, near London, 1891.

built in St Dunstan's Road, West Kensington, London, in the same year 1891 (Pl.87), the general proportions are closer to English traditions, cottage traditions, than anything in the house in Bedford Park, although the detail is again remarkably novel, above all the massive chimney, the batter of the buttresses on the right and also the ironwork in front (obviously inspired by Mackmurdo's woodwork of 1886).

When Voysey began to get commissions for houses in the country, his appreciation of English traditions was decisively strengthened.¹¹ A man of intense feeling for nature, as his designs prove him to have been, he could not but think of his houses in conjunction with the surrounding countryside, and so shapes offered themselves which were more akin to the English manor house and cottage of the past than to those he had evolved in London. His country-house practice began in the early nineties and by 1900 had assumed very large dimensions. He never built a church, never a public building, and only once a small warehouse.

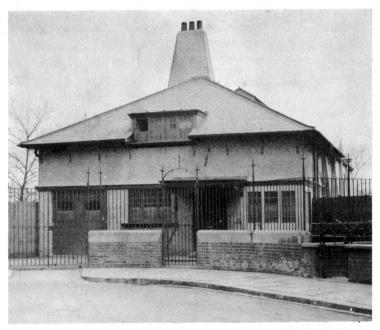

87. Voysey: Studio, St Dunstan's Road, West Kensington, London, 1891.

Perrycroft, Colwall, Malvern Hills, dates from 1893 (Pl.88). It is typical of Voysey's ideas of what a country house should be like. In spite of such strikingly modern features as the consistently horizontal fenestration and the massive block shapes of the chimney-stacks, it is nowhere demonstratively anti-traditional, and it fits perfectly with its natural surroundings (a garden was planned and planted together with the house) and the architectural character of the country.

This is even more evident in another building, the house erected for Canon L. Grane at Shackleford in Surrey, in 1897 (Pl. 89). Today it is not easy to appreciate the candour and simplicity of its façade. For, in Britain at least, it has become too much of a standard example ineptly imitated by hundreds of speculative builders all along the arterial roads and all over the suburbs. However, from the historian's point of view, it remains no small feat to have created the pattern for the vast majority

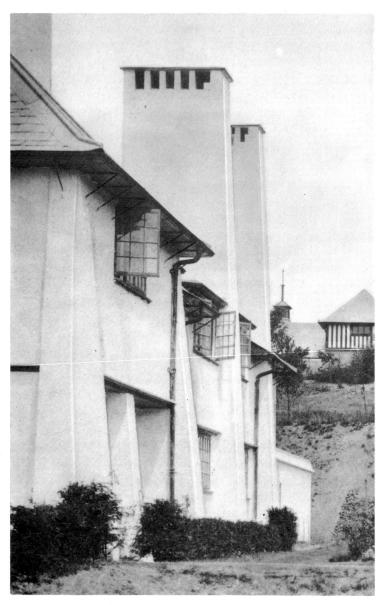

88. Voysey: Perrycroft, Colwall, Malvern Hills, 1893.

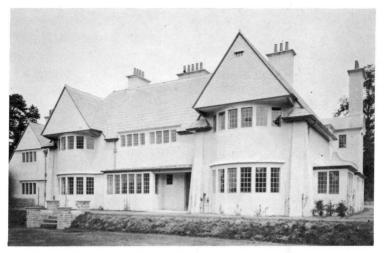

89. Voysey: House at Shackleford, Surrey, 1897.

of buildings carried out over a period of thirty years and more. What was not copied from Voysey, needless to say, was what impresses us today as his most progressive motifs – the long- drawn-out window strips and the completely bare triangles of the gables, broken only in one place by a charmingly tiny and just a trifle precious window.

This introduction of an occasional effect of Art Nouveau piquancy helps a great deal to lighten the otherwise puritan honesty of many of Voysey's houses. Thus for instance in the lodge of Merlshanger on the Hog's Back near Guildford, Surrey, designed in 1896 (Pl. 90), the typical Voysey buttresses and far projecting eaves carry a very flat curved cupola with a spirelet, needle-thin and ending in a weather-vane. In the same way in one of his most successful country houses, Broadleys on Lake Windermere (Pl. 91) of 1898 the eaves cornice is supported once again by thin iron brackets and their delicacy adds a touch of lightness to the whole front.

But such effects are only a little light relief in what is otherwise sound, balanced, vigorous design without any tendency to demonstrative novelty. That is what makes the water front of Broadleys so impressive. Here, one sees clearly, was a mind equally averse to the picturesque

90. Voysey: Lodge and stables, Merlshanger, near Guildford, Surrey, 1896.

tricks of the Shaw school and the preciousness of Art Nouveau. From this centre bay with its completely unmoulded mullions and transoms, from these windows cut clean and sheer into the wall, access to the architectural style of today could have been direct, more direct probably than from the designs of those few in England who in the late nineties appeared more revolutionary than Voysey. Whom should one count amongst them? Maybe Baillie Scott (1865-1945) who started a little later than Voysey and very much under his influence, 12 and C. R. Ashbee, whose writings and social activities have been mentioned before and whose most original houses, in Cheyne Walk, Chelsea, London were designed as early as 1899.13 Even more remarkable historically is the Mary Ward Settlement in Tavistock Place, London (Pl.92), built in 1895 by Dunbar Smith (1866-1933) and Cecil Brewer (1871-1918). Its relation to Norman Shaw (Venetian window) as well as to Voysey (top parts of the projecting wings) is evident. The rhythm of the blocks on the other hand, the proportions of the recessed centre part with its

91. Voysey: Broadleys on Lake Windermere, 1898.

92. Smith and Brewer: Mary Ward Settlement, Tavistock Place, London, 1895.

93. Townsend: Whitechapel Art Gallery, London, 1897–9.

blank brick wall and the high bare cornice, the wide projection of the roofs, all point distinctly forward to the style of today, and the asymmetrically projecting porch is freer and more 'organic' in treatment than Voysey ever wanted to be.

This particular feature in its turn must have impressed the older C. Harrison Townsend (1852–1928) whose principal work, the White-chapel Art Gallery, London, dates from 1897–9 (Pl.93). But Townsend's style is of more complex origins. The deliberate lack of symmetry between ground floor and upper floor, as well as the long row of surprisingly low windows and the leaf ornament of the friezes, ultimately point no doubt to Voysey, but the heavy arch above the entrance must reflect some knowledge on Townsend's part of what Richardson had

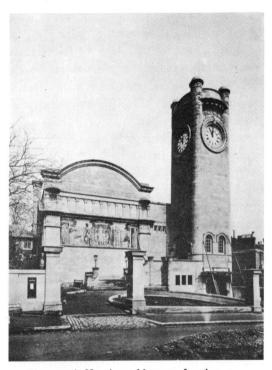

94. Townsend: Horniman Museum, London, 1900–1902.

done in America for twenty years and more.¹⁴ If this assumption is correct, we have here the first case of American influence on England. The two flat friezes above the row of windows also conjure up some memories of, say, Richardson's Brattle Square Church in Boston of 1870–72, and the American connexion became more distinct with Townsend's next building, the Horniman Museum in South London of 1900–1902 (Pl. 94). The robust square tower with its rounded corners and stumpy top is utterly different from the elegant spirelets which Voysey and his imitators adored so much. Townsend's designs during these years, in spite of all that it might be possible to say about sources in England and abroad, are without question the most remarkable example of a reckless repudiation of tradition among English architects of the time.

Among English, not among British architects. For in Glasgow there worked during these very years a group of artists as original and as imaginative as any in Europe. In painting, the Glasgow Boys, Guthrie, E. A. Walton, Lavery, Henry, Hornel, and so on are well enough known. Their first exhibition abroad impressed Europe considerably. But in design and decoration the first appearance of the Glasgow school at an exhibition in Vienna in 1900 was a revelation.

The centre of the group was Charles Rennie Mackintosh (1868-1928) with his wife Margaret Macdonald and her sister Mrs McNair. 15 In dealing with him, we are able at last to link up the development in England with the main tendency of Continental architecture in the nineties, with Art Nouveau. Before he was twenty-eight, Mackintosh was chosen to design the new building for the Glasgow School of Art, a remarkably bold choice due largely to the principal Francis H. Newbery. The designs date from 1897; the first part of the building was completed in 1899 (Pl. 95). Not a single feature here is derived from period styles. The façade is of a strongly personal character and, in many ways, leads on to the twentieth century, although the entrance bay with balcony and short turret is deliberately fantastical and not unlike Townsend's contemporary work. But the rest of the front is extremely simple, almost austere in its bold uniform fenestration. In the horizontal windows to the offices on the ground floor and the high studio windows on the upper floor, no curves are admitted; unbroken upright lines prevail even in the railing in front of the building, counteracted only by a few lighter and more playful Art Nouveau ornaments at the top. The same contrast exists between the rigidity of the upper-floor windows and the strange metal stalks at their base, functionally justified for putting planks on to facilitate window cleaning. However, be that as it may, this row of metal lines reveals one of Mackintosh's principal sources and at the same time one of his most characteristic qualities. The source, particularly telling in the strange balls at the top of the stalks, with their intertwined tentacles of iron, is clearly the Celtic and Viking art of Britain, as it became familiar beyond the circles of scholars just at this time. 16 The quality equally eloquent in the balls and the stalks is Mackintosh's intense feeling for spatial values. Our eves have

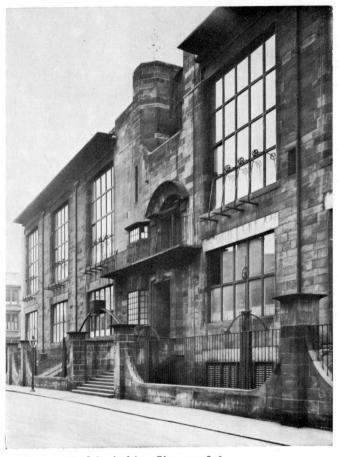

95. Mackintosh: School of Art, Glasgow, 1896-9.

to pass through the first layer of space, indicated by the stalks and balls before arriving at the solid stone front of the building. The same transparency of pure space will be found in all Mackintosh's principal works.

The ground plan of the building is clear and lucid, showing in another light the architect's interest in space, an interest rare among artists of Art Nouveau. One more instance may be given to prove that this is

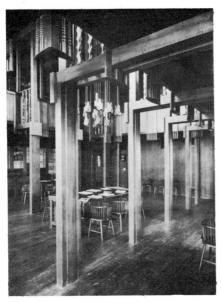

96. Mackintosh: School of Art, Glasgow, 1907–9. Interior of library.

really the keynote of Mackintosh's creation: the interior of the library of the Glasgow School of Art, which forms the centre room of the west wing, planned in 1907 (Pl.96). The simple motif of a high room with aisles and galleries around three sides is so enriched that the resulting impression is an overwhelmingly full polyphony of abstract form. The galleries do not project far enough to reach the pillars which separate 'nave' from 'aisles'. Horizontal beams are inserted to connect the walls with the pillars and to support the galleries. Airy balustrades, Art Nouveau in detail, run from the parapets of the gallery to the pillars. Their sole purpose is to offer interesting perspectives. Curves, rare and all the more expressive in Mackintosh's earlier work, have now completely disappeared. Uprights and horizontals, squares and oblongs determine the effect. This and the number of fascinating vistas which the architect has achieved here and in another principal work of the same period, the Cranston Tearoom in Sauchiehall Street, 1904 (Pl.97),

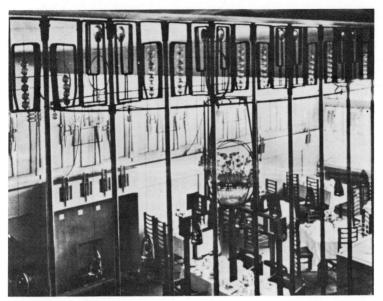

97. Mackintosh: Cranston Tearoom, Sauchiehall Street, Glasgow, 1904. Interior.

show him as the European counterpart of Frank Lloyd Wright and one of the few true forerunners of the most ingenious juggler with space now alive: Le Corbusier. Le Corbusier once confessed that his desire in building is to create poetry. Mackintosh's attitude is very similar. Building in his hands becomes an abstract art, both musical and mathematical.

The façade of the west wing of the art school is an instance of this. Here the abstract artist is primarily concerned with the shaping of volume and not of space, of solids, not of voids (Pl. 98). The aesthetic value of the straight, slender shafts into which the windows are inserted is entirely independent of their function. The contrasts between fretwork and solid ashlar, and between the menacing bareness on the left and the complex polyphony on the right, are also effects more comparable to abstract relief than to buildings of Voysey's kind.

A glance at the earlier and the later part of the art school reveals the

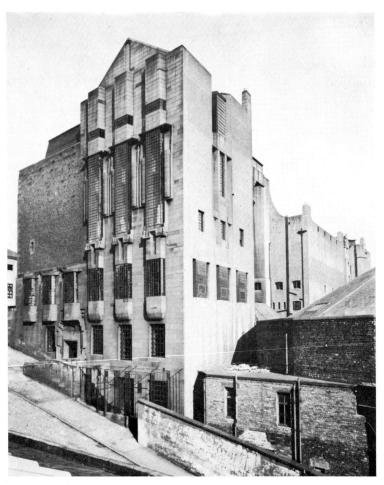

98. Mackintosh: School of Art, Glasgow, 1907-9. Library wing.

development of Mackintosh's taste between 1897 and 1907. Delicate metal ornament of linear appeal is no longer used. A squareness and robustness prevail which come as a surprise. They are, it seems certain, Mackintosh's way of admitting national tradition. His links with the Scottish baronial past are perhaps more evident in his country houses than in a public building such as the School of Art. If we look at the

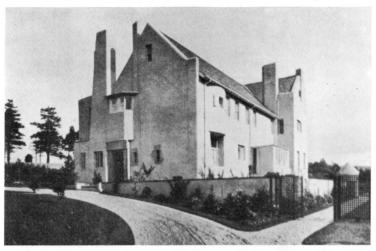

99. Mackintosh: Hill House, Helensburgh, near Glasgow, 1902-3.

general form and outline of Hill House at Helensburgh, 1902-3, the steep gables and the massive chimney-stacks are unmistakable (Pl. 99). Once that has been recognized, the library wing of the art school will at once show its baronial relations, perched as it is on the steep slope of the street leading up the front. Its great fascination is in fact its synthesis of traditional elements with a remarkable fearlessness in the functional distribution of the windows and the weird harshness of its narrow, angular, upright forms. From here a direct way leads to that peculiar and short-lived Expressionism in Continental and especially Dutch architecture which for a while held up the progress of the main stream of modern architecture about 1920.17 Whether the Dutch architects had actually taken notice of Mackintosh's later buildings is not certain. Their main source in any case was not foreign. It was H.P. Berlage (1856-1934). Berlage, regarded in Holland as of greater European significance than appears convincing, is essentially a counterpart to Voysey rather than to Mackintosh, that is, essentially a believer in the possibilities of developing native traditions towards modern goals. His point of departure was the brick architecture of the Dutch Middle Ages

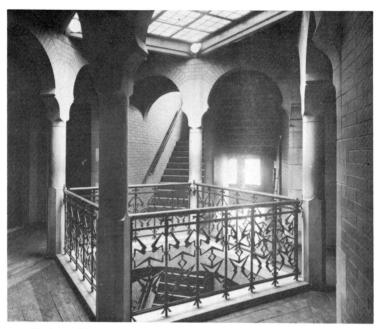

100. Berlage: House, 42-4 Oude Scheveningsche Weg, The Hague, 1898. Stair well.

and a faith in craftsmanship. That gives his most famous building, the Exchange in Amsterdam, begun in 1898, its solid, sane, trustworthy character. Yet inside it, and, even more, the house Nos. 42-4 Oude Scheveningsche Weg at The Hague (Pl. 100), there is curious, sharp, jagged decoration in brick and iron, as reminiscent of Gaudí as of Expressionism. J. M. van der Mey, fifteen years younger, in the Scheepvaarthuis at Amsterdam of 1911-16, the years which mark the end of the period under discussion in this book, made a whole big façade out of these Expressionist motifs of Berlage, scattering his fundamental soundness to the winds. Here architectural Expressionism is attained five or ten years earlier than anywhere else. The Scheepvaarthuis on the one hand, Gaudí's late works on the other, are the links between Art Nouveau and Expressionism.

However, while this may be the connexion between late Mackintosh

101. Mackintosh: Cranston Tearoom, Buchanan Street, Glasgow, 1897-8.

and the Continent, that between early Mackintosh and one particular Continental country, Austria, is of much greater historical interest and, because it also raises a somewhat intricate question, it demands a rather more detailed discussion. The obvious similarity between Mackintosh's earliest interior designs – or one should rather say the interior designs of Mackintosh and Margaret Macdonald – and the style of the Viennese Sezession, has often been commented on. The Cranston Tearoom in Buchanan Street of 1897–8 (Pl. 101) should be studied in this connexion – incidentally the first monument of the British tearoom movement, a movement, in its opposition to the snugness and stuffiness of the pub, again typical of the new desire for health and daintiness. In the Buchanan Street tearoom the walls are decorated with the same long and graceful lines and the same excessively slim figures which we find in the works of Klimt and his followers. But the tearoom dates from

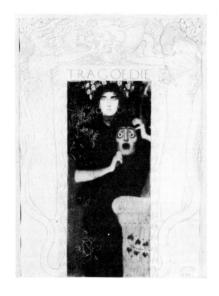

102. Klimt: Tragedy, 1897.

1897, and in that year, Klimt's manner was still dependent on that of the earlier draughtsmen of Art Nouveau (Pl. 102). One year later, in 1898, when the Sezession started their periodical Ver Sacrum, its pages were decorated in a style strikingly similar to Mackintosh's. As the Studio had published some designs for the Cranston Tearoom in 1897, one can safely conclude that the change of taste in the artists of the Sezession was at least partly caused by impressions received from Mackintosh's work. 18 This hypothesis is confirmed by the fact that in 1900 the Sezession in Vienna chose to invite Mackintosh and his group to show work at their annual exhibition in Vienna, and in 1901, as a result of this, Mackintosh furnished and decorated the Music Room for Fritz Wärndorfer who, two years later, gave the money for the foundation of the Wiener Werkstätte. The motifs of the music room were, incidentally, taken from Maeterlinck's Sept Princesses. What was so thrilling to the artists of Vienna in Mackintosh's style has been formulated very well by Ahlers-Hestermann: 'Here was indeed the oddest mixture of puritanically severe forms designed for use, with a truly lyrical evaporation of all interest in usefulness. These rooms were like

dreams, narrow panels, grey silk, very very slender wooden shafts verticals everywhere. Little cupboards of rectangular shape and with far projecting top cornices, smooth, not of visible frame-and-panel construction; straight, white, and serious-looking, as if they were young girls ready to go to their first Holy Communion - and yet not really; for somewhere there was a piece of decoration like a gem, never interfering with the contour, lines of hesitant elegance, like a faint distant echo of van de Velde. The fascination of these proportions, the aristocratically effortless certainty with which an ornament of enamel, coloured glass, semi-precious stone, beaten metal was placed, fascinated the artists of Vienna who were already a little bored with the eternal solid goodness of English interiors. Here was mysticism and asceticism, though by no means in a Christian sense, but with much of a scent of heliotrope, with well-manicured hands and a delicate sensuousness. . . . As against the former overcrowding, there was hardly anything in these rooms, except that, say, two straight chairs, with backs as tall as a man, stood on a white carpet and looked silently and spectrally at each other across a little table . . . "Chambres garnies pour belles âmes" is what Meier-Graefe wrote.'

Ideal evidence of these intentions was the house which Mackintosh designed for a competition held by the German publisher Koch in 1901 (Pl. 103). Here everything can be seen that Ahlers-Hestermann is talking about and it can also be seen clearly enough that Mackintosh's sources are Voysey, Beardsley, Toorop. 19 This synthesis of their style was the legacy of Britain to the coming Modern Movement. No other British contribution to European architecture before the First World War carries enough weight to be discussed here. 20 For various reasons England forfeited her leadership in the shaping of the new style just about 1900, that is, at the very moment when the work of all the pioneers began to converge into one universal movement. One reason was given in Chapter 1:21 the levelling tendency of the coming mass movement and a true architectural style is for every man - was too much against the grain of the English character. A similar antipathy prevented the ruthless scrapping of traditions which was essential to the achievement of a style fitting our century. So, at the very moment when Continental architects discovered the elements of a genuine style for the future in English building and English crafts, England herself receded into an eclectic Neo-Classicism, with hardly any bearing on present-day problems and needs. For country houses and town houses Neo-Georgian or Neo-Colonial became popular; in public buildings, banks and so on, solemn rows of colossal columns reappeared, not entirely free from the influence of the United States, where, after the Chicago Exhibition of 1893, a similar reaction against the Chicago school and Sullivan had set in. Burnham's Selfridge Building of 1908 in London illustrates this tendency at its most demonstrative.

The contention that the sudden fall in the European importance of English architecture really took place shortly after 1900 is also confirmed by the development of town planning. England was ahead during the second half of the nineteenth century. From the forties the beginnings of modern planning of flats and small houses for workmen can be traced. ²² The first planned estates of small houses were due to progressive manufacturers (Saltaire, Sir Titus Salt, begun in 1851). ²³ The earliest estate of friendly, semi-detached brick houses embedded in trees was erected at Bedford Park near London to Norman Shaw's designs from 1875 onwards. Shortly after Bedford Park, Port Sunlight and Bournville were started, both garden estates for members of the staff of a big firm. Port Sunlight was built for Lever's from 1888 on, Bournville for Cadbury's from 1895 on.

The idea of the independent garden city was put forward by Ebenezer Howard in his famous book *Tomorrow: a Peaceful Path to Real Reform* (1898). It was taken up by the founders of Letchworth. The plan of this garden city (begun in 1904) was due to Raymond Unwin and Barry Parker. The same architects were responsible for the layout of the Hampstead Garden Suburb (1907).

These English estates strongly influenced the Continent. Krupp's started its first workers' estate in 1891. The first independent garden city in Germany, Hellerau, near Dresden, was begun in 1909, on the initiative of the Deutsche Werkstätten. The plan was by Riemerschmid. However, in Germany the main interest soon shifted over from the question of the estate of small houses to that of large housing schemes

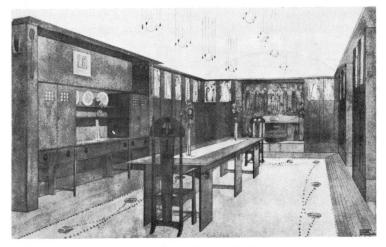

103. Mackintosh: Dining-room for the House of a Connoisseur, 1901.

consisting of blocks of flats. It is this problem and the related one of planning whole urban areas that occupied the minds of German town planners between 1900 and the First World War.

The history of town planning from 1850 to 1914 runs strikingly parallel to that of contemporary architecture and decoration. Of the two biggest tasks that were put to architects during the third quarter of the century, the Viennese Ringstrasse is a gorgeous chain of individual buildings entirely or almost entirely unrelated to each other, whereas Haussmann's memorable opening up of large boulevards all through the centre of Paris is certainly much more architectural in that spatial values are not neglected for those of volume. However, in Paris as well as in Vienna, the social questions of slum clearance and rehousing remained untouched, and the same may be said of all town planning in other European and American cities. Neither did the new tendencies which started about 1890 help to solve these urgent problems. Burnham in Chicago began the movement for the erection of monumental Civic Centres in the United States, a movement that conquered England after 1900. In Germany, Camillo Sitte's book Der Städtebau (1889) pleaded against the hollow grandeur of Neo-Baroque squares and roads, and

proposed a freer, more picturesque planning on medieval lines. Both Sitte and Burnham still thought in terms of individual pieces of planned development.

It has been shown that the interpretation of town planning not only as a display of civic power but as planning for the welfare and comfort of the whole population originated in England and remained confined to England for well over a decade. But, as soon as planning was applied to areas larger than the garden estate of a firm, municipal initiative had to replace private enterprise. It is extremely characteristic that directly this stage was reached, England dropped out and Germany took the lead. Most German towns own a great deal of the building land within their boundaries and - helped by legislation - try to acquire more. Theodor Fischer, one of the most energetic young architects, was elected city architect for Munich in the nineties; the periodical Der Städtebau began to appear in 1904; towns such as Nürnberg, Ulm, Mannheim, Frankfurt, worked out comprehensive schemes for the development of centre and suburbs. The town-planning exhibition held at Berlin in 1910 can be taken as the final summing-up of these tendencies as they flourished before the First World War.²⁴

Since 1918, the huge housing estates set up above all in Holland, Germany, and Austria have done more than any other type of building to draw the attention of other countries to the existence of a modern architectural style. In England it was hardly before 1930 that working-class estates of blocks of flats began to take an interest in the twentieth-century style, the style which, between 1900 and 1925, had been developed by American, French, and German architects.

7 · The Modern Movement before Nineteen-fourteen

THE most progressive countries in the fifteen years before the First World War were the United States, France, Germany, and Austria. At first, America took the lead; but no accepted style was evolved. The initiative was confined to a few great architects, one might even say to one man. In France, one side of the coming style was developed with admirable consistency, but again only by one small group of engineer-architects. Germany alone, and those Central European countries which were dependent on Germany (Switzerland, Austria, Scandinavia) responded so appreciatively to the adventurous achievements of the first pioneers that the recognized accepted style of our age could emerge from their individual experiments.

The contribution of France to the Modern Movement before the war consists exclusively in the work of two architects: Auguste Perret and Tony Garnier. Perret was born in 1874, Garnier in 1869. Their foremost distinction is that they were the first to use concrete outside and inside their buildings without concealing the material and its particular character and without adapting it to the spirit of past styles. In this, they went beyond Baudot, whose forms at St Jean de Montmartre, though not actually copied from Gothic architecture, tend to express through the medium of concrete the feelings enshrined in the medieval cathedral. In Perret's work, there is no such irresolution. The block of flats at No. 25 bis rue Franklin, which he built in 1902–3, and in which he lived himself, is equally uncompromising in ground plan and façade (Pl. 104). It is eight storeys high and constructed with a concrete framework. The two uppermost floors recede in the manner which has become compulsory in high American buildings, and is becoming more and

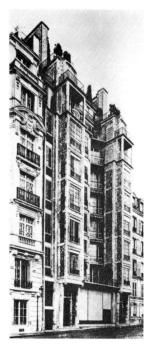

104. Perret: Block of flats, 25 bis rue Franklin, Paris, 1902-3.

more accepted in Europe too. On top is an open terrace with a few plants, a forecast of roof gardens to come. The façade exhibits the structure to a degree unprecedented in domestic architecture. Though the infilling panels are of ceramic ware with foliage decoration in relief, the eye is not detained by them, but follows the vertical and horizontal girders and beams all along the front. A nakedness appears that seemed shameless at the time when the house was built. Especially important for the future is the complexity of advance and recession, the fullness of spatial effects. It is hardly possible to decide which of the various vertical planes may be termed the façade proper. Above the two entrance doors a column of square bay-windows is projected. Six storeys thus seem balanced without any support. In the centre part, the façade recedes, but right in the middle another row of bay-windows projects slightly. Mackintosh alone of all European architects had a spatial imagination of comparable brilliance.

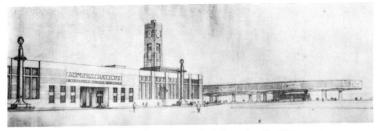

105. Garnier: Industrial City, 1901-4. Administration Building.

106. Garnier: Industrial City, 1901-4. Under the canopy, Administration Building.

Equally revolutionary is the style of Tony Garnier's plans for an Industrial City made in 1901 and exhibited in 1904.² Garnier (1869–1948) was a Pensionnaire de l'Académie de France in Rome, when he embarked upon the task of mapping out a modern city as it ought to be. It was a demonstration against all academism in the choice of subject, in its treatment, and in the introductory remarks which accompanied its presentation. 'Like all architecture based on false principles', Garnier had the audacity to write, 'ancient architecture is an error. Truth alone is beautiful. In architecture, truth is the result of calculations made to satisfy known necessities with known materials.' So, in

107. Garnier: Industrial City, 1901-4. Railway Station.

his chosen field of town planning he pleaded for a linear as against a concentric plan for his town, for a sensible grouping of industry, administration, and housing, and for sufficient open spaces; he enjoyed flat roofs, open and covered playgrounds for schools, and he refused to admit any narrow inner courts. Moreover there are certain buildings in the Industrial City which appear to be wholly of today. For the first time here the possibility of 'misdating' arises. In the Administration Building (Pls. 105 and 106), the flat roofs, the complete absence of mouldings, and above all the long canopy on the right with its few supports and its bold cantilevering - all this seems hardly possible at such an early date. Again in the Railway Station (Pl. 107) the transparent concrete tower and the unrelieved grid of the front and the cantilevered canopies on the slenderest supports are entirely of the twentieth century.4 So is the Cubism of the small houses (Pl. 108) and their placing in a street with freely grouped trees and patches of lawn (Pl. 109). The combination of cubic wings with a domed centre of highly unconventional shape (Pl. 110) is as surprising as the glass vault over the Palm Court of a hotel (Pl. 111). The material of this looks just like the glass

108. Garnier: Industrial City, 1901-4. Four private houses.

bricks which became so popular in the 1920s and 1930s. Equally popular was the newel staircase displaying its spiral on the outside, and that also is anticipated in the Industrial City, where a staircase tower, half looking back to Blois, half looking forward to 1914 and after, forms the centre of a block of one-room flats.

Technically the most interesting feature in Garnier's designs for the Industrial City is the cantilever for the administrative building. It implies an understanding of the possibilities of reinforced concrete which was still rare by 1904. Historians of engineering ought to pronounce on this point. Perret in the rue Franklin and to the end of his days used concrete in the post and lintel manner developed in stone building. The first, it is always said, fully to appreciate the combined advantages of reinforced concrete both under compression and under tension was the Swiss engineer Robert Maillart (1872–1940)⁵ a pupil of Hennebique. In his Tavenasa Bridge of 1905 the arch and the roadway are one structural unity (Pl.112). The slabs of which they consist, one curved, the other straight, are active structural elements. The same principle was applied by Maillart to the construction of buildings by

means of mushroom pillars merging with the ceiling slab above. His experiments showed their first results in 1908, the year in which the American engineer C.A.P. Turner published a paper in the Western Architect on the same technique evolved by himself. In 1910 Maillart built his first warehouse in this new 'monolithic' method.

Here, in Maillart's bridges, and in that mysterious cantilever of Garnier's drawing one becomes for the first time aware of completely new aesthetic potentialities lying in store for the twentieth century. France was not the country in which they were going to be developed. In fact France at this moment can disappear from our stage. Between 1904 and 1921, the year of Le Corbusier's Citrohan designs, she did not contribute anything of international significance. Le Corbusier⁶ (born in 1887) is Swiss, but has spent nearly his whole working life in Paris. If his work before 1921 is not considered in this book, the reason is that he cannot be considered in the same category of pioneers as the architects to whom it is devoted, though he has tried in his writings to make himself appear one of the first-comers. His designs for an estate called Domino, which was to be built entirely in concrete, are certainly very progressive, and they date from 1915; but in 1916 Le Corbusier could still build a private house that does not go beyond the stage reached by Perret or van de Velde before the war.7

Frank Lloyd Wright's own writings are almost as misleading as Le Corbusier's, but in his case the pioneer achievements of his early years are patent and easily documented. And Wright was not only one of our pioneers himself, but also pupil and follower of a pioneer. Of Sullivan much has already been said regarding his revolutionary theory (p. 28), his revolutionary ornament (p. 97), and his revolutionary treatment of the skyscraper in its earlier years (p. 141). His most astonishing aesthetic achievement, however, is the Schlesinger & Mayer, now Carson Pirie Scott, Store, in Chicago (Pl. 113). This was begun in 1899 in Madison Street and enlarged by a taller block round the corner into State Street in 1903–4. The ornament on the ground floor and second floor is Sullivan at his most fanciful, but the upper storeys exhibit the rhythm of the twentieth century more uncompromisingly than any building we have met so far in these pages. Here again, a detail photograph of several rows

109. Garnier: Industrial City, 1901-4. Street.

110. Garnier: Industrial City, 1901-4. Theatre.

111 Garnier: Industrial City, 1901-4. Palm Court.

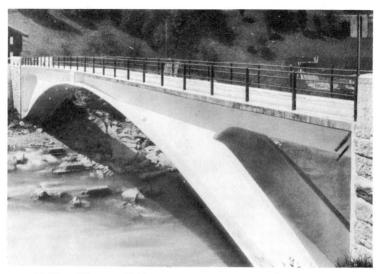

112. Maillart: Tavenasa Bridge, 1905.

of these horizontal windows with the unbroken white bands which separate them horizontally would no doubt be misdated by nearly everybody.

Meanwhile, Frank Lloyd Wright had begun to revolutionize the private house with similar courage. His inspiration came from Richardson's houses and from the forms and approach to architecture which he learned in Sullivan's office. The Charnley House in Astor Street, Chicago, of 1891 (Pl. 114), seems both to reflect Sullivan's style in the Wainwright Building and to foretell Wright's own later development. It can therefore be safely assumed that it represents Wright's fairly independent designing during the years when he was still employed by Sullivan. In date and originality it corresponds to the Mary Ward Settlement.

Two years later the Winslow House at River Forest (Pl. 115) has the same sense of broad flat surfaces and the same consistent emphasis on horizontals. It still possesses an upper floor decorated in the Sullivan manner and nothing yet of Wright's future mastery of spatial planning. Compared with Voysey at Colwall in the same year 1893, it is clear that

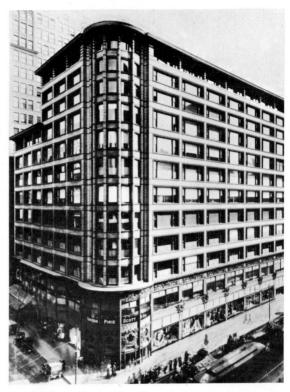

113. Sullivan: Carson Pirie Scott Store, Chicago, 1899 and 1903-4.

Wright was moving away from precedent, Voysey towards a compromise between the past and the present.

Wright's sense of three-dimensional composition leaped to maturity about 1900. The projected Yahara Boat Club at Madison of 1902 (Pl.116) shows far projecting canopies over the two doors and far stretching-out terraces in front of them taking some outer space close to the body of a house which is however still strictly symmetrical in its shape. The windows, high up and low, are now entirely of the characteristic rhythm of the twentieth-century style.

Another three years and the W.R. Heath House at Buffalo (Pl. 117)

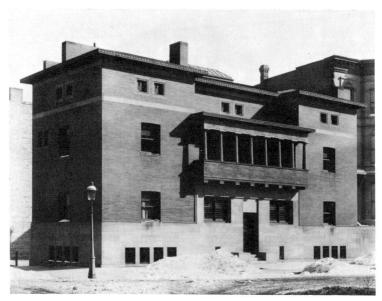

114. Sullivan and Wright: Charnley House, Chicago, 1891.

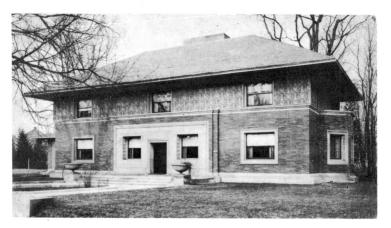

115. Wright: Winslow House, River Forest, Illinois, 1893.

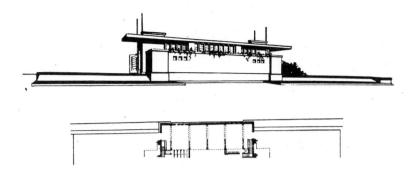

116. Wright: Project for the Yahara Boat Club, Madison, Wisconsin, 1902.

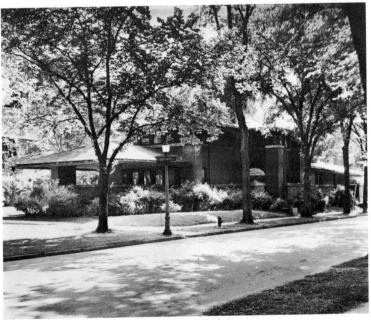

117. Wright: Heath House, Buffalo, New York, 1905.

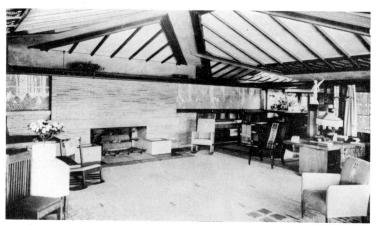

118. Wright: Coonley House, Riverside, Illinois, 1908. Interior.

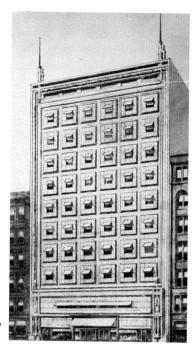

119. Wright: Design for a skyscraper, 1895.

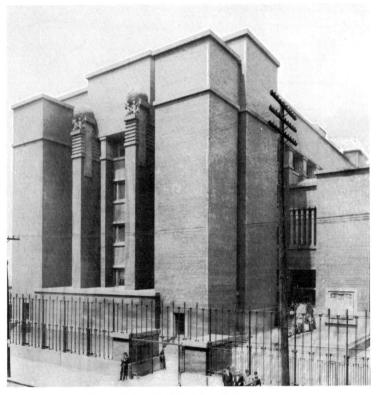

120. Wright: Larkin Building, Buffalo, New York, 1904.

has a plan spreading out loosely into a conglomeration of rooms which run comfortably into each other, and an outline of the broad, free, informal, prairie type of which Wright was so fond. There is no longer any hard boundary between outer and inner space. The low spacious interiors (Pl. 118) have something irresistibly inviting, in spite of Wright's never abating desire for harsh angular decorative forms – forms similar to those of Berlage in Europe. No wonder that the Dutch were the first to take kindly to Wright's peculiar style when it had been made known abroad by two German publications of 1910 and 1911. 10

The same difference between early and mature as that between the

Winslow and Heath Houses is to be found between a design for a sky-scraper done in 1895 and the Larkin Building at Buffalo of 1904 (Pls. 119 and 120). The skyscraper is again a personal paraphrase of Sullivan ideas; the Larkin Building, with its sheer walls of flat bricks unrelieved by windows or niches or mouldings, and with its string courses and cornices of the simplest rectangular profile, is over-whelmingly impressive, in the hard way of today. The interior with its spatial unity of all floors (Pl. 121), the 'etherealization' of which Wright is so fond (see p. 214) may be derived from the European department store. In Wright's particular form it became the prototype of many similar halls in European office buildings after the First World War.

To sum up, Frank Lloyd Wright's outstanding importance lies in

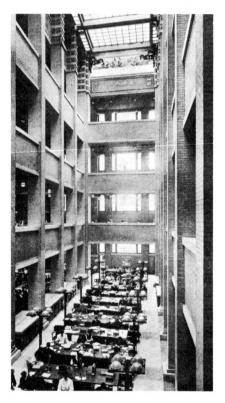

121. Wright: Larkin Building, Buffalo, New York, 1904. Interior.

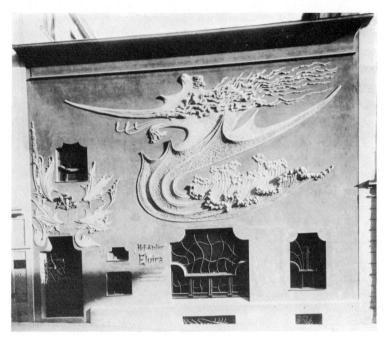

122. Endell: Elvira Studio, Munich, 1897-8.

the fact that nobody else had by 1904 come so near to the style of today in his actual buildings. Wright's later activity does not lie within the scope of this book, and, as the work of his contemporaries and followers before 1914 has not added anything essential beyond the master's own pronouncements, no more need be said here about the United States.

Thus the remaining pages can be devoted entirely to Germany and Austria, with one Swiss and one Italian exception. While the transition to the new simplicity and severity was facilitated in England by the absence of Art Nouveau and by an inborn English reasonableness, in America by the technical requirements of the huge office building, and in France by the splendid traditions of nineteenth-century engineering, Germany was, in 1900, almost completely under the spell of Art Nouveau, enjoying wild ornamentation, as she had done so often in past centuries. Only a few among those who had played a leading part

in the Jugendstil found a way out of its entanglement. Three artists above all must be mentioned, as a German parallel to Mackintosh in Great Britain.

August Endell's (1871-1925) most popular work was the Elvira Studio in Munich, built for a photographer in 1897-8 (Pl. 122). The deliberate lack of balance between openings and plain wall, or basement windows and ground-floor windows, and also the curves of the metal bars separating the window-panes, had affinities with Guimard in Paris, with Gaudí at Barcelona, and Mackintosh in Glasgow. However, the one dominant motif of the façade, that overpowering shape, shelllike or dragon-like, which covered the wall of the second floor, is entirely original. In this frantic outbreak of ornamental fury, the unbounded exuberance of Germanic patterns of the migration period re-emerged. This eternal quality of German art, traceable in Late Romanesque and Late Gothic as well as in the ornament of Baroque and Rococo, gives Endell his place in architecture; though it seems highly probable that Obrist's embroideries provided him with more direct inspiration. Be that as it may, the Elvira Studio remains an admirable tour de force, and one could rightly expect more surprises from its inventor.

In the same year, when the front of the studio building was revealed, Endell published a study on the emotional meaning of certain basic proportions in building, which is equally original and inspiring. 11 The text to the illustration shown here (Pl. 123) describes the quiet balance of Fig. 4, the strain of Fig. 2, a certain ease and comfortableness in Fig. 3. Apart from this interesting attempt at an interpretation of architecture as an abstract art, the forms of the façade shown in Fig. 3 are astonishingly similar to those of certain German houses after the First World War. The shape of the first-floor windows and the flat roof are again almost 'misdatable'.

A similar ambivalence appears in the work of the much older Viennese architect Otto Wagner (1841–1918) and then of his pupil Josef Maria Olbrich (1867–1908). Wagner, by his age, stood closer to Shaw and McKim, Mead, & White than to Wright, Perret, and Garnier. He began indeed with the conventional Neo-Baroque and turned, as Shaw and

123. Endell: Studies in basic building proportions, 1898.

McKim, Mead, & White did, to soberer forms of Neo-Classicism. His remarkably progressive Inaugural Lecture quoted in Chapter 1 dates from 1894. After that date, that is when he was well over fifty, he changed his style fundamentally, stimulated perhaps by his own pupil. This at least the dates of the buildings seem to indicate. Olbrich¹² made his name with the building for the Sezession, the group of artists which he, together with Klimt and others, founded and which developed the Austrian version of Art Nouveau, and later on led the way from linear decoration towards the more architectural though equally graceful style of the Wiener Werkstätte. 13 The building of the Sezession (Pl. 124) was designed and erected in 1898-9. There is no need here to say much about the Jugendstil qualities of this metal cupola with its superabundant floral decoration. A more essential point in our context is the simplicity of its semicircular contour and the rhythm of the three blocks which dominate the front view. This is in fact as novel as anything to be found in Wright's work of the same period. 14 In 1907-8,

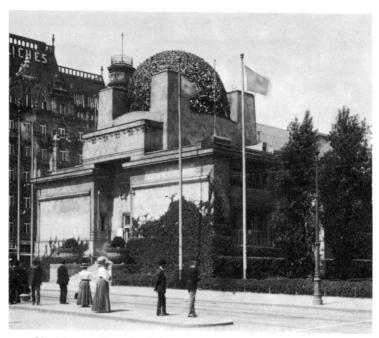

124. Olbrich: The Sezession, Vienna, 1898-9.

Olbrich built the Hochzeitsturm (Pl.125) as a centre of the artists' colony which the Grand Duke of Hessen had started in 1899 (cf. p. 230 n. 31). Again a comparison with Mackintosh, this time with the library wing of the Glasgow School of Art, seems justified. The conspicuous five organ-pipe shapes on top of the tower are characteristic of the restlessness of many of those who wanted to break away from Art Nouveau, but felt unable to make an altogether clean break. The most remarkable feature from the point of view of today is the two narrow horizontal strips with small windows which are wrapped round the corner, the earliest instance probably of this motif, so much favoured by later architects.

In reviewing the work of the second leader of Viennese architecture at the beginning of the twentieth century, we are led one step further. The most remarkable of Josef Hoffmann's (1870–1955)¹⁵ early works

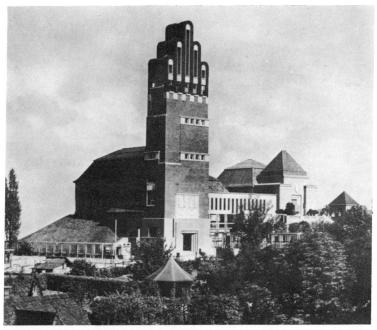

125. Olbrich: Hochzeitsturm, Darmstadt, 1907-8.

is also the most 'modern', the Convalescent Home in Purkersdorf of 1903-4 (Pl. 126). Here again, even experts might be deceived and might take these flat roofs, these windows without any mouldings, the squareness of this projecting roof over the entrance, and the high, upright staircase window as something impossible before the First World War. International as these motifs are, local peculiarities are all the same clearly visible in the rhythm of the small window-panes and the delicate bands running round the windows and along the edges of the block. Josef Hoffmann's magnum opus however is without any doubt the Palais Stoclet in Brussels (Pl. 127), designed in 1905. Its unusual size and splendour have overshadowed all his other works. The Palais Stoclet is a work of exceedingly spirited composition, its exquisitely spaced openings and light walls are a joy to the eye, and the high uninterrupted window of the staircase is again present; but the artistic

126. Hoffmann: Convalescent Home, Purkersdorf, 1903-4.

attitude is here far from sachlich (rightly, no doubt): a charm and play-fulness are expressed in these façades which are alien to most of the outstanding buildings in the new style, though they are essentially Austrian in character. In acknowledging the international unity of the new style, it ought not to be forgotten that in Hoffmann's elegance, in Perret's clarity, in Wright's expansive broadness and comfortable solidity, or in Gropius's uncompromising directness, national qualities are represented at their best.

But the art historian has to watch personal as well as national qualities. Only the interaction of these with an age produces the complete picture

127. Hoffmann: Palais Stoclet, Brussels, 1905.

of the art of an epoch, as we see it. Rubens, Bernini, Rembrandt, Vermeer are all representatives of their age, the age of Baroque. Yet Rubens is as wholly a Fleming as Bernini is a Neapolitan and Rembrandt and Vermeer are Dutchmen. But Rembrandt as a personality is completely opposed to Vermeer, when one compares them within the smaller orbit of their national art. So it may be profitable to contrast Hoffmann's delightful building with the work of Adolf Loos¹⁶ (1870-1933), so completely opposed in character, though Loos was also an Austrian. His position in the development of aesthetic theory about 1900 has already been outlined. Now we have to define his place in architectural history proper. Remembering his attacks on ornament and his panegyrics upon the plumber, we are not surprised to find in his first work, the interior of a shop in Vienna, 1898 (Pl. 128), nothing that can, strictly speaking, be called ornament. The value of this work depends entirely on the high quality of the materials used and the dignity of the proportions. The decorative effect of the upper frieze is obtained by the introduction of convex curves and a quicker rhythm of intersecting verticals and horizontals. Perret's concrete ornament, created without any knowledge of Loos's style, is surprisingly similar in character.

Six years later, in a house on the Lake of Geneva, Loos reached the

128. Loos: Shop interior, Vienna, 1898.

same delicately proportioned simplicity in an exterior, and six years after that, in the Steiner House in Vienna (Pl. 129), he achieved the style of 1930 completely and without any limitation. The unmitigated contrast of receding centre and projecting wings, the unbroken line of the roofs, the small openings in the attic, the horizontal windows with their large undivided panes: who, without being informed, would not misdate these features? Loos's influence, in spite of such wholly uncompromising designs, remained negligible for a long time. All the other pioneers were more widely known and imitated.

That Otto Wagner, although over sixty years old, was freshly stimulated by these young pupils or followers of his, seems almost certain in his Post Office Savings Bank in Vienna (Pl. 130), the most surprising building of his. It dates from 1905, and its crisp, glass-vaulted banking hall is the first full realization of his own preaching of ten years earlier.

129. Loos: Steiner House, Vienna, 1910.

Historically speaking, it is as free of period inspiration on the one hand and of Art Nouveau on the other as any contemporary buildings of Hoffmann and Loos in Austria, of Wright in America, and of Garnier and Perret in France.

In Germany the most important architect during those years was Peter Behrens¹⁸ (1868–1940). Characteristically of the situation about 1900, he began as a painter and underwent the 'moral' reformation towards the applied arts, before he trained as an architect. The applied arts, when Behrens started, meant Art Nouveau. He soon escaped from its enervating atmosphere. His first building, his own house in Darmstadt (1901), already shows a hardening of the tender curves of Art Nouveau. ¹⁹ In the same year, Behrens designed a type face in which the change is complete. The curves are straightened, and ornamental initials are decorated with squares and circles only. A comparison

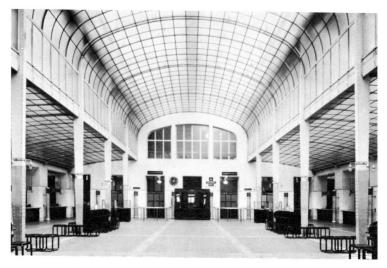

130. Wagner: Post Office Savings Bank, Vienna, 1905.

between Behrens's first type face and Eckmann's (1900) is historically very instructive. ²⁰ Again this new simplicity was brought about under English influence. The Doves Press stands at the beginning of German twentieth-century printing. Honesty and saneness became the ideals that replaced the sultry dreams of Art Nouveau aesthetics.

Behrens was not alone in this revulsion from Art Nouveau. Its earliest witness in Germany seems to be the flat designed by R.A. Schröder (1878–1962), a poet and decorator and a founder of the Insel Verlag, for his cousin Alfred Walter von Heymel (1878–1914), also a poet and also a founder of the Insel Verlag. The flat was in Berlin and dates from 1899 (Pl. 131). ²¹ Here for the first time – even if perhaps not without some inspiration from the hieratic stiffness of some Mackintosh furniture – are chairs without curves, and walls, ceilings, and fireplaces divided into simple rectangular geometric patterns.

In Behrens's buildings from 1904 onwards the same new somewhat classicist spirit is expressed in the exteriors. Take for instance the Art Building at an exhibition held at Oldenburg in 1905 (Pl. 132) and compare it with Olbrich's Sezession. In Behrens's design the florid cupola

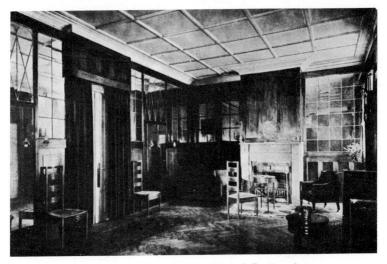

131. Schröder: Apartment for A. W. von Heymel, Berlin, 1899.

and the curved cornice have disappeared. The centrepiece and the outer pavilions have roofs of pyramidal form – a motif incidentally taken over by Olbrich in his exhibition buildings at Darmstadt in 1907–8 (Pl. 125) – the rest of the building has flat roofs. Walls without windows are decorated with delicate lines forming oblong panels and squares. The porch has been left completely bare, just two square posts and a square lintel. ²²

This indicates the direction in which Behrens was to develop during the years that followed. His principal buildings before the war he designed for the AEG, one of the big German electrical combines, of which the managing director, P. Jordan, had appointed him architect and adviser. In 1909 the turbine factory was built, perhaps the most beautiful industrial building ever erected up to that time (Pl. 133). The steel frame is clearly exhibited; wide, perfectly spaced glass panes replace the walls on the side and in the middle of the ends; and if the corners are still expressed by heavy stone with banded rustication and rounded at the angles, the metal frame projecting its sharp corners above these stone pylons redresses the balance boldly and effectively. This design

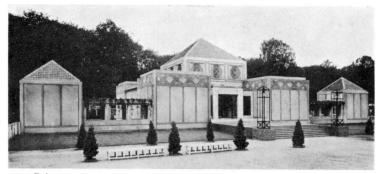

132. Behrens: Art Building, Oldenburg Exhibition, 1905.

has nothing in common with the ordinary factories of that time, not even the most functional American ones of Albert Kahn with their exposed steel frames. Here for the first time the imaginative possibilities of industrial architecture were visualized. The result is a pure work of architecture, so finely balanced that the huge dimensions are scarcely realized, unless one looks at the people in the street for comparison. The two-storeyed aisle on the left has the flat roof and the row of windows which we find in all the most advanced works of that time.

The factory for the production of small electric motors was built in 1911 (Pl. 134). The proportions of that part of the building which is to be seen on the left, its rows of rather narrow high windows without any mouldings, are reminiscent of the factory of 1909 and more reminiscent of Schinkel's, than of Hoffmann's or Loos's favourite proportions. The same strength and noble vigour are expressed in the composition of the main block with its round-fronted pillars and recessed windows.

And while Behrens was employed on such monumental tasks, he managed to spend the same amount of care and thought on improvements in the design of small things for everyday use and larger things of so utilitarian a kind that they had never before been regarded as works of art at all. An example of the first is the excellent tea-kettle brought out in 1910 (Pl. 135), an example of the second the street lamps of 1907–8 (Pl. 136). They show the same purity of form, the same sobriety in

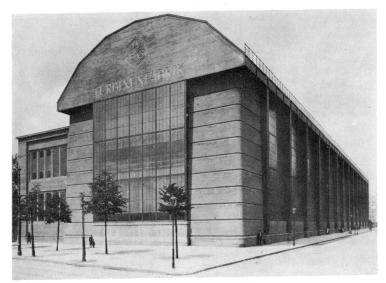

133. Behrens: Turbine factory, Huttenstrasse, Berlin, 1909.

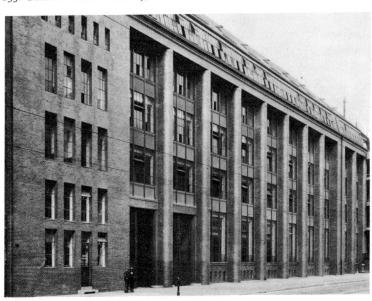

134. Behrens: Factory, Voltastrasse, Berlin, 1911.

limiting the design to simple geometrical forms, and the same beauty of proportion which delight us in Behrens's buildings.

The solidarity of the Deutscher Werkbund with this attitude of Behrens's is a matter of course. It has already been reported that the Werkbund was founded in 1907. Behrens had become adviser to the AEG in the same year. One year earlier the Deutsche Werkstätten, as we have also seen before, had shown their first machine-made furniture at an exhibition in Dresden. By the time the Werkbund brought out its first Annual, that is by 1912, they could without effort show well over a hundred illustrations of works of industrial design as well as architecture in the style of which they approved. Both the Deutsche Werkstätten and the AEG appeared in its pages, and Riemerschmid, and Josef Hoffmann, and also Gropius. But before passing on to Gropius's work. a few words must be said about some early buildings by two or three other German architects. Ludwig Mies van der Rohe²³ was born in 1886, Hans Poelzig²⁴ in 1869 (he died in 1948), Max Berg in 1870. Max Berg (1870-1947) in his Jahrhunderthalle at Breslau in 1910-12 (Pl. 137) did with reinforced concrete what Behrens had done with steel framing. He created a noble monumentality without concealing the boldness of his structure. The Jahrhunderthalle covered an area of nearly 21,000 square feet with a weight of 4200 tons, whereas for instance the dome of St Peter's in Rome has an area of 5250 square feet and needs a weight of about 10,000 tons to cover it. Moreover, the supports have an elegance of span and curvature heralding the achievements of Pier Luigi Nervi after the Second World War.

Mies van der Rohe and Poelzig represent two opposite modes of self-expression in terms of the twentieth-century style. Mies van der Rohe's design of 1912 for the house of Mrs Kröller-Müller (Pl. 138) is evidently derived from Behrens, but also, though perhaps less evidently, from Schinkel, who has had to be mentioned in these pages more than once before, and who was just then being rediscovered and reappreciated.²⁵ From him come Mies's sparseness and extreme precision, from him and Behrens his sense of cubic relations.

Mies's Kröller House has a permanence even in the drawing and a convincing monumentality which makes Poelzig's office building in

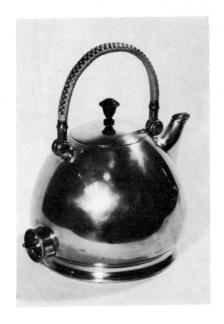

135. Behrens: Electric tea-kettle for the AEG, 1910.

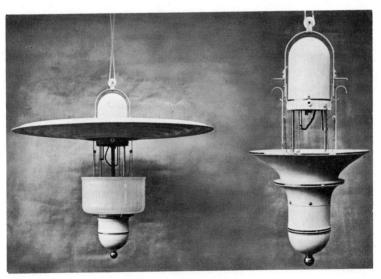

136. Behrens: Street lamps for the AEG, 1907-8.

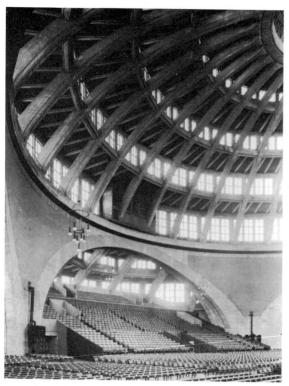

137. Berg: Centenary Hall, Breslau, 1910-12.

Breslau of 1911 (Pl. 139) look as if it were surging ponderously towards us. These thick bands curving round the corner are of great dynamic power, in spite of their somewhat elephantine detail, and a very personal statement. And although Poelzig's next building of importance, a chemical factory at Luban in Silesia (Pl. 140), designed in 1911, is much more elegant and refined, its contrast of semicircular and strangely spaced small square windows is again personal to the verge of caprice.

The inventiveness and the vein of fantasy in these buildings made Poelzig the leader of German architectural Expressionism in the first years after the First World War, when this riotous style culminated in

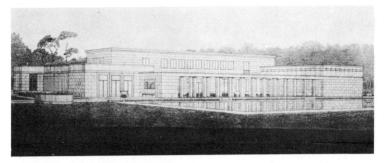

138. Mies van der Rohe: Design for a house for Mrs Kröller-Müller, 1912.

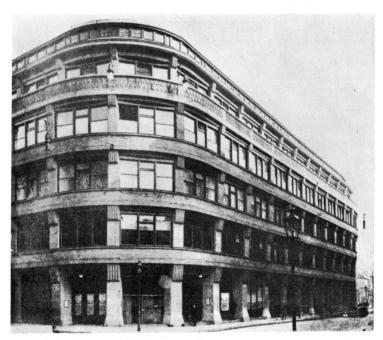

139. Poelzig: Office building, Breslau, 1911.

painting and sculpture as well as in architecture. His Grosses Schauspielhaus dates from 1919. It was in the same years that Erich Mendelsohn (1887–1953) took up the motif of the curved façade and the bands of windows sweeping round corners and made them into an effective tool of Expressionism. The motif dominates his Einstein Tower of 1921 and in a more rational treatment his somewhat later designs for stores. It became one of the most popular motifs of the years between the First and Second World Wars and can be made responsible for much of that functionally unjustified but emotionally justifiable bogus streamlining which went on in refrigerators, prams, and many other industrially produced objects.

The Modern Movement in architecture, in order to be fully expressive of the twentieth century, had to possess both qualities, the faith in science and technology, in social science and rational planning, and the romantic faith in speed and the roar of machines. We have seen in Chapter 1 how the one set of values was appreciated by Muthesius, the Werkbund, and finally Gropius's Bauhaus, the other by the Italian Futurists and by Sant'Elia, their architectural precursor rather than representative. It is the same in architecture. Sant'Elia's drawings and Gropius's first buildings stand for the two interpretations of the new metropolitan, technological civilization of the twentieth century. A decision had to be taken between the two, as soon as the First World War was over, and a decision has still or again to be taken now.

The structures on Sant'Elia's drawings which are not precisely datable but must belong to the years 1912–14 or 1913–14 (Pls. 141, 142, 143) are immensely impressive. They mean factories, power stations, railway stations, skyscrapers along two- or more-level roads. The sweep of the architect's pen, the sweep of the sheer verticals or the closely banded curved fronts of towers, all this is highly original, highly inventive, and heady with the passion for the great city and its machine-propelled traffic. The source of the forms is no doubt the Vienna of the Sezession; the only parallels in reality are Poelzig's office building of 1911 and Mendelsohn's drawings of the same years. A connexion between Sant'Elia and Mendelsohn seems at least probable.

How Sant'Elia, who died when he was no more than twenty-nine

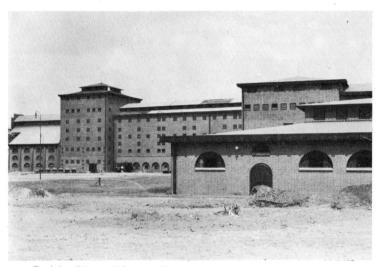

140. Poelzig: Chemical factory, Luban, 1911-12.

years old, would have coped with real buildings, we do not know. Nor do those built in later years by Mario Chiattone (died 1957), his only Italian fellow-architect and fellow-Futurist of similar ideals, give us a clue. ²⁶ Chiattone's designs of about 1914 (Pl. 144) are as astonishingly prophetic of the twenties as Sant'Elia's, and perhaps a little less Utopian. Sant'Elia in his sketches shows no interest in plans and the precise function of a building. They are sheer Expressionism. His passion for the Great City was no more realistic than Gautier's for metallic architecture or Turner's for steam and speed. From Sant'Elia the way of twentieth-century architecture leads once more to Expressionism, including Le Corbusier's first dream city for three million people (1922).

The real solid achievement had its source not in Sant'Elia, not in Poelzig and Mendelsohn, but in Behrens and his great pupil Walter Gropius (born in 1883). Almost immediately after he had left Behrens's office, in 1911, he was commissioned to build a factory at Alfeld on the Leine (Fagus-Fabrik, Pl. 145). His designs go distinctly beyond those by Behrens for the AEG. Only small details such as the windows on the right of the main block show Behrens's influence. As for the main block

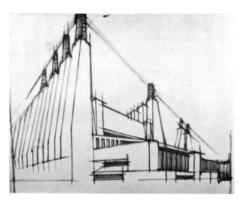

141.

142.

Sant'Elia: Sketches, 1912-14 or 1913-14. 143.

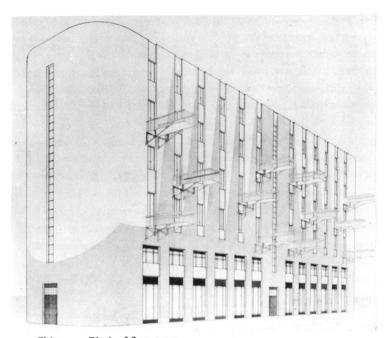

144. Chiattone: Block of flats, 1914.

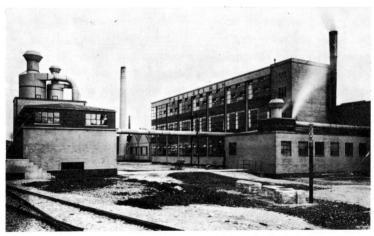

145. Gropius and Meyer: Fagus Factory, Alfeld-on-the-Leine, 1911.

itself, everything is new and full of stimulating ideas. For the first time a complete façade is conceived in glass. The supporting piers are reduced to narrow mullions of brick. The corners are left without any support, a treatment which has since been imitated over and over again. The expression of the flat roof has also changed. Only in the building by Loos which was done one year before the Fagus Factory, have we seen the same feeling for the pure cube. Another exceedingly important quality of Gropius's building is that, thanks to the large expanses of clear glass, the usual hard separation of exterior and interior is annihilated. Light and air can pass freely through the walls so that the closed-in space is no longer different in essence from the great universe of space outside. This 'etherealization' of architecture, as Frank Lloyd Wright had called it in 1901, 27 is one of the most characteristic features of the new style. We have seen it develop in the usual ground plan of late-nineteenth-century office buildings, where the supporting steel girders made all the partition walls easily removable, and then in Wright's ground plans of private houses, in the arrangement of the rooms in Perret's house of 1903, and in Mackintosh's entrancing vistas: and we may recognize its counterpart in the field of planning in the move from the town to a whole province, which was made in Germany immediately after the First World War (Landesplanung, Ruhr District, 1920). Here too it is the conquest of space, the spanning of great distances, the rational co-ordination of heterogeneous functions that fascinates architects. The profound affinity of this passion for planning with the characteristics of the twentieth-century style in architecture and with the eternal concern of Western architecture with the conquest of space is evident. The new style in the form Gropius gave it takes its place in the procession which leads from the Romanesque and the Gothic to the Renaissance of Brunelleschi and Alberti and the Baroque of Borromini and Neumann. The warmth and directness with which ages of craft and a more personal relation between architect and client endowed buildings of the past may have gone for good. The architect, to represent this century of ours, must be colder, cold to keep in command of mechanized production, cold to design for the satisfaction of anonymous clients.

146. Gropius and Meyer: Model Factory, Werkbund Exhibition, Cologne, 1914. North Side.

However, genius will find its own way even in times of overpowering collective energy, even within the medium of this new style of the twentieth century which, because it is a genuine style as opposed to a passing fashion, is universal. For the Werkbund Exhibition of 1914, Gropius built a small model factory. The north side (Pl.146) is his comment on his master's turbine factory of five years before. The reduction of motifs to an absolute minimum and the sweeping simplification of outline are patent. The replacement of Behrens's heavy corner piers by thin metallic lines is specially impressive. Bolder still is the south front (Pl.147) with the superb contrast between the decidedly Wrightian brick centre and the completely glazed corners. In the middle there are only the narrowest slits for the windows and the lowest entrance; at the corner, where according to all standards of the past, a sufficient-looking supporting force should show itself, there is nothing but glass encasing transparently two spiral staircases.

The motif has since been imitated as often as the girderless corner of the Fagus Factory; and it shows that Gropius's personal expression

147. Gropius and Meyer: Model Factory. Werkbund Exhibition, Cologne, 1914. South Side.

by no means lacks grace. There is something sublime in this effortless mastery of material and weight. Never since the Sainte-Chapelle and the choir of Beauvais had the human art of building been so triumphant over matter. Yet the character of the new buildings is entirely un-Gothic,

anti-Gothic. While in the thirteenth century all lines, functional though they were, served the one artistic purpose of pointing heavenwards to a goal beyond this world, and walls were made translucent to carry the transcendental magic of saintly figures rendered in coloured glass, the glass walls are now clear and without mystery, the steel frame is hard, and its expression discourages all other-worldly speculation. It is the creative energy of this world in which we live and work and which we want to master, a world of science and technology, of speed and danger, of hard struggles and no personal security, that is glorified in Gropius's architecture, and as long as this is the world and these are its ambitions and problems, the style of Gropius and the other pioneers will be valid.

The forty years since the First World War called a halt have seen its triumph. Expressionism was a short interlude, following early Gropius and preceding the mature Gropius of the Bauhaus buildings at Dessau, the mature Le Corbusier of the villas of the mid twenties, and the mature Mies van der Rohe of the German exhibition pavilion at Barcelona. We are now in the middle of a second such interlude, the one for which Le Corbusier (with such recent buildings as the pilgrimage chapel of Ronchamp) and the Brazilians are responsible. Like Gaudí between Sullivan and Behrens, Loos and the others of after 1900, like Expressionism between the Fagus and the Bauhaus buildings, so late Le Corbusier and the structural acrobatics of the Brazilians and all those who imitate them or are inspired by them are attempts to satisfy the craving of architects for individual expression, the craving of the public for the surprising and fantastic, and for an escape out of reality into a fairy world. Yet architects as well as clients must know that today's reality, exactly as that of 1914, can find its complete expression only in the style created by the giants of that by now distant past. Society has not changed since, industrialization has expanded, anonymity of the client has not been overcome, anonymity of architectural design has increased. The whims of individual architects, the strokes of genius of others cannot be accepted as an answer to the serious questions which it is the responsibility of the architect to answer. Whether his answer ought to differ from that of the pioneers of 1914, and in what way it ought to differ, it is not for this book to decide.

Notes

1 · Theories of Art from Morris to Gropius

 Ruskin, John. Architecture and Painting. Addenda to Lectures I and II, Library Edition, xii, 1904, p. 83.

Ruskin, John. The Seven Lamps of Architecture, New York, 1849, p. 7. Scott, Sir George Gilbert. Remarks on Secular and Domestic Architecture, London, 1858, p. 221.

- Scott, Sir George Gilbert. Personal and Professional Recollections, London, 1879, pp. 117ff.
- 3. Cf. Mackail, J.W. The Life of William Morris, London, 1899. Reissued in the World's Classics, O.U.P., 1950. Morris's Collected Works were edited by May Morris and published in 1910–15. May Morris added to them two volumes of biography: William Morris, Artist, Writer, Socialist, 1936. Morris's letters were published by P. Henderson, London, 1950. He quotes more literature in his foreword. Recently the pace of work on Morris has quickened, thanks to the foundation of the William Morris Society in London.
- 4. Mackail, op. cit., ii, p. 80.
- 5. The Collected Works of William Morris, London, 1915, xxiii, p. 147.
- 6. Ibid., 1914, xxii, p. 26.
- 7. Mackail, op. cit., ii, p. 99.
- 8. Coll. Works, xxii, p. 42; xxiii, p. 173.
- 9. Ibid., xxii, pp. 47, 50, 58, 73, 80, etc.
- 10. Mackail, op. cit., i, p. 186.
- 11. Coll. Works, xxii, p. 47.
- 12. Mackail, op. cit., ii, p. 106.
- 13. Coll. Works, xxiii, pp. 194, 201.
- 14. Mackail, op. cit., ii, p. 105.
- 15. Ibid., p. 144; i, p. 305.
- 16. Coll. Works, xxii, p. 75.

17. Lethaby, W.R. Philip Webb and His Works, Oxford, 1935, p. 94. One of the first to notice this contradiction was Morris's earliest French follower, Henri Cazalis (1840–1909), who wrote under the pseudonym Jean Lahor. Cf. Lahor, Jean. W. Morris et le mouvement nouveau de l'art décoratif, Geneva, 1897, pp. 41–2.

Walton, T. 'A French disciple of William Morris "Jean Lahor".' Revue de littérature comparée, 1935, pp. 524-35.

- 18. Coll. Works, xxii, pp. 335-6.
- 19. Ibid., pp. 352, 356; xxiii, p. 179.
- Arts and Crafts Exhibition Society. Catalogue of the first exhibition. London, 1888, p. 7.
- The National Association for the Advancement of Art and its Application to Industry. Transactions, Liverpool Meeting, 1888, London, 1888, p. 216.
- 22. Crane, Walter. The Claims of Decorative Art, London, 1892, p. 75.
- 23. Arts and Crafts Exhibition Society. Catalogue of the third exhibition. London, 1890, p. 8.
- 24. Crane, op. cit., p. 6.
- 25. Ibid., pp. 76, 65.
- 26. Cf. Pevsner, Nikolaus. 'William Morris, C.R. Ashbee und das zwanzigste Jahrhundert.' Deutsche Vierteljahrsschrift für Literaturwissenschaft und Geistesgeschichte, xiv, 1936, pp. 536ff., published in a translation in Manchester Review, vii, 1956, pp. 437ff.
- 27. Ashbee, Charles R. A Few Chapters on Workshop Reconstruction and Citizenship, London, 1894, pp. 16, 24.
- Idem. An Endeavour towards the Teachings of J. Ruskin and W. Morris, London, 1901, p. 47.
- 29. Idem. Craftsmanship in Competitive Industry, Campden, Glos., 1908, p. 194.
- 30. Idem. Should We Stop Teaching Art? London, 1911, p. 4; Where the Great City Stands, London, 1917, p. 3.
- 31. Day, Lewis F. Everyday Art: Short Essays on the Arts Not-Fine, London, 1882, pp. 273-4.
- 32. Sedding, John D. Art and Handicraft, London, 1893, pp. 128-9.
- 33. Above all Lethaby; cf. his lectures on Modern German Architecture and on Design and Industry, delivered in 1915: 'Up to twenty years ago there had been a very remarkable development of English art in all kinds. . . . Then . . . there came a timid reaction and the re-emergence of the catalogued "styles" . . . German advances . . . have been founded on the English Arts and Crafts. They saw the essence of our best essays in furniture, glass, textiles, printing, and all the rest. . . . 'Form in Civilization, London, 1922, pp. 46 ff. and 96 ff. Cf. also Ashbee who, in his Should We Stop Teaching Art?, p. 4, says that since about 1900 the growth of the English movement

- 'has been arrested, and its principles are now more consistently and logically studied in Germany and America'.
- 34. Wilde, Oscar. Essays and Lectures, London, 4th ed., 1913, p. 178.
- 35. Wagner, Otto. Moderne Architektur, Vienna, 1896, p. 95.
- 36. Loos, Adolf. Ins Leere gesprochen, 1897-1900, Innsbruck, 1932, p. 18.
- 37. Van de Velde, Henri. Die Renaissance im modernen Kunstgewerbe, Berlin, 1901, p. 23.
- 38. Sullivan, Louis. Kindergarten Chats, New York, 1947. They were first serialized in the Interstate Architect and Builder, 8 February 1901 to 16 February 1902.
- 39. Ibid., p. 187.
- 40. Op. cit., p. 2.
- 41. viii, 1898-9.
- 42. My attention was drawn to this article by a remark in Carroll L.V. Meeks, The Architectural Development of the American Railroad Station, Dissertation, Harvard University, 1948, published in an altered form as The Railroad Station, Yale University Press and London, 1956. Sturgis's article may have formed the direct source for Henry James's description of his Great Good Place as 'a great square fair chamber all beautified by omissions'. The Great Good Place was published in 1900 (see Novels and Stories, new and complete edition, xxi, 1922, p. 221).
- 43. Arts and Crafts Exhibition Society. Catalogue of the second exhibition. London, 1889, p. 7.
- 44. Studio, i, p. 234.
- 45. The first of them was delivered in that adventurous club of young Belgian artists which was originally called Les Vingt, and since 1894 La Libre Esthétique. Cf. Madeleine Octave Maus, Trente années de lutte pour l'art, 1884-1914, Brussels, 1926. Van de Velde's lectures are collected in two books: Kunstgewerbliche Laienpredigten, Leipzig, 1902, and Die Renaissance im modernen Kunstgewerbe, Leipzig, 1903. Maus, op. cit., p. 183, gives 1894 as the date of the first lecture, van de Velde, 1890. The latter date seems highly improbable, because we know from van de Velde's biography that he had a nervous breakdown in 1889 and did not really recover until 1893 (Osthaus, Karl Ernst. Van de Velde, Hagen, 1920, p. 10). Moreover, he admitted that he and his friends knew nothing of the English Arts and Crafts before 1891 (Die Renaissance. . . , p. 61). As early as 1901 critics complained of inaccuracies in van de Velde's historical accounts (Dekorative Kunst, vii, 1900-1, p. 376). Van de Velde had for years before his death in 1957 worked on his autobiography. The part of it dealing with these crucial years was published in the Architectural Review, cxii, 1952, pp. 143 ff. But there also chronology is somewhat vague. Van de Velde writes

indeed himself: 'I leave it to others to determine the order of their respective dates.' What is now certain is that the important lecture called *Déblaiement d'art* was published in *La Société nouvelle*, and that van de Velde had given some lectures on Modern Industrial Art at the Royal Academy of Art at Antwerp in 1893 (letter of 23 June 1952, from M. Schiltz, the administrator of the academy).

- 46. Van de Velde, Die Renaissance. . . , p. 98.
- 47. Idem. . . . Laienpredigten, p. 36.
- 48. Idem. Die Renaissance. . . , pp. 30, 111-12.
- 49. Idem. . . . Laienpredigten, p. 172.
- 50. Idem. Die Renaissance. . . , pp. 12, 111.
- 51. Ibid., p. 110. This is identical with the principles of industrial art put forward by the Deutscher Werkbund (see Chapter 7) and later by the British Design and Industries Association founded in 1915: fitness for use, and honesty towards materials and working processes.
- 52. Idem. . . . Laienpredigten, p. 166. How strikingly topical is this statement, if one replaces cement by concrete, and celluloid by plastics.
- 53. Idem. Die Renaissance. . . , p. 36.
- 54. Ibid., p. 91.
- Kulka, Heinrich. Adolf Loos: das Werk des Architekten, Vienna, 1931,
 p. 11. Recently Casabella has dedicated a whole number to Loos: No. 233,
 Nov. 1959.
- Wagner, Otto. Moderne Architektur, Vienna, 1896.
 Lux, J. A. Otto Wagner, Munich, 1914.
- 57. Wagner, op. cit., p. 8.
- 58. Ibid., p. 37.
- 59. Ibid., p. 41.
- 60. Ibid., p. 37.
- 61. Ibid., p. 99.
- 62. Loos, op. cit. His writings after 1900 were printed in a volume called *Trotzdem*, 1900–1930, Innsbruck, 1931.
- 63. Idem. *Ins Leere gesprochen*, p. 66. In 1908 Loos wrote an article called 'Ornament and Crime', which was reprinted in *Trotzdem*, pp. 79ff.
- 64. Idem. Ins Leere gesprochen, p. 49.
- 65. Ibid., p. 58.
- 66. Ibid., p. 78.
- Reprinted in Wright, Frank Lloyd. Modern Architecture, Princeton, 1931, pp. 7ff.
- 68. Ibid., p. 8.
- 69. Ibid., p. 20.
- 70. Ibid., p. 8.

- 71. Ibid., p. 16.
- 72. Ibid., p. 15.
- 73. Ibid., p. 14.
- 74. Ibid., p. 20.
- 75. Address at the First International Congress of Architects, quoted from Giedion, Sigfried, Space, Time and Architecture, Cambridge, Mass., 1941, p. 151.
- 76. Berlage, H.P. 'Over Architectuur.' Tweemaandelijk Tijdschrift, ii, part 1, 1896, pp. 233-4. Dr H. Gerson was kind enough to look up for me the exact words of Berlage's text.
- 77. Berlage, H.P. Gedanken über Stil in der Baukunst, Leipzig, 1905, p. 48.
- 78. Cf. many quotations in Schmalenbach, Fritz, Jugendstil, Würzburg, 1935, a very useful book, which describes minutely the history of the decorative arts in Germany between 1895 and 1902.
- 79. Graul, Richard. Die Krisis im Kunstgewerbe, Leipzig, 1901, p. 2.
- 80. Muthesius, Hermann. 'Kunst und Maschine.' Dekorative Kunst, ix, 1901-2, pp. 141 ff.
- 81. Idem. Stilarchitektur und Baukunst, Mülheim-Ruhr, 1902, pp. 50, 51, 53.
- 82. Lichtwark, Alfred. Palastfenster und Flügeltür, Berlin, 1899, pp. 128, 144, 169.

Idem. Makartbouquet und Blumenstrauss, Munich, 1894.

- 83. Obrist, Hermann. 'Neue Möglichkeiten in der bildenden Kunst.' Kunstwart, xvi, part 2, 1903, p. 21.
- 84. Schäfer, W. 'Die neue Kunstgewerbeschule in Düsseldorf.' *Die Rheinlande*, 1903, pp. 62-3.
- 85. Naumann, Friedrich. 'Die Kunst im Zeitalter der Maschine.' Kunstwart, xvii, part 2, 1904, p. 323.
- 86. See recently E. Pfeiffer-Belli in Werk und Zeit, vii, December 1959.
- 87. I am very grateful to Professor H.Rettig of Dresden and Herr Heinz Thiersch of Munich for having drawn my attention to the importance of Riemerschmid which had remained unrecognized by me when I first wrote this book. On Riemerschmid see Rettig, H., Baumeister, XLV, 1948, and Bauen und Wohnen, III, 1948. Two other architects equally keenly interested in machine-made furniture during these early years were Adelbert Niemeyer and Karl Bertsch who had joined the circle of the Deutsche Werkstätten from the Münchner Werkstätten. By 1910 Baillie Scott, Josef Hoffmann, Kolo Moser, and a number of others also worked occasionally for the Werkstätten.
- 88. Cf. Popp, J. Die Deutschen Werkstätten. Written about 1923, typescript. I am greatly indebted to the late Karl Schmidt for kindly letting me

- read the typescript and lending me a series of photographs of D.W. furniture.
- 89. 'Der Bund will eine Auslese der besten in Kunst, Industrie, Handwerk und Handel tätigen Kräfte vollziehen. Er will zusammenfassen, was in Qualitätsleistung und Streben in der gewerblichen Arbeit vorhanden ist. Er bildet den Sammelpunkt für alle, welche zur Qualitätsleistung befähigt und gewillt sind.' On the history of the Werkbund cf. Fünfzig Jahre Deutscher Werkbund, Berlin, 1958; also Die Form, vii, 1932, pp. 297-324.
- 90. Ibid., p. 302.
- 91. Ibid., p. 310.
- 92. The Beginnings of a Journal of the D.I.A., 1916, p. 6.
- 93. Pevsner, Nikolaus. *Academies of Art, Past and Present*, London (Cambridge U.P.), 1940, pp. 267, 281 ff.
- 94. Die Form, loc. cit., pp. 316, 317.
- 95. On Sant'Elia much has been published in the last years. Until then the standard literature had been: Sartoris, Alberto, L'Architetto Antonio Sant'Elia, Milan, 1930; Argan, G.C., 'Il pensiero critico di Antonio Sant'Elia', L Arte, xxxiii, 1930; and the same and others, Dopo Sant'Elia, Milan, 1935. The new contributions started with Banham, R., Architectural Review, cxvii, 1955, who found a large number of hitherto unpublished and unconsidered drawings at Como, followed immediately by Tentori, F., and Mariani, L., L'Architettura, i, 1955–6, pp. 206 ff. and 704 ff. Then G. Bernasconi joined in and published Sant'Elia's Messaggio for the first time (Rivista Tecnica della Svizzera Italiana, xliii, 1956, No. 7). After that Banham, R., Architectural Review, cxix, 1956, p. 343; Banham R., in Journal of the R. Inst. of Brit. Architects, 3rd series, lxiv, 1957; Zevi, B. in L'Architettura, ii, 1956–7, pp. 476 ff.; and Mariani, L., ibid., iv, 1958–9, p. 841.
- 96. The translation is from Dr R.P. Banham's Theory and Design in the First Machine Age, London, 1960, which I was privileged to use before publication.
- 97. This was never published. Letter of W. Gropius to the author, 16 January 1936.
- 98. Letter of W. Gropius to the author, 16 January 1936.
- 99. Cf. William Morris: 'The synonym for applied art is architecture.' National Association for the Advancement of Art and its Application to Industry, *Transactions, Edinburgh Meeting, 1889*, London, 1890, p. 192.
- 100. Gropius, Walter. The New Architecture and the Bauhaus, New York (Museum of Modern Art), 1936.
- 101. Gropius, Walter, et al. Staatliches Bauhaus in Weimar, 1919-23. Weimar, n.d., p. 8.

2 · From Eighteen-fifty-one to Morris and the Arts and Crafts

- I. On the Exhibition of 1851 see Hobhouse, C., 1851 and the Crystal Palace, London, 1st ed., 1937; ffrench, Y., The Great Exhibition, London, 1951; and with specific reference to the problems with which this book is concerned, Pevsner, N., High Victorian Design, London, 1951. Attention must also be drawn to the Catalogue of an Exhibition of Victorian and Edwardian Decorative Arts, London (Victoria & Albert Museum), 1952, for which the late Peter Floud was chiefly responsible.
- 2. The Principal Speeches and Addresses of H.R.H. the Prince Consort, London, 1862, pp. 110, 111.
- 3. The Great Exhibition of the Works of Industry of All Nations, 1851, London, 1851, introductory volume, p. 1.
- 4. Cf. J.F. and Barbara Hammond, *The Town Labourer*, 1760–1832, the New Civilization, London, 1917, who quote some typical sayings of members of the upper class in defending their unscrupulous attitude with the weapons of Utilitarian philosophy: 'Trade, industry and barter always find their own level' (Pitt). 'By following the dictates of their own interests, landowners and farmers become, in the natural order of things, the best trustees and guardians for the public' (Rep. H. Comm. Poor Laws, 1827).
- 5. The importance of this group for the reform of design was first seen by Sigfried Giedion in *Mechanization takes Command*, first edition 1948. When Professor Giedion's book came out, I had also been working on them, and my results went into the following two books: *Matthew Digby Wyatt*, London (Cambridge U.P.), 1950 (Inaugural Lecture, Cambridge, 1949), and *High Victorian Design*, see above. Since then the group has been treated in more detail by A. Bøe, *From Gothic Revival to Functional Form*, Oslo, 1957 (B. Litt. Thesis, Oxford, 1954).
- 6. The following is based on my *High Victorian Design*, pp. 146ff. Page references to the quotations from Pugin are given there.
- 7. Journal of Design and Manufactures, vi, 1852, p. 110.
- 8. In his last article Peter Floud commented on the development of Morris's textiles: Architectural Review, cxxvi, 1959.
- 9. Mackail, J.W. The Life of William Morris, London, 1899, ii, p. 5.
- 10. Mackail says (loc. cit., ii, p. 272): 'Sir Edward Burne-Jones told me that Morris would have liked the faces in his pictures less highly finished, and less charged with the concentrated meaning of emotion of the painting. As with the artists of Greece and of the Middle Ages, the human face was to him merely a part, though no doubt a very important part, of the human body.'

- 11. Pevsner, Nikolaus. 'Christopher Dresser, Industrial Designer.' Architectural Review, lxxxi, 1937, pp. 183-6.
- 12. Two examples are in the Victoria and Albert Museum (C. 788–1925, a plate, and C. 295–1926, a bottle), and neither is in any respect superior to other English artistic pottery of that time.
- Blomfield, Sir Reginald. Richard Norman Shaw, R.A., London, 1940.
 Pevsner, Nikolaus. 'Richard Norman Shaw, 1831–1912' in Victorian Architecture (ed. Ferriday, P.), London, 1963.
- 14. Hitchcock, Henry-Russell. The Architecture of H. H. Richardson and his Times, New York (Museum of Modern Art), 2nd ed., 1961.
- A Monograph of the Work of McKim, Mead and White, 1879–1915, New York, 1915–19, i. Also Scully, V. J. The Shingle Style, New Haven, 1955.

3 · Eighteen-ninety in Painting

- 1. Vollard, Ambroise. Renoir, an Intimate Record, New York, 1925, p. 129.
- 2. Gasquet, Joachim. Cézanne, Paris, 1921, p. 46.
- 3. Cézanne, Paul. Letters, London, 1941, p. 234.
- 4. Van Gogh, Vincent. Letters to Émile Bernard, New York (Museum of Modern Art), 1938, p. 51.
- Further Letters of Vincent van Gogh to his Brother, 1886-1889, London, 1929,
 p. 174.
- 6. Ibid., p. 171.
- 7. Ibid., p. 166. It is interesting to see that certain remarks of Cézanne point to the same idea. He refused to paint Clemenceau because he could not help imagining 'bitter blue and poisonous yellow' and 'convulsive lines' as soon as he began thinking of him. He accounts for this by saying: 'This man does not believe in God.' Gasquet, op. cit., p. 118.
- 8. Further Letters. . . , p. 384.
- 9. Ibid., pp. 332, 413.
- 10. Ibid., p. 203.
- 11. For all that concerns Gauguin and the other early French Post-Impressionists, except Cézanne, see now J. Rewald, Post-Impressionism, from van Gogh to Gauguin, New York (Museum of Modern Art), n.d. (1956).
- 12. Cf. Fegdal, Charles. Félix Vallotton, Paris, 1931.
- Cf. Sponsel, Jean Louis. Das moderne Plakat, Dresden, 1897.
 Price, Charles Matlack. Posters, New York, 1913.

Kauffer, E. McKnight. The Art of the Poster, London, 1924.

Koch, R. 'Art Nouveau Posters.' Gazette des beaux arts, 6th ser., 1, 1957.

14. Jamot, Paul. Maurice Denis, Paris, 1945.

- 15. Rewald, op. cit., p. 446.
- 16. Koch, R. Marsyas, v, 1950-53.
- 17. Plasschaert, A. Jan Toorop, Amsterdam, 1925.
 Knipping, J.B. Jan Toorop, Amsterdam, 1945.
 18. Deborating Kunst. i. 1808. Quoted from Madsen, S.T., Sources of Amsterdam, 1945.
- Dekorative Kunst, i, 1898. Quoted from Madsen, S.T., Sources of Art Nouveau, Oslo, 1956, p. 199.
- 19. Cf. Bahr, Hermann. Die Überwindung des Naturalismus, Berlin, 1891.
- 20. Maeterlinck was a friend of Toorop.

4 · Art Nouveau

- I. Schmutzler, R. 'The English Sources of Art Nouveau', Architectural Review, cxvii, 1955, and 'Blake and Art Nouveau', Architectural Review, cxviii, 1955. Also Pevsner, N., 'Beautiful and, if need be, useful', Architectural Review, cxxii, 1957. This is a review of Madsen, Stefan Tschudi, Sources of Art Nouveau, Oslo, 1956, for the time being the standard work on its subject. Another review of the same book which is worth studying is that by J.M. Jacobus Jr in Art Bulletin, xl, 1958, p. 362. Very useful is the Art Nouveau bibliography compiled by J. Grady (Journal of the Society of Architectural Historians, xiv, 1955), but Madsen's book has a long bibliography too. Mackmurdo was introduced to art history by Pevsner, N., Architectural Review, lxxxiii, 1938. On the typographical aspects of Mackmurdo's title-page, see Baurmann, R., 'Art Nouveau Script', Architectural Review, cxxiii, 1958. On Art Nouveau in general a symposium came out in Germany in 1959, too late to be made use of here: Jugendstil, der Weg ins 20. Jahrhundert, edited by H. Seling, Heidelberg and Munich, 1959.
- 2. See his decoration of a porch and staircase at Chalfont St Peter of 1888. Illustrated in the *British Architect*, xxxiii, 1890, pp. 26-7.
- 3. A case in point is Alfred Gilbert, the sculptor, in whose Fountain of Eros in Piccadilly Circus, of 1892, Arts and Crafts innovations and personal Baroque leanings merge into a very personal Art Nouveau.
- 4. Cf. The Early Work of Aubrey Beardsley, London, 1899, and The Later Work of Aubrey Beardsley, London, 1901. Recently Reade, B. Aubrey Beardsley, London, 1966.
- 5. Yet he may still have been impressed even at that time by some such works of Rossetti as the wood engravings to Moxon's edition of Tennyson's *Poems* (London, 1857) especially *The Lady of Shallott*, p. 75, and *The Palace of Art*, p. 113.
- 6. On Sullivan see: Morrison, Hugh. Louis Sullivan, New York (Museum of Modern Art), 1935.

Hope, Henry R. 'Louis Sullivan's Architectural Ornament.' Magazine of Art, xl, 1947, pp. 110–17 (reprinted in the Architectural Review, cii, 1947, pp. 111–14).

Szarkowski, J. The Idea of Louis Sullivan, New York and London, 1957.

- 7. Sullivan. Kindergarten Chats, p. 189.
- 8. In a letter to the author, dated 23 January 1936, he said that his only intention in designing No. 6 rue Paul-Émile Janson was 'de faire œuvre personnelle d'architecte, à l'égale du peintre et du sculpteur qui ne souciaient que de voir avec leurs yeux et sentir avec leur cœur...,' though at the same time he stressed the rational plan and construction of the house. He added that Voysey and Beardsley were unknown to him when he designed his early works. Toorop he did not mention. The most scholarly publication on Horta is Madsen, S. T., Architectural Review, cxviii, 1955. Cf. also the eight fully illustrated features in L'Architettura, iii, 1957-8, pp. 334, 408, 479, 548,622, 698, 766, 836; Kaufmann, Edgar, Architects' Year Book, viii, 1957 and, yet more recently, R. L. Delevoy, Victor Horta, Brussels, 1958.
- 9. Van de Velde. Die Renaissance. . . , pp. 61ff., and Architectural Review, cxii, 1952.
- 10. Quoted from Madsen, p. 319.
- Conrady, Ch., and Thibaut, R. Paul Hankar, Édition Texhuc, Revue La Cité, 1923.
- 12. And incidentally also the connexion between his style and the fact that he advocated a reformed 'organic' style in women's clothes.
- 13. Altogether it is remarkable how often functionalist theory in the nineteenth century contradicts freely ornamental performance. Pugin's is the first case. His profession of faith in fitness which has been referred to in Chapter I would not make one expect his elaborate Gothic drawings and their exuberant decoration. For Art Nouveau Madsen has given several striking examples among artists of Art Nouveau: (Gallé 1900, p. 178; Gaillard 1906, pp. 372–3), and Obrist's remark quoted by me in Chapter I does not prepare one for his embroidery illustrated and discussed later on in this chapter. Van de Velde's references to structurizing etc. come from essays written in 1902–6; perhaps he would have been less radical earlier on.
- 14. Koch, R. Gazette des beaux arts, 6th ser., liii, 1959.
- 15. How far he was entirely on his own in these innovations cannot yet be said. Gallé had been in England in the early seventies, but what would he have seen there at so early a date? On the other hand, in my research into the work of Christopher Dresser (see note 10, Chapter 2), I came across photographs of some of Dresser's Clutha glass of between 1880 and 1890 which is oddly similar to Gallé's. One vase is illustrated in the Architectural Review, lxxxi, 1937, p. 184. It may be inspired by Gallé or independent of him.

- 16. The Art Work of Louis C. Tiffany, New York, 1914; also a prospectus with illustrations called Tiffany, Favrile Glass, 1896, and the catalogue of a Tiffany exhibition held by the Museum of Contemporary Crafts in New York in 1958 (text etc. by R. Koch).
- 17. Illustrated in Pan, ii, 1896-7, p. 252.
- 18. On these and Art Nouveau in Paris altogether see Cheronnet, L., Paris vers 1900, Paris, 1932.
- 19. Hitchcock, Henry-Russell. 'London Coal Exchange.' Architectural Review, ci, 1947, pp. 185-7.
- 20. A.D. F. Hamlin in his article 'L'Art Nouveau, Its Origin and Development' (Craftsman, iii, 1902–3, pp. 129–43) overrated the originality and importance of France. After all, he says himself that as early as 1895 an article came out in Paris pleading for a restoration of the independence of French designers from Belgium. At least one of the leading French representatives of Art Nouveau was Belgian himself: Jean Dampt.
- 21. Van de Velde is wrong in saying (*Die Renaissance...*, p. 15) that before the Dresden Exhibition 'nobody in Germany had thought of a revival of artistic craftsmanship'.
- 22. For further information cf. Schmalenbach, Jugendstil, and more recently the personal reminiscences of Friedrich Ahlers-Hestermann, Stilwende, Berlin, 1941, and of Karl Scheffler, Die fetten und die mageren Jahre, Leipzig, 1946.
- 23. Fendler, F. Special issue of Berliner Architekturwelt, 1901.
- 24. Cf. Schmalenbach, op. cit., p. 26.
- 25. Their most eruptive form is the Oertel Monument of 1901–2, illustrated e.g. in Scheffler, Karl, *Die Architektur der Grosstadt*, Berlin, 1913, p. 182, and Ahlers-Hestermann, op. cit., p. 63. It should be understood in conjunction with the contemporary ornament of Sullivan on the one hand and of Gaudí on the other.
- 26. Vienna on the one hand and the Paris of Guimard on the other are the source from which Italy made up her late and regionally restricted flowering of Art Nouveau. The chief representatives are Raimondo d'Aronco (1857–1932) and Giuseppe Sommaruga (1867–1917). The magnum opus of the former was the buildings for the Turin Exhibition of 1902. They are very Viennese indeed, yet in some details seem to prove direct British sources as well. Sommaruga built the Palazzo Castiglioni in the Corso Venezia in Milan in 1903 and the Hotel Campo dei Fiori at Varese in 1909–12. Theirs is a thick, lava-like decoration which does not however touch the substance of the buildings. On d'Aronco see: Nicoletti, M., Raimondo d'Aronco, Milan (Il Balcone), 1955; and Mattioni, E., L'Architettura, ii, 1956–7. On Sommaruga see: Monneret de Villard, U., L'Architettura di G.

Sommaruga, Milan, no date; Angelini, L., Emporium, xlv, 1917; Rivista del Comune di Milano, 31 May 1926; Tentori, F., Casabella, No. 217, 1958.

The revived interest in Art Nouveau which is so noticeable in the last years and finds its explanation in the 'Neo-Liberty' tendencies of recent architecture has as its most monumental demonstration up to date the re-erection of the façade of Cattaneo's Albergo Corso in Milan of 1907 as part of a modern frontage in Via San Paolo. The new building is an insurance company office, and its architects, responsible for this curious preservation of a topical ancient monument, are Pasquali and Galimberti.

- 27. 15 April 1901. Quoted from Madsen, p. 300.
- 28. Art Journal, October 1900, quoted from Madsen, p. 300.
- 29. Crane, Walter. William Morris to Whistler, London, 1911, p. 232.
- 30. The other editor was the author and poet Otto Julius Bierbaum.
- 31. A similar change of trend about that time is to be noticed in the German periodical *Innendekoration*. This journal was started by Alexander Koch (1860–1939) in 1890. Whereas the first years are entirely concerned with period decoration, there are in 1894 some few illustrations of work of Ernest Newton's and George and Peto's and also of English wallpapers printed by Jeffrey's and Essex's. From 1895 on, forms of Art Nouveau began to penetrate. The victory of the new style in *Innendekoration* is marked by Koch's publication of Baillie Scott's and Ashbee's rooms for the Grand-Ducal Palace at Darmstadt. He was largely responsible for the foundation of that colony of artists at the Darmstadt Court which is mentioned on page 196. My friend, the late Ernst Michalski, whose article on the Jugendstil ('Die entwicklungsgeschichtliche Bedeutung des Jugendstils', *Repertorium für Kunstwissenschaft*, xlvi, 1925, pp. 133–49) is, as far as I can see, the earliest of all attempts at seeing Art Nouveau as a worthwhile art-historical problem, was also a friend of Ludwig Prince of Hesse.
- 32. As well as Puvis de Chavannes, Degas, Monet, and the Flemish and Scandinavian painters of folk-life and folk-lore.
- 33. Madsen, Post-Impressionism, pp 141, 231, 360.
- 34. Rewald, Post-Impressionism, p. 487.
- 35. Maus. Trente années de lutte pour l'art, 1884–1914.
- 36. See Madsen, loc. cit., p. 284.
- 37. On Gaudí the first book came out in 1928: Ráfols, J.P., Antoni Gaudí. This was followed by Puig Boada, I., El Templo de la Sagrada Familia, Barcelona, 1929. It is worth recording that in 1930 Mr Evelyn Waugh wrote an article on Gaudí (Architectural Review, lxvii, pp. 309ff.) in which, apart from the Sagrada Familia, the Casa Milá and the Parque Güell are illustrated. Mr Waugh very shrewdly compares its buildings to those of Expressionist German films. Literature on Gaudí has multiplied in the last few years:

Cirlot, J. El arte de Gaudí, Barcelona, 1950.

Martinell, C. Antonio Gaudí, Milan (Astra Arengaria), 1955.

'Gaudi', Cuadernos de Arquitectura, No. 26, 1956.

Bergós, J. Antoni Gaudí, l'hombre i l'obra, Barcelona, 1957.

Hitchcock, H.-R. Antoni Gaudí. Catalogue of an exhibition held at the Museum of Modern Art, New York, 1948.

Vallés, J. Prats, Gaudí (foreword by Le Corbusier), Barcelona, 1958.

5 · Engineering and Architecture in the Nineteenth Century

- But in the author's opinion no more potent. It is the one objection to Sigfried Giedion's brilliant Space, Time and Architecture, Cambridge, Mass., 1941, that he over-emphasizes the technical as against the aesthetic components of the modern style.
- 2. Since this book was first published in 1936, our knowledge of iron in architecture has been greatly increased by the relevant chapters of Giedion's book mentioned in the previous note. They amplify considerably what Dr Giedion had compiled for his Bauen in Frankreich, Eisen, Eisenbeton, Leipzig, 1928, a book in its turn clearly dependent on Alfred Gotthold Meyer's Eisenbauten, Esslingen, 1907. Of books after Dr Giedion's the two most important are: Gloag, John, and Bridgewater, Derek, Cast Iron in Architecture, London, 1948; Sheppard, Richard, Cast Iron in Building, London, 1945. A yet more recent treatment of the subject and one which goes beyond anything published before is Bannister, T., 'The first iron framed buildings', Architectural Review, cvii, 1950, pp. 231ff. This in its turn has been corrected in some important points by A.W. Skempton and H.R. Johnson in a paper in the Transactions of the Newcomen Society, xxx, 1956. Cf. also Skempton, A.W., 'Evolution of the Steel Frame Building', The Guild Engineer, x, 1959.
- 3. Von Wolzogen, Alfred. Aus Schinkels Nachlass, Berlin, 1862-4, iii, p. 141.
- 4. Ettlinger, L. 'A German Architect's Visit to England in 1826.' Architectural Review, xcvii, 1945.
- 5. Gilchrist, A. Architectural Review, cxv, 1954, p. 224.
- 6. Braunschweig, 1852, p. 21.
- 7. The warehouses on the river front of St Louis which Dr Giedion published in Space, Time and Architecture are apparently all later. Cast-iron façades in New York are mentioned and illustrated in Building News, xvi, 1869.
- 8. Woodward, G. Architectural Review, cxix, 1956, pp. 268ff.
- 9. Lecture to the Royal Institute of British Architects, 29 February 1864, quoted from Harris, Thomas, The Three Periods of English Architecture,

- London, 1894, p. 84. Aitchison built, for example, Nos. 59-61 Mark Lane in London in 1863. For these early iron façades in England cf. Hitchcock, H.-R., Architectural Review, cix, 1951, pp. 113ff., and Early Victorian Architecture in Britain, New Haven and London, 1954.
- Architectural Review, cxxii, 1957, p. 32. Cf. Skempton, A. W., The Times,
 February 1959, and a paper by the same in the Trans. Newc. Soc.,
 xxxii, 1960.
- 11. I owe the photograph of this building to Mr John Maass who also drew my attention to its publication by Miss A. L. Huxtable in *Progressive Architecture*, xxxvii, 1956. Briefer notes had appeared in the *Journal of the Society* of Architectural Historians, October 1950 and March 1951.
- 12. British Architect, xxxvii, 1892, p. 347.
- 13. Builder, xxiii, 1865, p. 296.
- 14. Illustrated in Giedion, S., Space, Time and Architecture, 1st ed., p. 139.
- 15. Maguire, R., and Matthews, P. 'The Iron Bridge at Coalbrookdale.' Architectural Association Journal, lxxiv, 1958. This supersedes Professor Bannister as well as Raistrick, A., Dynasty of Ironfounders, London, 1953.
- Professor Bannister, loc. cit., mentions a yet earlier illustration of an iron suspension bridge in Venanzio, Fausto, Machinae Novae, Venice, 1595.
- 17. On the Tees bridge: Hutchinson, W., History and Antiquities of the County Palatine of Durham, iii, p. 297. Also Country Life, 23 September and 4 November 1965. On the Jacob's Creek bridge: Finley, James, 'A Description of the Patent Chain Bridge', Port Folio, n.s. iii, 1810, pp. 441-53.
- 18. On Telford see Rolt, L.T.C., Thomas Telford, London, 1958.
- 19. On Brunel see Rolt, L. T. C., Isambert Kingdom Brunel, London, 1957.
- 20. A cast-iron obelisk earlier than Wilkinson's exists at Ullersdorf in Silesia. Its date is 1802 and it is 72 feet high (see Schmitz, Berliner Eisenguss, Berlin, 1917, p. 19). The philosopher Fichte received another as a monument in 1814. Iron flèches became quite usual in the nineteenth century, see for instance the cathedrals of Rouen and of Notre Dame in Paris.
- 21. This example was unpublished until I mentioned it in *The Buildings of England*, *The West Riding of Yorkshire*. Harmondsworth (Penguin Books), 1959.
- 22. Whiffen, Marcus. Stuart and Georgian Churches outside London, London, 1947-8, p. 53, Pl. 67. Dr Giedion, Space, Time and Architecture, has illustrated a London bookshop with undisguised iron shafts supporting a little dome. The date is 1794.
- On Covent Garden: Britton, J., and Pugin, A. Illustrations of the Public Buildings of London, London, 1825-8, i, p. 220, Pl. VI. On the Liverpool iron churches: Brown, A. T. How Gothic Came Back to Liverpool, Liverpool (University of Liverpool Press), 1937. On John Cragg: Nasmyth, J.

Autobiography, London, 1883, p. 183. Nasmyth speaks of St James's, Liverpool, as an iron church by Blore. It has not been possible to verify this. Mr Whiffen's notes (Stuart and Georgian Churches...) are headed by a reference to Tetbury, Gloucestershire, of 1777-81. However, the vicar has since denied in a letter that the slim piers have iron cores. So Everton may well be the first instance of main piers of iron.

- 24. The Works of Sir John Soane. Sir John Soane's Museum Publication No. 8. London, 1923, p. 91.
- 25. Mackenzie, Sir G.S. 'On the Form which the Glass of a Forcing-House ought to have, in order to receive the greatest possible Quantity of Rays from the Sun.' Transactions of the Horticultural Society of London, ii, 1818, pp. 170-77.

Knight, Thomas Andrew. 'Upon the Advantages and Disadvantages of Curvilinear Iron Roofs to Hot-Houses.' *Transactions of the Horticultural Society of London*, v, 1824, pp. 227-33.

- Loudon, J.C. Remarks on the Construction of Hothouses, London, 1817.
- Loudon, J.C. Encyclopaedia of Gardening, London, 1822, No. 6174.
- Loudon, J.C. Encyclopaedia of Cottage, Farm and Villa Architecture and Furniture, London, 1842, Fig. 1732.
- 26. On Horeau see Doin, J. Gazette des beaux arts, 4th ser., xi, 1914.
- 27. On railway architecture the standard work is now Meeks, Carroll L.V., The Railroad Station, Yale University Press and London, 1956. Professor Meeks compares this wide span with the largest stone spans ever achieved, notably the Pantheon in Rome 142 feet, St Paul's in London 112 feet, St Sophia in Constantinople 107 feet, etc.
- 28. All these quotations are from unpublished letters found by Mrs Stanton and to be printed in her forthcoming monograph on Pugin. I am very grateful to her for allowing me to offer my readers this preview.
- 29. Ruskin, John. The Stones of Venice, London, 1851, i, pp. 407, 405.
- 30. Pevsner, N. Matthew Digby Wyatt, London (Cambridge U.P.), 1905, pp. 19-20.
- 31. Harris, T. 'What is Architecture?' Examples of the Architecture in the Victorian Age, London, 1862, p. 57. Peter F.R.Donner, in 'A Harris Florilegium', Architectural Review, xciii, 1943, pp. 53-4, suggested that Harris was also the editor of this volume, which was to be the first of a series. However, only this one appeared.
- 32. Seven Lamps of Architecture, London, 1849, p. 337.
- 33. Scott, Sir George Gilbert. Remarks on Secular and Domestic Architecture, London, 1858, pp. 109-10.
- 34. Quoted from Meeks, loc. cit., p. 65. This view lingered on to the end of the century. Madsen quotes a saying of Charles Garnier, the architect

of the Paris Opéra in 1893 to the effect that iron 'is a means, it will never be a principle' (p. 224) and of Grasset, the leading French poster-designer, in 1896, that 'iron architecture is horrible, because people have the foolish pretence to want to show everything. Art is born precisely from the need to clothe the merely useful which is always repugnant and horrible' (p. 224).

- 35. The passage is rightly the motto to Professor Meeks's book; see also p. 10.
- 36. In La Presse. Quoted from Giedion, Bauen in Frankreich, Leipzig, 1928, p. 10.
- 37. Le Vésinet (Seine-et-Oise), 1863, by Louis-Charles and the former Notre Dame de France off Leicester Square in London by Louis-Auguste, 1868 (see *Builder*, xxiii, 1865, pp. 800, 805, and *Architectural Review*, ci, 1947, p. 111).
- 38. Quoted from the English edition, London, 1877, pp. 385 and 461.
- 39. English edition, London, 1881, pp. 58, 59, 87, 91, 120-21. According to Dr Robin Middleton's research Lecture III of Volume II dates from 1868, Lecture IV from 1869, Lectures V, etc. from 1870 to 1872. Dr Middleton's thesis on Viollet-le-Duc (Cambridge, 1958) is as yet unpublished.
- 40. Bisset, Maurice. Gustave Eiffel, Milan (Astra Arengaria), 1957.
- 41. Summed up succinctly in the mimeographed catalogue Early Modern Architecture, Chicago, 1870–1910, 2nd ed., New York (Museum of Modern Art), 1940. Cf. also: Giedion, Space, Time and Architecture; Condit, C. W., The Rise of the Skyscraper, Chicago, 1952.
- 42. L. S. Buffington's dreams of cloud-scrapers of 1880-81 were based on Viollet-le-Duc's *Entretiens* and remained vague. He did not take out his patent until 1888 by which time the first Chicago skyscrapers were already in existence.

Cf. Morrison, Hugh. 'Ruffington and the Invention of the Skyscraper.' Art Bulletin, xxvi, 1944, pp. 1-2.

Tselos, Dimitros. 'The Enigma of Buffington's Skyscraper.' Art Bulletin, xxvi, 1944, pp. 3–12.

Christison, Muriel B. 'How Buffington Staked His Claim.' Art Bulletin, xxvi, 1944, pp. 13–24.

The Origin of the Skyscraper. Report of the Committee appointed by the Trustees of the Estate of Marshall Field for the Examination of the Structure of the Home Insurance Building. Thomas E. Tallmadge, ed., Chicago, 1939.

43. Sullivan, Louis H. 'The Tall Office Building Artistically Considered.' Lippincott's Monthly Magazine, lvii, 1896, p. 405. Cf. also the paper by Sullivan's partner Dankmar Adler: 'The influence of steel construction and of plate glass upon the development of the Modern Style.' Inland

- Architect and News Review, xxviii, 1896. I have not been able to see this paper.
- 44. The most recent literature on the Chicago school is Randall, F.A., History of Building Construction in Chicago, Urbana, 1949; and Randall, J.D., A Guide to significant Chicago Architecture of 1872 to 1922, Glencoe, Illinois, privately printed, 1959.
- 45. Peter Collins. Concrete, London, 1959.
- 46. Collins, op. cit., p. 27.
- 47. See Note 37 above.
- 48. § 1792.
- 49. Wilkinson, W.B., see Collins, op. cit., p. 38.
- 50. Collins, op. cit., p. 29.
- 51. Ruskin. The Stones of Venice, p. 406.

6 · England, Eighteen-ninety to Nineteen-fourteen

- There is as yet no book in existence on Voysey. The best paper is Brandon Jones, John, 'C. F. A. Voysey', Architectural Association Journal, lxxii, 1957, pp. 238-62. See also Pevsner, Nikolaus, 'Charles F. Annesley Voysey', Elsevier's Maandschrift, 1940, pp. 343-55. For earlier publications of Voysey's work cf.: Dekorative Kunst, i, 1898, pp. 241 ff.; Muthesius, H., Das englische Haus, Berlin, 1904-5, i, pp. 162 ff.
- The clearest proof of this influence of Voysey's is Adolphe Crespin's wallpapers, designed at Brussels in the nineties. Art et décoration, ii, 1897, pp. 92 ff.
- 3. The Studio, i, 1893, p. 234.
- 4. On the Japanese influence in the sixties see for instance Rewald, John, The History of Impressionism, New York (Museum of Modern Art), 1946, p. 176. On the influence of Japan on Art Nouveau see Lancaster, Clay, 'Oriental Contribution to Art Nouveau', Art Bulletin, xxxiv, 1952, and more recently Madsen, Sources of Art Nouveau, pp. 188, etc. A general treatment of the subject before 1900 is Gonse, L., 'L'art japonais et son influence sur le goût européen', Revue des arts décoratifs, xviii, 1898. A few key dates are 1854 for the first official treaty between the United States and Japan, 1854 for the first between Britain and Japan; 1859 for the first trade agreement between the United States and Japan, and 1859 for the first between Britain and Japan; 1856 for the chance discovery of Japanese woodcuts in a Paris shop by Braquemond, the etcher (who then introduced them to the Goncourts, Baudelaire, Manet, and Degas, and probably also Whistler); 1862 for the participation of Japan in the International Exhibition in London. Christopher Dresser's journey to Japan in 1876

- has been referred to on p. 55. Owen Jones, who has also appeared in this book before, published *Examples of Chinese Ornament* in 1867.
- The Peacock Room now at the Freer Gallery of Art in Washington was decorated by Whistler in 1876-7; the Princesse had been painted in 1863-4.
- 6. Pennell, E.R. and J., The Life of J. McN. Whistler, London, 1908, i, p. 219; and Way, T.R., and Dennis, G.R., The Art of J. McN. Whistler, London, 1903, p. 99. The exhibitions for which Whistler was responsible in 1883 and 1884 had white and lemon yellow and white and pink walls (Pennell, pp. 310 and 313).
- 7. Two more interesting instances of this confusion between old i.e. *l'art pour l'art* outlook and new ideas are the passage from Théophile Gautier, quoted on p. 135 and that from Oscar Wilde quoted on p. 27. See also: Gatz, Felix M., 'Die Theorie des l'art pour l'art und Théophile Gautier', *Zeitschrift für Aesthetik und allgemeine Kunstwissenschaft*, xxix, 1935, pp. 116-40.
- 8. He speaks of the 'impression on a very shortsighted person of divers ugly incidents seen through the medium of a London fog'. National Association for the Advancement of Art and its Application to Industry, *Transactions*, *Edinburgh Meeting*, 1889, London, 1890, p. 199.
- 9. Ernest Gimson, His Life and Work, Stratford-on-Avon, 1924.
- Weaver, Sir Lawrence. 'Tradition and Modernity in Craftsmanship.' Architectural Review, Ixiii, 1928, pp. 247-9.
- 11. Two examples of the sort of Tudor or seventeenth-century manor houses which must have impressed Voysey are: Westwood near Bradford-on-Avon, illustrated in Garner, T., and Stratton, A., Domestic Architecture during the Tudor Period, 2nd ed., London, 1929; and Perse Caundle in Dorset, illustrated in Oswald, A., Country Houses of Dorset, London, 1935.
- First illustrations in the Studio, v, 1895. Cf. also Baillie Scott, M.H., Houses and Gardens, London, 1906.
- 13. The Magpie and Stump on the right is less interesting.
- 14. The same arch appears already in Townsend's early work, the Bishopsgate Institute in London of 1892-4. Its connexion with Richardson was spotted by P.F.R. Donner, 'Treasure Hunt', Architectural Review, xci, 1941, pp. 23-5. Townsend's brother wrote on Richardson in The Magazine of Art, Feb. 1894.
- 15. When this book was originally written, no book existed yet on Mackintosh. When it was revised in 1949 the gap had not yet been filled. Professor T. Howarth's monograph, Charles Rennie Mackintosh and the Modern Movement, came out at last in 1952 and contains all the information needed. My own earlier little book (Pevsner, N., Charles R. Mackintosh, Milan (Il Balcone), 1950) need only be quoted because of points of interpretation

148. H. B. Creswell: Queensferry Factory, near Chester, 1901.

on which I differ from Professor Howarth. Of the earliest English illustrations and accounts of Mackintosh's work the following may be noted: *British Architect*, xxxvii, 1892; xliv, 1895; xlvi, 1896; *Studio*, ix, 1896, p. 205 (a settee); xi, 1897, pp. 86–100 (a special article on the Glasgow group by Gleeson White). Abroad the first appearance is in *Dekorative Kunst*, iii, 1899, p. 69, etc.; iv, 1899, pp. 78–9.

- 16. See e.g. Abbot, T.K., Celtic Ornaments from the Book of Kells, London, 1892-5; Allen, J. Romilly, 'Early Scandinavian Woodcarvings', Studio, x, 1897, and xii, 1898. Madsen offers more information on the Celtic trend (pp. 207, etc.). He refers to Morris's journey to Iceland in 1872; to Sir J.T. Gilbert's Account of Facsimiles of National Manuscripts of Ireland, Parts I-IV, 1874-84; to Yeats's Wanderings of Oisin of 1889 and his Twilight of 1893; and draws a convincing parallel with the Dragon-style in Norway which accompanied the medieval revival in the country from c. 1840 onwards (see Madsen, S. Tschudi, 'Dragestilen', Vestlandske Kunstindustrimuseum Årbok, 1949-50, pp. 19-62).
- 17. The principal representatives of this fantastic Expressionist aberration in Amsterdam are Michel de Klerk and Piet Kramer. Dudok also sacrificed at its altars for a few years.
- 18. In his interpretation of the events I differ from Professor Howarth and Dr Madsen. Professor Howarth writes (loc. cit., p. 268): 'For long it has been assumed that Hoffmann modelled his work on that of Mackintosh; all the evidence examined by the author would indicate that this was not so.' Madsen writes (p. 404): 'The architectural development has undoubtedly developed independently in the two countries as well as the development of certain decorative forms.' On the other hand Dr I. Hatle in a doctoral thesis (Gustav Klimt, Graz, 1955, p. 66) fully accepts the influence of the Scots on

- Klimt's style. It is all the more piquant that the paintings which Mackintosh created in his later years seem to reflect the manner which was developed by Klimt's pupils, especially E. Schiele, during the first years of our century.
- 19. Mrs J.R. Newbery, in the introduction to the catalogue of the Glasgow Memorial Exhibition, also gives the names of Beardsley, Toorop, and Voysey, and adds that of Carlos Schwabe. Toorop's The Three Brides was illustrated in the Studio, i, 1893, p. 247. Of Schwabe, Madsen (p. 180) illustrates a book of 1891 which indeed heralds Eckmann, if not Mackintosh. Also Professor Howarth told Madsen that the Newberys owned Zola's Le Rêve with Schwabe's illustrations.
- 20. What else is of interest in England between 1900 and 1914 as heralding the Modern Movement has been collected by the author in an article: 'Nine Swallows No Summer', Architectural Review, xci, 1942, pp. 109-12. The most noteworthy buildings are H.B. Creswell's Queensferry Factory of 1901 (Pl. 148) and Lethaby's Eagle Insurance in Birmingham of 1900.
- 21. P. 27 and note 33, Chapter 1.
- Pevsner, Nikolaus. 'Model Houses for the Labouring Classes.' Architectural Review, xciii, 1943, pp. 119-28.
- Richards, J.M. 'Sir Titus Salt.' Architectural Review, lxxx, 1936, pp. 213-18.
- 24. Cf. Hegemann, Werner. Der Städtebau, Berlin, 1911-13, 2 vols. With regard to the outstanding position of Germany in pre-1914 town planning H. Inigo Triggs writes in his Town Planning, Past, Present and Possible, London, 1909, p. 39: 'Nowhere has the subject of town planning received more careful attention than in Germany, where for many years the foremost architects of the country have given much thought to the subject, and where the State practically compels municipalities to own land for public improvement. . . .'

7 · The Modern Movement before Nineteen-fourteen

- Perret died in 1954. On Perret see Jamot, Paul, A.-G. Perret et l'architecture du béton armé, Paris, 1927, and Rogers, E., Auguste Perret, Milan (Il Balcone), 1955; on Garnier see Veronesi, Giulia, Tony Garnier, Milan (Il Balcone), 1948.
- Garnier, Tony. Une Cite Industrielle, Paris, 1917 and Pawlowski, Christophe, Tony Garnier, Paris, 1967.
- 3. Quoted from the Builder, lxxx, 1901, p. 98.
- 4. Garnier's station, even if never built, is one of the first of the great twentieth-century stations. The first was that at Helsinki by Eliel Saarinen (1870–1950). This was designed in 1905 and completed in 1914. Its style is influenced by that of Vienna about 1900. The grouping is bold and

- characterized by an asymmetrically placed tower like Garnier's. The initiative went from Helsinki to Germany, where a number of excellent stations went up culminating in that of Stuttgart (by Bonatz and Scholer) begun in 1911 and completed only in 1928.
- Bill, M. Robert Maillart, Zürich, 1949. 2nd ed., 1955. Also the chapter on Maillart in the later editions of Dr Giedion's Space, Time and Architecture.
- Le Corbusier and Jeanneret, P. Ihr gesamtes Werk von 1910–1929, Zürich, 1930.
- Le Corbusier. Towards a New Architecture, London, 1931, pp. 80, 82.
 Also Architectural Review, Ixxvi, 1934, p. 41.
- The standard work on Frank Lloyd Wright is Hitchcock, Henry-Russell, In the Nature of Materials, New York, 1942.
- 10. Ausgeführte Bauten und Entwürfe von Frank Lloyd Wright, Berlin (Wasmuth), 1910; and Frank Lloyd Wright: Ausgeführte Bauten (with an introduction by C.R. Ashbee), Berlin (Wasmuth), 1911. In the same year 1911 Berlage went to America and especially Chicago. W.G.Purcell, a young Chicago architect working in the same vein as Wright, had introduced him to Sullivan's and Wright's buildings as early as 1906. Berlage was especially impressed by the Carson Pirie Scott Store (Pl. 113) and also saw Wright's Larkin Building (Pls. 120, 121) and his houses around Chicago. Back in Holland, Berlage lectured on what he had seen in the United States and also wrote on it in the Schweizer Bauzeitung in 1912 (cf. Eaton, L. K., 'Louis Sullivan and Hendrik Berlage', Progressive Architecture, xxxvii, 1956). So Wright was fairly familiar in Holland, when after the First World War two special publications on him were brought out by two Dutchmen: Wijdeveld, H.T., The Life-Work of the American Architect Frank Lloyd Wright, seven special numbers of Wendingen, 1925; and de Fries, H., Frank Lloyd Wright, Berlin, 1926. After that there came two French books, one of them with an introduction by Henry-Russell Hitchcock. America followed very much later. The most striking example of Wright's influence on Holland is a house by van't Hoff of 1915, illustrated with a few other Wrightian buildings in Europe by Pevsner, Nikolaus, 'Frank Lloyd Wright's Peaceful Penetration of Europe', The Architects' Journal, lxxxix, 1939, pp. 731-4.
- Endell, A. 'Formenschönheit und dekorative Kunst.' Dekorative Kunst, ii, 1898, pp. 121 ff.
- 12. Lux, J.A. Josef Maria Olbrich, Vienna, 1919.
 - Roethel, J. 'Josef Maria Olbrich.' Der Architekt, vii, 1958, pp. 291-318.
- 13. It has already been mentioned that the money which made possible the establishment of the Wiener Werkstätte in 1903 was given by Fritz Wärndorfer, the same who had his Music Room decorated by Mackintosh

- in 1901. The moving spirits in the early days of the Werkstätte were Josef Hoffmann and Kolo Moser.
- 14. But there once again Sullivan had come first. Olbrich's block with its semi-spheric dome and Olbrich's sense of flat vegetal decoration already appear in Sullivan's Wainwright Tomb, Bellefontaine Cemetery, St Louis, in 1892. Illustrated in Morrison, Hugh, Early American Architecture, New York, 1952, Pl. 41.
- 15. Kleiner, Leopold. Josef Hoffmann, Berlin, 1927.

Rochowalski, L. W. Josef Hoffmann, Vienna, 1950.

Veronesi, Giulia. Josef Hoffmann, Milan (Il Balcone), 1956.

Also Wendingen, Nos. 8-9, 1920, and L'Architettura, ii, 1956-7, pp. 362ff. and 432ff.

On the Stoclet Palace in particular Sekler, E.F. in *Essays in the History of Architecture presented to Rudolf Witthower*, London, 1967, full and very profitable.

- Kulka, Heinrich. Adolf Loos: das Werk des Architekten, Vienna, 1931.
 Münz, Ludwig. Adolf Loos, Milan (Il Balcone), 1956.
- Cf. for example, the house built by Peter Behrens for Mr Bassett-Lowke at Northampton in 1926; illustrated in the Architectural Review, lx, 1926, p. 177.
- 18. Hoeber, Fritz. Peter Behrens, Munich, 1913.

Cremers, Paul Joseph. Peter Behrens, sein Werk von 1909 bis zur Gegenwart, Essen, 1928.

- 19. Illustrated in the Architectural Review, lxxvi, 1934, p. 40.
- 20. Cf. Schmalenbach, F. Jugendstil, pp. 28-9, 85.

Rodenberg, J. 'Karl Klingspor.' Fleuron, v, 1926.

Baurmann, Roswitha, 'Schrift', in Jugendstil, edited by Seling, H., Heidelberg and Munich, 1959.

- On this see Ahlers-Hestermann, Stilwende, p. 109. He dates the room 1901, but Dr Schröder himself told me in a letter that the date is 1899.
- 22. Linear decoration in squares and oblongs is as typical of Behrens at this stage as of Schröder, of Mackintosh, and of course of Josef Hoffmann whose nickname was 'Quadratl-Hoffmann'.
- Johnson, Philip C. Mies van der Rohe, New York (Museum of Modern Art), 1947.
- 24. Heuss, Theodor. Hans Poelzig, Berlin, 1939.
- 25. See Mebes, Paul. Um 1800, Munich, 1920.

Stahl, Fritz. Karl Friedrich Schinkel, Berlin, 1911.

- 26. See L'Architettura, iii, 1957-8, 438.
- 27. And as Octave Mirbeau had visualized it as early as 1889. His term is 'combinaisons aériennes' (Giedion, Bauen in Frankreich, p. 18).

Supplementary Bibliography

GENERAL

Cassou, J., Langui, E., Pevsner, N. The Sources of Modern Art, London, 1962. This sumptuous volume is the commemoration of the exhibition 'Les Sources du XXe. siècle' held in Paris in 1960. Architecture and design is the part treated by Pevsner. It has recently been revised and published separately as a paperback (London, 1968).

Benevolo, L. Storia dell'architettura moderna, 2 vols., Bari, 1964.

Collins, P. Changing Ideals in Modern Architecture, London, 1965. Deals with 1760 to 1960.

Posener, J. Anfänge des Funktionalismus, Berlin, 1964. An anthology.

Ponente, N. Structures of the Modern World, 1850-1900, London, 1965.

Pevsner, N. Studies in Art, Architecture and Design, 2 vols., London, 1968. Collected essays: among them are those quoted in the notes on 'Morris and Architecture', Mackmurdo, Voysey and Mackintosh, and also a paper on George Walton, another of the Glasgow pioneers of c. 1900.

Sharp, D. Sources of Modern Architecture, London, 1967 (Architectural Associ-

ation Papers II - a bibliography).

Jordan, R. Furneaux. Victorian Architecture, Harmondsworth, 1966. The story is taken as far as 1914.

Hilberseimer, L. Contemporary Architecture, its Roots and Trends, Chicago, 1964.

TOPICS

Industry and Early Iron:

John Harris, (Arch. Rev., cxxx, 1961) has made the use of cast iron columns in the Houses of Parliament in 1706 more than likely. The earliest church with cast iron columns to support galleries seems to have been St James, Toxteth, Liverpool, in the 1770s (The Buildings of England, South Lancashire, Harmondsworth, 1969). Dr R. Middleton referred me to Pierre Patte in Blondel's Cours, vol. v, 1770, p. 387 and pl.82 about iron columns in hothouses. The plate shows one in the rue de Babylone 'qui avait pris pour modèle les plus belles serres anglaises'; for Patte writes, 'aujourd'hui ce sont les Anglais qui passent pour surpasser tous les autres'. On the Strutts and the Arkwrights see now Fitton,

R. S. and Wadsworth, A. P., Manchester, 1964, on Boulton & Watt, Gale, W. K. W., a City of Birmingham Museum publication, 1952. On the Miners' Bank, Pottsville (p. 122) see Gilchrist, A. Journal of the Society of Architectural Historians, XX, 1961, p. 137.

American Architecture (pp. 140 etc.):

Condit, C. W. American Building Art. The Nineteenth Century, New York, 1960. Also Condit, C. W. The Chicago School, 1875–1925, 2nd ed., Chicago, 1964. Moreover, more popular, Siegel, A. Chicago's Famous Buildings, Chicago, 1965 and, in Italian, Pellegrini, L., nine articles from the Chicago School to Elmslie, Purcell, etc., in L'Architettura i, 1955–6; ii, 1956–7.

Art Nouveau (p. 90):

The flood of new books is not yet subsiding. The following list for 1955–67 (and indeed with four exceptions 1964–7) is long, yet not complete. They are given here in chronological order and should be linked with note 1 to Chapter 4.

Pollack, B. Het Fin-de-Siècle in de Nederlandsche Schilderkunst, The Hague, 1955 (on painting and especially Toorop). Grady, James, in 1955 brought out 'A Bibliography of the Art Nouveau' (Journal of the Society of Architectural Historians, xiv). Selz, J. and Constantine, M. Art Nouveau, Museum of Modern Art, New York, 1959, is brief, but as all publications of the museum, extremely useful. On S. Bing of the shop 'L'Art Nouveau' see Koch, R., in Gazette des Beaux Arts, per. vi, vol. liii, 1959. Schmutzler, R. Art Nouveau-Jugendstil, Stuttgart, 1962 (and London, 1964), is comprehensive and brilliant, the best book on the subject. In 1964 two more exhibition catalogues came out: Munich, Haus der Kunst (Sezession: Europäische Kunst um die Jahrhundertwende) and Vienna (Wien 1898-1914, Finale und Auftakt). Of the same year the first Italian book: Cremona, I. Il Tempo dell'Art Nouveau, Florence, 1964. Hermand, J. Jugendstil, ein Forschungsbericht, 1918-64, Stuttgart, 1965, is an intelligently done report on the development of Art Nouveau research. Guerrand, R. H. L'Art Nouveau en Europe, Paris, 1965, a paperback, quite comprehensive, but lighter reading than Madsen's book (see below). Rheims, M. L'art 1900, Paris, 1965, (English, London 1966) is a picture book with about 600 illustrations, many of them unknown. Kunsthandwerk um 1900 is the title of the sumptuous catalogue of an exhibition held at Darmstadt in 1965 (vol. i, 1965). 1966 brought a volume on the art of the book: Taylor, Russell J. The Art Nouveau Book in Britain, London, 1966. In the same year and in 1967 two paperbacks appeared: Amaya, M. Art Nouveau, London, 1966, and Madsen, S. Tschudi Art Nouveau, London, 1967, the latter eminently suitable as a textbook for students. Finally, also of 1967, the catalogue of an exhibition at Ostend ('Europe 1900') and a specialist treatise on typography and allied matters, by the author of two earlier books on Art Nouveau painting: Hofstätter, H. H. Druckkunst des Jugendstils, Baden-Baden, 1967. Pestalozzi, K. and Klotz, V. (ed.), Darmstadt 1968 I have not seen.

Art Nouveau Painting:

For Pollack, B. Het Fin-de-Siècle . . ., 1955 see the list for Art Nouveau. Hochstätter, H. H. Geschichte der europäischen Jugendstilmalerei, Cologne, 1963, and Symbolismus in der Kunst der Jahrhundertwende, Cologne, 1965. On the Nabis, and especially Maurice Denis, Humbert, A. Les Nabis et leur époche, Paris, 1954, ought to have been noted earlier.

Journals:

Pan (see p. 105): Salzmann, K. H. Archiv für Geschichte des Buchwesens I, 1958. The Studio (see pp. 107-8). As a sign of the international popularity of The Studio in its early years and of the veneration extended to it, here are passages from Peter Altenberg (1839–1919): Was der Tag mir zuträgt (1900); Altenberg was a master of the feuilleton. 'Everything took place in good order for Iolanthe . . . Once a month, on every 15th, there appeared from London for her "The Studio, an illustrated Magazine of fine and applied Art". On that evening, after supper, Iolanthe placed herself in a low easy chair in the corner under a mild English standing lamp. On her delicate knees rested The Studio and slowly she turned page after page. Sometimes she stopped for a long while. Then her husband said: "Iolanthe . . ." She never called out to him, she never said: "Look." He remained seated at the supper table, smoking quietly, resting from the day. She sat in the low easy chair, turning the pages. Sometimes he moved towards the standing lamp, improved the light, adjusted the green silk shade, and retired again. It was like a holiday, that 15th of the month. "I am in England", she felt, "in England." He never touched her after such an evening, in such a night.'

RADICAL MOVEMENTS BEFORE 1914

For Futurism the most recent treatment is Schmidt-Thomsen, J. P. Floreale und futuristische Architektur, Berlin, 1967. There was also an interesting movement of a cubist kind in Czechoslovakia, and the group, especially Josef Chochol and Joseph Gocar, both born in 1880, has been treated recently by J. Vokoun in The Architectural Review cxxxix, 1966, pp. 229 etc. Also Architektura ČSSR, III, 1966 and – a partial translation of this – Casabella No. 314, 1967.

PLACES AND BUILDINGS

Bedford Park, London (top p. 157): Artists and Architecture of Bedford Park, exhibition booklet, 1967 (architecture by Greeves, T. A.). Also Greeves, T. A. in Country Life, cxlii, Nos. 3692 and 3693, 1967, and Fletcher, I. in Romantic Mythologies, London, 1967.

Fagus Factory (top p. 211): Weber, H.: Walter Gropius und das Faguswerk, Munich, 1961.

BIOGRAPHICAL

Behrens: Catalogue of an exhibition Kaiserslautern, Darmstadt, Vienna, 1966-7. Also Schriften, Manifeste, Briefe (Agora No. 20), 1967.

Berenguer (a Catalan developing parallel to Gaudí): Mackay, D. The Architectural Review, cxxxvi, 1964.

Bernard: Catalogue of an exhibition, Lille, 1967.

Burnham & Root: Architectural Record, xxxviii, 1915.

Domenech (another of the Barcelona pioneers): Bohigas, O.: The Architectural Réview, cxlii, 1967.

Gaudí: Collins, G. R., New York, 1960, is all-round the best book up to date, not long, not complicated, and always reliable. Sweeney, J. J. and Sert, J. L., London, 1960, is longer, more richly illustrated and perhaps more stimulating. Pane, R., Milan, 1964, large, beautifully illustrated but textually questionable. Yet another book: Casanelles, E., London, 1967, I had not seen at the time of writing. Nor have I seen Martinell, C., Barcelona, 1967, large and fully illustrated. On the Parque Güell exclusively see Giedion-Welcker, C., Barcelona, 1966.

Horta: Delavoy, R. L., Brussels, 1958.

Klimt: Catalogue of an exhibition in the Galerie Weltz, 1965.

Loos: Sämtliche Schriften, vol. 1, Vienna and Munich, 1962. Münz, L., and Künstler, G., Vienna and Munich, 1964. The English edition, London, 1966, has translation of three of Loos' essays and a long introduction by Pevsner, N.

Mackmurdo: Pond, E., The Architectural Review, cxxviii, 1960.

Morris: The most recent biographies are Thompson, E. P., London, 1955, an intelligent treatment from the Marxist point of view, Thompson, Paul, London, 1967, all-round the best book up to date, and Henderson, P., London, 1967.

Muthesius: Posener, J., in Architects' Yearbook, x, 1962.

Perret: Zahar, M., D'une doctrine d'architecture: Auguste Perret, Paris 1959.
Peter Collins, in Concrete, 1959, quoted above, has 100 pages on Perret.

Pritchard (J. F.): The date of birth given on p. 126, was published in *Blackmanbury*, 1, No. 3, 1964.

Sant' Elia: Caramel, L., and Longatti, A.: Catalogue of the permanent collection, Como, 1962.

Sullivan: Louis Sullivan and the Architecture of Free Enterprise (ed. E. Kaufmann), Chicago, 1956. On Sullivan's ornament Scully, V. in Perspecta, v, 1959. On the share of Elmslie, G. G. in that ornament see Paul Sherman, Englewood Cliffs, N. J., 1962.

Tiffany: Koch, R., New York, 1964.

Van de Velde: Catalogue of, an exhibition at the Kröller-Müller Museum, Otterloo, 1964. Very recent and lavish, Hammacher, A. M., Le monde de H. van de Velde, Paris, 1967.

Wagner: Gerettsegger, H., and Peinter, M., Salzburg, 1964.

Second Supplementary Bibliography

GENERAL

Until now additions to the original text of 1936 had not touched the essential matter of the book. This time that is not so. Professor Herwin Schaefer's The Roots of Modern Design (London, 1970) builds up a prehistory of twentiethcentury design, totally different from mine. His thesis is something like this: my pioneers are individual innovators from c. 1890 onwards creating the modern style of the first half of the twentieth century, i.e. broadly speaking, functionalism. But Herwin Schaefer unfolds a whole history of functionalism in the eighteenth and nineteenth centuries, discussing and illustrating such things as microscopes, quadrants, compasses, adding machines, scales, lathes, big machines, locomotives, carriages, coffee-makers, scissors, ploughs and so on - all or nearly all anonymously designed. His examples are indubitably functional, but they are innocent of aesthetic efforts. So, according to him, my book is only part two, and his book ought to become part one. In this he is right, but where he is in my opinion in error is that he believes in a direct and conscious transmission of his impersonal functionalism to the functionalists dealt with in my book. I do not believe in this direct transmission and have not yet come across any evidence. And there is another aspect to Herwin Schaefer's book. His examples are mostly Victorian in date, but they are anti-Victorian in approach to design. His display and his arguments make me wonder whether I ought not to re-title my book 'Pioneers of the International Modern to 1914'. Such a re-titling would have the added advantage of drawing attention to the fact that the so-called International Modern which reached its climax in the thirties is no longer the style of today. We live in the shadow of Ronchamp and Chandigarh, of Paul Rudolph and James Stirling. Philip Johnson said to me some ten years ago: 'You are the only man alive who can still say Functionalism with a straight face.' I am unrepentant enough to take that as a compliment. So would of course Herwin Schaefer who gave his book the sub-title 'Functional Tradition in the Nineteenth Century'. Readers must make up their minds whether they want the history of the late nineteenth and early twentieth centuries as reflected by me, or as reflected by anti-rationalism.

Other general books:

The list of other general books may just as well start with *The Anti-Rationalists*, edited by Sir James Richards and myself, London, 1973. The book is a symposium and has chapters on Guimard, Wagner, Lechner (of Budapest), Mackmurdo, Mackintosh, Poelzig and others. The authors of most of these chapters will be found in the Biographical Addenda on pp. 251-3.

Posener, J., Anfänge des Funktionalismus: von Arts und Crafts zum Deutschen Werkbund, Berlin, etc., 1964. Readings from Lethaby, T. G. Jackson, Voysey, Ashbee, G. Scott, Muthesius and the Werkbund Conference of 1914.

Posener, J., From Schinkel to the Bauhaus, Architectural Association Papers V. London, 1972.

MacLeod, R., Style and Society; Architectural Ideology in Britain, 1835–1914, London, 1971.

Pevsner, N., Studies in Art, Architecture and Design, 2 vols., London, 1968. In volume 2 are chapters on Morris, Mackmurdo, Voysey and Mackintosh. For these, see pp. 252 and 253.

Chapter 1: Theories of Art, from Morris to Gropius

(For additions to individual architects and writers see Biographical Addenda.)

To the first sentences of the chapter cf. James Fergusson, A History of Architecture, 1861, vol. 1, p. 9: Architecture is 'the art of ornamented or ornamental construction'. To the partiality in favour of the engineers cf. Franz Wickhoff (who died in 1909): 'The new style which one is always seeking has already been found, and it would be better if all building were done by engineers instead of architects'. I am quoting from U. Kulturmann, Geschichte der Kunstgeschichte, Vienna and Düsseldorf, 1966, p. 285.

Chapter 2: From 1851 to Morris and the Arts and Crafts

From 1851 to Morris means the High Victorian and the beginnings of the Late Victorian. It would far transcend the limits of this bibliography even to try listing the new literature of the last twenty years.

On Design and the Arts and Crafts:

Victorian Church Art, Exhibition, Victoria and Albert Museum, 1971-1972.

Victorian and Edwardian Decorative Art (The Handley-Read Collection), Exhibition, Royal Academy, London, 1972.

Naylor, G., The Arts and Crafts Movement, London, 1971.

Aslin, E., The Aesthetic Movement, Prelude to Art Nouveau, London, 1969.

MacCarthy, F., All Things Bright and Beautiful; Design in Britain, 1830 to Today, London, 1972.

On Nesfield and Norman Shaw:

Girouard, M., The Victorian Country House, Oxford, 1971 (chapters on Nesfield's Kinmel Park, on Shaw's Cragside and Adcote, and on Webb's Standen).

Chapter 3: Eighteen-ninety in Painting

Gauguin: Jaworska, W., Gauguin and the Pont Aven School, London, 1972. Symbolism: Lehmann, A. G., The Symbolist Aesthetic in France, 1885–1895, 2nd ed., Glasgow, 1968; Jullian, P., The Symbolists, London, 1973.

Munch: Hodin, J. P., Munch, London, 1972, the most recent of a large number of monographs. Specially recent: Edvard Munch-Probleme-Forschungen-Thesen, ed. H. Bock and G. Busch, Munich, 1973.

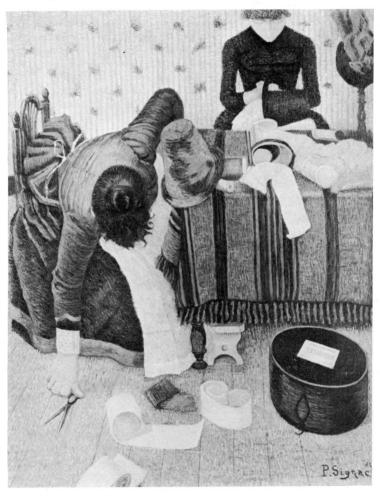

149. Signac: Two Milliners, 1885.

Valloton: Valloton, M., and Goerg, C., Felix Valloton, catalogue raisonné of the printed Graphic Work, 1972.

Signac's Two Milliners (Ill. 149), Rübele Collection, Zurich) is an additional illustration, because the picture is dated 1885 and yet is as ruthlessly stylized as any Seurat.

Chapter 4: Art Nouveau

I wrote in 1968 (p. 242): 'the flood of new books is not yet subsiding'. It has not subsided since. Here is a list, very probably far from complete.

Battersby, M., Art Nouveau, London, 1969.

Barilli, R., Art Nouveau, London, 1969 (Italian: Il Liberty, Milan, 1966).

Koreska-Hartmann, L., Jugendstil - Stil der 'Jugend', Munich, 1969.

Grover, R. and L., Art Glass Nouveau, Rutland, 1967.

Bing, S., Artistic America: Tiffany Glass and Art Nouveau, Boston (M.I.T.), 1970.

Hensing-Schefeld, M., and Schaefer, I., Struktur und Dekoration: Architektur-Tendenzen in Paris und Brüssel im späten neunzehnten Jahrhundert, Stuttgart, 1969.

The reception of Art Nouveau in England was not enthusiastic. When a number of Art Nouveau objects shown at the Paris Exhibition of 1900 had been presented by Mr George Donaldson to the Victoria and Albert Museum, Belcher, Blomfield, Macartney and Prior, all four architects of distinction, joined in a protest letter to *The Times*: 'It is much to be regretted that the authorities of South Kensington have introduced into the museum specimens of the work styled 'l'Art Nouveau". This work is neither right in principle nor does it evince a proper regard for the materials employed. As cabinet maker's work it is badly executed. It represents only a trick of design, developed from debased forms, [and it] has prejudicially affected the design of furniture and buildings in neighbouring countries.'

Chapter 5: Engineering and Architecture in the Nineteenth Century

The mill-owners: Fitton, R. S., and Wadsworth, A. P., The Strutts and the Arkwrights, 1758-1830, London, 1958; Taylor, B., Richard Arkwright, London, 1957; Hills, R. L., Richard Arkwright and Cotton Spinning, London, 1973.

Early Iron: John Harris in his edition of C. R. Cockerell's *Ichnographia Domestica* (Architectural History, XIV, 1971) illustrates Cockerell's drawing of Richard Payne Knight's library at No. 3 Soho Square, and this had iron Gothic vaults.

Crystal Palace: Beaver, P., The Crystal Palace, London, 1970; Fay, C. R., Palace of Industry, 1851, Cambridge, 1951.

Beutler, 'St Eugène und die Bibliothèque Nationale', Miscellanea pro Arte (Festschrift H. Schnitzler), Düsseldorf, 1965.

Chapter 6: England, Eighteen-ninety to Nineteen-fourteen

Japonisme: Chesnau, E., 'Le Japon à Paris', Gazette des Beaux Arts (Second Period, XVIII, 385-97 and 845-56), 1878. This should have been quoted ever since the first edition. It refers to Manet, Whistler, Degas, Monet, Tissot and Stevens.

The Aesthetic Movement and the Cult of Japan: Exhibition, Fine Arts Society, London, 1972.

Anti-Voysey: Lethaby (see below, p. 252) said to Edward Johnston, when in 1898 he wanted to enter the Central School of Arts and Crafts (quoted from P. Johnston, Edward Johnston, London, 1959, p. 74): 'If you draw a straight line with a heart at the top and a bunch of worms at the bottom, and call it a tree, I've done with you.'

Townsend: The church of Great Warley in Essex ought to have been mentioned (1904) and in connection with this the Watts Chapel at Compton in Surrey (interior 1901). There are chapters on both of them in *The Anti-Rationalists*—see note under General, p. 246.

Working-Class Housing: Tarn, J. N., Working-Class Housing in Nineteenth Century Britain, London, 1971.

Bedford Park: The reference to Country Life on p. 243 should read: Country Life, cxlii, 1967, pp. 1524 ff. and 1600 ff. Mr Greeves emphasizes that Norman Shaw was not in on Bedford Park at the very beginning (see Building News, Vol. 33, 1877; Vol. 34, 1878; Vol. 36, 1879). I should have stressed Godwin more.

Chapter 7: The Modern Movement before Nineteen-fourteen

Side by side with Perret, Henri Sauvage ought to have been mentioned. His flats at 26 rue Vavin with their stepped-back façade are as early as 1910. The date is wrong in my Sources of Modern Architecture and Design, where the building is illustrated on p. 193. The correct date was pointed out to me by Professor Bisset.

Concerning Garnier's Cité Industrielle, I ought to have quoted more of the text. Here are some samples: 'C'est à des raisons industrielles que la plupart des villes neuves que l'on fondera désormais, vaudront leur fondation.' His town is to have 35,000 inhabitants. The public authorities can dispose of the ground as they think best. Dwellings have neither backyards nor inner courtyards. No more than half the total area is built over; the rest is public green, and there are plenty of pedestrian passages. As for his building material, these are Garnier's words: 'Tous les édifices importants sont presque exclusivement bâtis en ciment armé.' As for character, the buildings are 'sans ornement' and even 'sans moulures'. Once the basic structure is complete the decorative arts can then be called in and decoration can contribute all the more 'nette et pure' as it is 'totalement independente de la construction'.

McKim, Mead and White: My text has not done justice to them. Before they moved to their Neo-Renaissance and their Classical Re-revival (see pp. 65, 66, 195) they designed with far greater originality. Of their houses the most daring

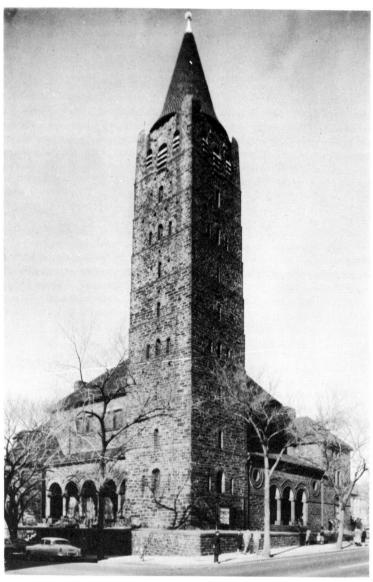

150. McKim, Mead and White: Lovely Lane Methodist Church, Baltimore, Maryland, 1883–7.

one, the Low House at Bristol, Rhode Island, was built in 1887. I have illustrated it in *The Sources of Modern Architecture and Design*, p. 35. Less well known is the Lovely Lane Methodist Church at Baltimore (Ill. 150). This dates from 1883–1887 and is a progressive continuation of the Richardson Romanesque. I owe the photograph to Professor Jordy. He illustrated the church in his edition of Schuyler (Montgomery Schuyler, *American Architecture and other Writings*, ed. W. H. Jordy and R. Coe, Harvard University Press, 1971, I, pp. 43 and 215).

Secession: See Waissenberger, R., Die Wiener Sezession, Vienna and Munich, 1971.

On page 196 I said of Olbrich's Hochzeitsturm of 1907–1908 that the strips of low horizontal window wrapped round a corner are probably earlier here than anywhere else. Herr Edgar Engelskircher drew my attention to Olbrich's Haus Deiters of 1900–1901 on the Mathildenhöhe, where the same motif occurs in a dormer.

Anonymous functional design: see General on the first page of this new bibliography. A parallel to Herwin Schaefer's book was an exhibition held in Munich in 1971: Die verborgene Vernunft, Exhibition Neue Sammlung, Munich, 1971.

Futurism: Schmidt-Thomsen, J. P., Floreale und futuristische Architektur, das Werk von Antonio Sant'Elia, Berlin, 1967 (doctoral thesis); Martin, M. N., Futurist Art and Theory, 1909–1915, Oxford University Press, 1968; Apollonio, U., (ed.), Futurist Manifestos, London, 1973.

BIOGRAPHICAL ADDENDA

Ashbee: Ashbee, C. R., *Memoirs*, 1938 (manuscript, Victoria and Albert Museum); Burroughs, B. G., 'Three Disciples of William Morris', *Connoisseur*, clxxi-clxxiii, 1969-1970; 'C. R. Ashbee', clxxii, pp. 85-90 and 262-6.

Berlage: Singelenberg, P., H. P. Berlage, Amsterdam, 1969; Reinink, A. D., 'American Influences on late-nineteenth century Architecture in the Netherlands', Journal of the Society of Architectural Historians, xxix, 1970, pp. 163-74.

Dresser: Christopher Dresser, Exhibition, Fine Arts Society, London, 1972.

Eiffel: Prévost, J., Eiffel, Paris, 1929. (Not quoted in previous editions.); Besset, M., Gustave Eiffel, Paris, 1957; Igat, Y., Eiffel, Paris, 1961.

Endell: Schaefer, I., August Endell, Werk, lviii, 1971, pp. 402-408; Anonymous: 'Endell', Architectural Design, February 1972.

Garnier: Wiebenson, D., Tony Garnier: the Cité Industrielle, London, 1969.

Gaudí: Martinell, C., Gaudí, su vida, su teoría, su obra, Barcelona, 1967; Perucha, J., Gaudí, an Architecture of Anticipation, Barcelona, 1967; Sert, J. L., Gomis, J., and Prats Valles, J., Cripta de la Colonia Güell de A. Gaudí, Barcelona, 1968; Masini, L. V., Gaudí, Florence, 1969.

Gimson: Burroughs, B. G., 'Three Disciples of William Morris', Connoisseur,

- clxxi-clxxiii, 1969-1970; 'Ernest Gimson', clxxi, pp. 228-32 and clxxii, 8-14.
- Gropius: Franciscono, M., Walter Gropius and the Creation of the Bauhaus in Weimar, University of Illinois Press, 1971.
- Guimard: Lanier Graham, F., *Hector Guimard*, Museum of Modern Art, New York, 1970; Cantacuzino, S., 'Hector Guimard', in *The Anti-Rationalists*, London, 1973, pp. 9-31.
- Hoffmann: Sekler, F., 'Art Nouveau Bergerhöhe', Architectural Review, cxlix, 1971, pp. 75-6.
- Horta: Borsi, F., and Portoghesi, P., Victor Horta, Brussels, 1969.
- Klimt: Nebehay, C. M., Gustav Klimt: Dokumentation, Vienna, 1969; Hofmann, W., Gustav Klimt und die Jahrhundertwende, Salzburg, 1970; Novotny, F., and Dobai, J., Gustav Klimt, Salzburg, 1971.
- Lethaby: Burroughs, B. G., 'Three Disciples of William Morris', Connoisseur clxxi-clxxiii, 1969–1970; 'W. R. Lethaby', clxxiii, pp. 33-7.
 - Weir, R. W. S., William Richard Lethaby, London, 1932.
- Loos: Gradmann, E., Adolf Loos, Aufsätze zur Architektur, Institut für Geschichte und Theorie der Architektur, VI, Zurich; Basel, 1968, pp. 37-41.
- Mackintosh: MacLeod, R., Charles Rennie Mackintosh, London, 1968; Pevsner, N., 'Charles Rennie Mackintosh', in Studies (see General Literature), pp. 152-75; Walker, D., 'The Early Works of Mackintosh', in The Anti-Rationalists, London, 1973, pp. 116-35; Sekler, E., 'Mackintosh and Vienna', in The Anti-Rationalists, pp. 136-42.
- Mackmurdo: 'Arthur H. Mackmurdo', in *Studies* (see General Literature), pp. 132-9; Pond, E., 'Mackmurdo Gleanings', in *The Anti-Rationalists* (see General Literature), pp. 111-15.
- Maillart: Gunschel, G., Grosse Konstrukteure, Berlin, etc., 1965. Chapters on Freyssinet and Maillart.
- Morris: Lamire, E. D. (ed.), The Unpublished Lectures of William Morris, Detroit, 1969; Meier, Paul, La pensée utopique de William Morris, Paris, 1972; Pevsner, N., 'Morris', in Some Architectural Writers of the Nineteenth Century, Oxford, 1972, pp. 269-89 and 315-24; Pevsner, N., 'Morris and Architecture', in Studies (see General Literature), pp. 108-17.
- Olbrich: Olbrich: das Werk des Architekten, Exhibition, Darmstadt, Vienna, Berlin, 1967.
 - Schreyl, K. H., J. M. Olbrich: die Zeichnungen in der Kunstbibliothek Berlin, Berlin, 1972.
- Perret: Goldfinger, E., (ed.), Auguste Perret, Writings on Architecture, Studio Vista, 1971.
- Poelzig: Heuss, T., Poelzig, ein Lebensbild, Tübingen, 1939; Hans Poelzig (ed. J. Posener), Berlin, 1970; Posener, J., 'Poelzig', in The Anti-Rationalists (see General Literature), pp. 193–202.
- Richardson: Eaton, L. K., American Architecture Comes of Age; the European Reaction to H. H. Richardson and Louis Sullivan, Boston (M.I.T.), 1972.
- Root: Hoffmann, D. D., (ed.), The Meaning of Architecture; Buildings and Writings of J. W. Root, New York, 1967.

Baillie Scott: Kornwulf, J. D., M. H. Baillie Scott and the Arts and Crafts Movement, Baltimore and London, 1972.

Serrurier-Bovy: Watelet, J. G., 'Le décorateur liégeois Gustave Serrurier-Bovy, 1858-1910', Cahiers van de Velde, xi, 1970.

Sullivan: See Richardson.

van de Velde: Huter, K.-H., Henry van de Velde, Berlin, 1967. Cahiers van de Velde; so far eleven issues.

Voysey: Pevsner, N., 'C. F. A. Voysey', in Studies (see General Literature), pp. 85-96.

Wagner: Giusti Bacolo, A., Otto Wagner, Naples, 1970; Graf, O. A., 'Wagner and the Vienna School', in *The Anti-Rationalists* (see General Literature), pp. 85-96.

Table of Names and Dates

	Architects and Designers		Painters	
1750-1830	Telford	1757-1834		
	Finley	? -1828		
	Paxton	1801–65		
	Horeau	1801-72		
	Labrouste	1801-75		
	Brunel	1806-59		
	Boileau	1812–96		
			Moreau Rossetti	1826–98 1828–82
1831-40	Shaw	1831-1912		
3- 4-	Webb	1831-1915		
	Jenney	1832-1907		
	Eiffel	1832-1923		
	Godwin	1833-86		
	0041111	1055 00	Burne-Jones	1833-98
	Morris	1834-96	During Jones	1033 70
	Dresser	1834-1904		
	de Baudot	1834-1915		
		54 -7-5	Whistler	1834-1923
	Nesfield	1835-88		
	Richardson	1838–86		
		3-	Cézanne	1839-1906
	Contamin	1840-93	34241111	
		4- 73	Redon	1840-1916
1841-50	Wagner	1841-1918		
4- 5-			Rousseau	1844-1910
	Dutert	1845-1906		
	Day	1845-1910		
	Crane	1845-1915		
	Gallé	1846-1904		
		4>-4	Gauguin	1848-1903
	Koepping	1848-1914	8	
	Tiffany	1848-1933		
	Root	1850-91		
1851-60	Mackmurdo	1851-1942		
	Gaudí	1852-1926		
	Townsend	1852-1928		
			van Gogh	1853-90
	White	1853-1906		
	Messel	1853-1909		
			Hodler	1853-1918
	Daum	1854-1909		
	Holabird	1854-1923		

	Architects and Designers		Painters	
	Gilbert	1854-1934		
	Roche	1855-1927		
	Sullivan	1856-1924		
	Berlage	1856-1934		
	Voysey	1857-1941		
	Delaherche	1857- ?		
		,	Khnopff	1858-1921
			Toorop	1858-1928
	Majorelle	1859-1926	•	
		,,	Seurat	1859-91
			Ensor	1860-1949
	Hankar	1861-1901		212
1861-70	Muthesius	1861-1927		
1001 /	Plumet	1861-1925		
	Horta	1861-1947		
	110111	1001 1947	Klimt	1862-1918
	Obrist	1863-1927		1002 1,11
	Ashbee	1863-1942		
	11011000	1003 1942	Munch	1863-1944
	van de Velde	1863-1957		1003 1944
	Gimson	1864–1920		
	Eckmann	1865-1902		
	Lexinaini	1005 1902	Vallotton	1865-1925
	Smith	1866-1933	v direction.	100) 192)
	Olbrich	1867–1908		
	Guimard	1867-1942		
	Brangwyn	1867–1956		
	Mackintosh	1868–1928		
	Behrens	1868-1940		
	Poelzig	1869-1948		
	Garnier	1869–1948		
	Wright	1869-1959		
	Loos	1870-1933		
	1003	10/0-1933	Denis	1870-1945
	Berg	1870-1947	Dems	10/0-1945
	Hoffmann	1870–1955		
1871-80	Selmersheim	1871-		
18/1-80	Brewer	1871–1918		
	Endell	1871-1918		
	Enden	10/1-1925	Beardsley	1972 09
	Maillart	1972-1040	Beardsley	1872–98
	Heal	1872-1940		
	Schmidt	1872-1959		
	Perret	1873-1948		
		1874-1954		
	Paul	1874-1968		
-00	Schröder	1878-1962		
1881–90	Gropius	1883-1969		
	Mies van der Rohe			
	Sant'Elia	1888-1917		

Index

Roman numerals refer to the text, italic numerals to the pages where illustrations appear.

AEG: 203, 206 Casa Batlló: 115 AEG small motors factory: 204, 205; Casa Vicens: 112 turbine factory: 203-4, 205 Parque Güell: 111, 112, 230 n. 37 Aitchison, George: 122, 232 n. 9 Sagrada Familia: 113-14, 115-16, Albert, Prince: 40 230 n. 37 Barlow, W. H.: 132, 134 Alfeld, Fagus Factory: 211-14, 213, Baudot, Anatole de: 32, 145, 146, 179 American Architecture (Schuyler): 28 Bauhaus: 38-9, 210 Beardsley, Aubrey: 91-4, 94, 98, 106, Amsterdam, Exchange: 172 Scheepvarthuis: 172 107, 108, 110, 175, 228 n. 8, 238 n. 19 Arkwright, Richard: 45, 119-20 Bedford Park: 157, 158, 176, 243, 249 Aronco, Raimondo d': 229 n. 26 Behrens, Peter: 36, 38, 39, 201-6, Art décoratif, L': 108 204-5, 207, 211, 215, 240 nn. 17, 18, Art et décoration: 108 22, 243 Art Nouveau: 29, 30, 32, 34, 67, 70, Benson, W. A. S.: 54 89, 90-116, 142, 147, 148, 149, Benyon, Bage, & Marshall: 119, 120 151, 152, 157, 161, 162, 166, 167, Berg, Max: 206, 208 168, 172, 174, 193, 195, 196, 201, Bergson, Henri: 152 202, 227 n. I, 228 n. I3, 229 n. 26, Berlage, H. P.: 32, 171-2, 172, 239 230 n. 31 n. 10, 251 Arts and Crafts Exhibition Society: Berlin, Grosses Schauspielhaus: 210 54, 108 Haby's barber shop: 101 Arts and Crafts Movement: 25, 29, Heymel flat: 202, 203 34, 84, 91, 94, 106, 107, 108, 110, Berlin Town-Planning Exhibition, 118, 147, 151, 220 n. 33 1910: 178 Art Workers' Guild: 54 Bernard, Émile: 74, 78, 244 Ashbee, C. R.: 25-6, 54, 108, 110, Bertsch, Karl: 223 n. 87 Berwick-on-Tweed, Union Bridge: 162, 220 n. 33, 230 n. 31, 251 Astorga, Palace of the bishop of: 112 128 Aubert, Felix: 108 Bessemer, Henry: 45 Aubertor, Jean: 44 Beuth, B. C. W. von: 121 Austrian Werkbund: 36 Bexleyheath, Red House: 22, 49, 57, Avenarius, Ferdinand: 33 58, 58–60 Bing, Samuel: 101, 102, 108, 110 Baillie Scott, M. H.: 162, 223 n. 87, Birmingham, Eagle Insurance: 238 n. 230 n. 31, 253 20 Baltard, Victor: 132, 136 New Street Station: 132 Baltimore, Lovely Lane Methodist Blake, William: 86, 90 Church: 250 Blore, E.: 233 n. 23

Bogardus, James: 121, 122

Barcelona, Casa Milá: 117, 230 n. 37

Cazalis, Henri: 220 n. 17 Boileau, Louis-Auguste: 135-6, 136, Century Guild: 54, 90, 98, 99, 156 234 n. 37 Cézanne, Paul: 69, 70-71, 75, 80, 88, Boileau, Louis-Charles: 136, 234 n. 37 Bonatz & Scholer: 239 n. 4 89, 109, 226 n. 7 Boston, Brattle Square Church: 165 Chatsworth, conservatory: 132 Boulton, Matthew: 110 Chiattone, Mario: 211, 213 Chicago, Anshe Ma'ariv Synagogue: Bourneville: 176 Bradley, cast-iron pulpit: 129 98 Brangwyn, Frank: 108, 152 Auditorium Building: 97, 97 Braquemond, Félix: 235 n. 4 Carson Pirie Scott Store: 98, 184-6, Breslau, Jahrhunderthalle: 206, 208 187, 239 n. 10 Charnley House: 186, 188 Office building by Poelzig: 206-8, Home Insurance Building: 140 Bretton Hall, conservatory: 132 Hull House: 27-8 Brewer, Cecil: 162, 163 Marshall Field Wholesale Store: 142 Brighton Chain Pier: 128 Monadnock Block: 142, 143 Tacoma Building: 141 Brighton Pavilion: 131 Chicago Exhibition 1893: 176 Broadleys, Lake Windermere: 161, Chicago School: 140-42, 176 Chippendale, Thomas: 20 Brooklyn, grain elevator: 125 Chipping Campden: 26 Brown, Samuel: 128 Brunel, Isambard Kingdom: 128, 129 Chorleywood, The Orchard: 152, 153 Brussels, Maison du Peuple: 104 Cinq, Les: 102 Citrohan designs: 184 Old England Store: 104 Rue Paul-Émile Janson (No. 6): 98, Clifton Bridge: 128, 129 Clutha glass: 55, 228 n. 15 99, 104, 228 n. 8 Coalbrookdale Bridge: 104, 126, 127 Stoclet House: 197-8, 199 Cobden-Sanderson, T. J.: 54, 108, 254 Buffalo, Heath House: 187, 189 Coignet, François: 144 Larkin Building: 191-2, 192, 239 Cole, Sir Henry: 46, 48, 49, 55, 133, Buffington, L. S.: 234 n. 42 Colenbrander, T. A. C.: 86 Bunning, J. B.: 104, 135 Coleridge, S. T.: 21 Burges, William: 62, 90, 93, 97, 112 Cologne Werkbund Exhibition: 215, Burne-Jones, Sir Edward: 53, 90, 92, 108, 110, 151, 225 n. 10 215–16 Colonia Güell: 112 Burnham, D. H.: 142, 143, 176, 177, Colwall (Malvern), Perrycroft: 159, 178 160, 186 Contamin: 138, 140 Callet, F.-E.: 133 Cambridge, Mass., Stoughton House, Cort, Henry: 44 Courbet, Gustave: 70 65,65 Cowper: 132 Caröe, W. D.: 116 Carr, John: 129 Cragg, John: 130 Crane, Walter: 25, 26, 29, 54, 99, 107, Cartwright, Edmund: 45 108, 109, 110, 152 Catel, Ludwig: 118

Crespin, Adolphe: 235 n. 2 Creswell, H. B.: 237, 238 n. 20 Crompton, Samuel: 45 Cubism: 75, 182

Dampt, Jean: 229 n. 20 Darby, Abraham: 44, 126

Darmstadt, Hochzeitsturm: 196, 197

Daum, Augustin: 102 Day, Lewis F.: 26, 55, 107 Deane, Sir Thomas: 135

Degas, Edgar: 80, 150, 151, 230 n. 32,

235 n. 4

Dehmel, Richard: 108 Dekorative Kunst: 108 Delacroix, Eugène: 70 Delaherche, Auguste:

Delaherche, Auguste: 102, 108, 109 De Morgan, William: 54, 55, 56

Denis, Maurice: 77-8, 79, 95

Design and Industries Association

(D.I.A.): 36, 222 n. 51
eutsche Kunst und Deko

Deutsche Kunst und Dekoration: 108 Deutscher Werkbund: 35, 36-7, 39, 206, 210, 222 n. 51

Deutsche Werkstätten: 34, 35, 176, 206

Dial: 91, 98

Ditherington, flax-spinning mill: 119,

Domino designs: 184 Douro Bridge: 140

Doves Press: 35, 54, 154, 202

Dresden Exhibition, 1897: 110; 1899:

34; 1905: 34

Dresser, Christopher: 54, 55, 228 n. 15,

235 n. 4, 251

Dudok, W. M.: 237 n. 13 Dülfer, Martin: 110

Dürerbund: 33

Dutert, C.-L.-F.: 138, 140

Eckmann, Otto: 105-6, 105, 108, 110,

École Polytechnique: 44 Eiffel, Gustave: 139, 140, 251

Encyclopaedia of Cottage, Farm, and

Villa Architecture (Loudon): 144
Endell, August: 106, 108, 110, 193,

194, 195, 251

Enfield, Private Road (No. 8): 156, 156

Ensor, James: 70, 81-3, 82, 109, 150 Entretiens (Viollet-le-Duc): 104, 137,

137

Everton, church: 130, 233 n. 23 Expressionism: 74, 75, 171, 217

Favrile glass: 102 Fergusson, James: 134 Finch, A. W.: 98

Finley, James: 126–8 Firth of Forth Bridge: 138–9 Fischer, Theodor: 35–6, 110, 178

Fontaine: 125 Foulston, John: 118 Fry, Roger: 239 n. 8

Fry, Roger: 239 n. 8 Futurists: 37, 38, 210

Gaillard, Eugène: 102 Galimberti: 230 n. 6

Gallé, Émile: 101–2, 103, 106, 228 n.15

Garabit Viaduct: 140

Garnier, Tony: 179, 181-3, 181-3, 184, 185, 201, 238 n. 4, 251

Gaudí, Antoni: 111, 112–16, 113–15, 117, 172, 194, 217, 229 n. 25, 244, 251

Gauguin, Faul: 70, 73-4, 75, 75, 76, 76, 77, 78, 80, 81, 86, 88, 109, 151, 247

Gautier, Théophile: 135, 211, 236 n. 7

Gilbert, Alfred: 227 n. 3

Gimson, Ernest: 152-4, 155, 251-2 Glasgow, Cranston Tearoom, Buchanan Street: 173, 173, 174

Buchanan Street: 173, 173, 174 Cranston Tearoom, Sauchiehall

Street: 168, 169 Jamaica Street warehouse: 122, 123 School of Art: 110, 166–8, 167–8,

169–70, 170, 196

Godwin, Edward: 62-4, 64, 151, 156

Goncourt, E. and J. de: 101, 235 n. 4
Gothic Revival: 19-20, 26, 56
Grammar of Ornament (Jones): 49
Grasset, Eugène: 234 n. 34
Great Exhibition of All Nations 1851:
40-42, 41-3, 55
Greene, G. T.: 124, 124
Grims Dyke: 61
Gropius, Walter: 38-9, 198, 206, 210,
211-17, 213, 215-16, 252
Güell, Eusebio: 112
Guild and School of Handicraft:
25-6, 54
Guimard, Hector: 102, 104, 194,

229 n. 26, 252 Hague, The, Oude Scheveningsche Weg (Nos. 42-4): 172, 172 Hampstead Garden Suburb: 176 Hankar, Paul: 99, 108 Hardman, John: 48 Hargreaves, James: 45 Harris, Thomas: 134 Hauptmann, Gerhard: 89 Haussmann, G.-E., Baron: 177 Haviland, John: 122 Heal, Sir Ambrose: 154, 155 Heimatschutz: 33 Heine, Th. Th.: 108 Helensburgh, Hill House: 171, 171 Hellerau: 176 Helsinki railway station: 238 n. 4 Hennebique, François: 144-6, 183 Heymel, Alfred Walter von: 202 History of the Modern Styles of Architecture (Fergusson): 134 Hodler, Ferdinand: 70, 85, 86, 88, 94-5, 96 Hoff, van't: 239 n. 10 Hoffmann, Josef: 36, 196-8, 198-9, 201, 204, 206, 223 n. 87, 237 n. 18, 240 nn. 13, 22, 252 Hofmann, Ludwig von: 108 Holabird, William: 141

Home Arts and Industries Association:

Horta, Victor: 96-7, 98, 99, 99, 100, 104, 105, 108, 156, 228 n. 8, 244, 252 Howard, Ebenezer: 176 Huntsman, Benjamin: 44 Huysmans, J. K .: 29, 84 Hyatt, Thaddeus: 144 Image, Selwyn: 99, 110 Impressionism: 70, 72, 78, 80, 82, 83, 86, 109, 150, 151, 152 Impressionists: 68, 70, 74, 82 Imprint type: 35 Industrial City, designed by Garnier: 181-3, 181-3, 185 Industrial Revolution: 20, 22, 44 Innendekoration: 230 n. 31 Israels, Josef: 109 Jacob's Creek, bridge: 128 Japanese woodcuts: 150, 235 n. 4 Jenney, William le Baron: 140 Johnston, W. J.: 124, 125 Jones, Owen: 46, 47, 48, 49, 235 n. 4 Jourdain, Frantz: 104 Journal of Design and Manufactures: 46 Jugend: 108, 110 Jugendstil: 110, 194, 195 Kahn, Albert: 204 Kay, J.: 45 Kay, R.: 45 Keats, John: 21 Kelmscott Press, 110, 154 Kew Gardens, lodge: 62 Khnopff, Fernand: 83, 84-5, 86, 89, 108, 109 Kindergarten Chats (Sullivan): 28 Kinmel Park: 62, 63 Klerk, Michel de: 237 n. 17

54

Horeau, Hector: 132

Horne, Herbert: 110

Klimt, Gustav: 173-4, 174, 195, 238 n. 18, 244, 252 Klinger, Max: 108, 109 Knight, T. A.: 132 Koch, Alexander: 230 n. 31 Koenen: 144 Koepping, Karl: 102, 108 Kramer, Piet: 237 n. 17 Kröller-Müller House, design: 206, Kröyer, Peter: 109 Kulturarbeiten: 33 Kunst und Kunsthandwerk: 108 Labrouste, Henri: 135 Lahor, Jean: 220 n. 17 Lalique: 108 Landesplanung: 214 Larsson, Carl: 109 Lechter, Melchior: 108 Le Corbusier: 146, 169, 184, 211, 217 Lemmen, Georges: 108 Letchworth Garden City: 176 Lethaby, W. R.: 220 n. 33, 238 n. 20, Le Vésinet, church: 234 n. 37 Leys Wood: 61 Liberty's: 108, 110, 150 Libre Esthétique, La: 108, 109, 221 Lichtwark, Alfred: 33, 108 Liebermann, Max: 109 Lightcliffe, church: 129 Liliencron, Detlev: 108 Linthorpe ware: 55 Liverpool, Oriel Chambers: 122, 123, St Anne: 129 St James's: 233 n. 23 Toxteth, St Michael: 130 Liverpool, Century Guild Exhibition 1886: 156-7, 157

London, Bishopsgate Institute: 236 n.

Carlton House Terrace: 130

Cheyne Walk: 162 Coal Exchange: 104, 135 Covent Garden Theatre: 129 Crystal Palace: 25, 132, 133, 134, 248 Ellerdale Road, Shaw's House: 61, Eros, Piccadilly Circus: 227 n. 3 Horniman Museum: 165, 165 King's Cross Station: 134 Mark Lane (Nos. 59-61): 232 n. 9 Mary Ward Settlement: 162, 163 Melbury Road (No. 9): 90, 93, 97, New Zealand Chambers: 60, 61-2 Notre Dame de France: 234 n. 37 Palace Green (No. 1): 59, 60 Queen's Gate (No. 170): 62, 63 Regent Street Quadrant: 130 St Dunstan's Road, studio: 158, 159 St Pancras Station: 132, 134 Selfridge's Store: 176 Whitechapel Art Gallery: 164, 164 White House, Tite Street: 64, 64, London Bridge, Telford's design: 126, 127 Loos, Adolf: 27, 28, 30, 39, 199-200, 200-201, 201, 204, 214, 222 nn. 62, 63, 244, 252 Lorillard: 120 Loudon, J. C.: 131, 132, 144 Louis, Victor: 118 Luban, chemical factory: 208, 211 Macdonald, Margaret: 166, 173 Mackenzie, Sir G. S.: 132 McKim, Mead, & White: 195, 249, 250, 251 Mackintosh, Charles Rennie: 39, 106, 146, 166–71, *167–71*, 172–5, *173*,

177, 180, 194, 196, 202, 214,

237 n. 18, 240 n. 22, 252 Mackmurdo, Arthur H.: 54, 55, 90, 91, 91, 98, 112, 156–7, 156–7, 158, 244, 252

McNair, Frances: 166

Madison, Wisconsin, Yahara Boat

Club: 187, 187

Maeterlinck, Maurice: 89, 174, 227

Maillart, Robert: 183-4, 186

Majorelle, Louis: 102

Mallarmé, Stéphane: 89, 108

Manet, Édouard: 68, 72, 73, 80, 150,

235 n. 4 Manzini: 109

Marinetti, Filippo: 38

Marx, Karl: 24 Maschinenstil: 33

Mason, J. H.: 35

Meier-Graefe, Julius: 101, 105, 108,

151, 175

Menai Suspension Bridge: 128 Mendelsohn, Erich: 210, 211

Menzel, Adolf von: 135

Merlshanger, near Guildford: 161,

162

Merton Works: 56

Messaggio (Sant' Elia): 37

Mey, J. M. van der: 172

Meyer, Adolf: 213, 215-16

Mies van der Rohe, Ludwig: 206, 209,

Milan, Nuove Tendenze Exhibition:

Minne, Georges: 109

Mirbeau, Octave: 101, 240 n. 27

Mir Isskustva: 108

Monet, Claude: 70, 80, 109, 135,

230 n. 32

Monier, Joseph: 144

Monotype Corporation: 35

Monticelli, Adolphe: 109

Moreau, Gustave: 84

Morris, William: 20, 21-5, 26, 28, 29,

31, 33, 38, 39, 48, 49-54, 50-52, 55, 56, 58, 68, 94, 100, 105, 110, 118,

146, 147, 148, 150, 151, 152, 154,

156, 224 n. 99, 225 n. 10, 244, 252

Morris, Marshall & Faulkner: 22

Moser, Kolo: 223 n. 87, 240 n. 13

Munch, Edvard: 70, 86-8, 87, 95-6,

96, 106, 247

Munich, Elvira Studio: 193, 194

Sezession: 108

Munich, Glaspalast Exhibition 1897:

Munich Werkstatten: 223 n. 87

Munthe, Gerhard: 108

Muthesius, Hermann: 32-3, 33-4, 35,

36-7, 38, 152, 210, 244

Nash, John: 118, 130, 131

Nasmyth, James: 44

Naumann, Friedrich: 34

Neo-Impressionists: 100

Nervi, Pier Luigi: 206

Nesfield, W. Eden: 61, 62, 63, 246

Newbery, Francis: 110, 166

New English Art Club: 108

Newport, R. I., Casino: 65, 66

Taylor House: 66

New York, Brooklyn Bridge: 138

Gold Street warehouse: 120, 122

Harper Bros Building: 121, 122

Pulitzer Building: 140

Shot tower: 125

Villard Houses: 66

Nicholson, W.: 77

Niemeyer, Adelbert: 232 n. 87

Noisiel-sur-Marne, Menier Factory:

125

Nolde, Emil: 80

Northampton, Bassett-Lowke House:

240 n. 17

Town Hall: 64

North Easton, Ames Gate Lodge: 65

Obrist, Hermann: 34, 105, 106, 107,

108, 110, 194, 228 n. 13

Oertel Monument: 229 n. 25

Œuvre artistique, L': 110

Olbrich, Josef Maria: 106, 194, 195-6,

196, 202-3, 240 n. 14, 252

Oldenburg Exhibition 1905: 202-3, Plumet, Charles: 102, 108, 109 204 Poelzig, Hans: 36, 206-10, 209, 211, Omega Workshops: 239 n. 8 211, 252 Ornament in Architecture (Sullivan): Port Sunlight: 176 28 Potsdam, Einstein Tower: 210 Österreichisches Museum, Vienna: 28 Pottsville, Pa, Farmers' and Miners' Oxford Museum: 104, 135 Bank: 122 Powell, John Hardman: 54 Paine, Tom: 126 Préfontaine: 125 Palmerston, Lord: 19, 20 Pre-Raphaelites: 22, 53, 59, 83, 84, 90, Pan: 105, 105, 108 91,94 Paris, Bibliothèque Ste Geneviève: Pritchard, Thomas Farnoll: 126, 127 135 Pryde, J.: 77 Castel Béranger: 102, 104 Pugin, A. W. N.: 23, 47-8, 48, 56, 133, Conservatoire des Arts et des 136, 137, 229 n. 13 Métiers: 44 Purcell, W. G.: 239 n. 10 Eiffel Tower: 139, 140 Purkersdorf, Convalescent Home: Gare de l'Est: 134-5 197, 198 Halles au Blé: 131 Jardin des Plantes: 132 Queensferry Factory, near Chester: Market Halls: 132 237, 239 n. 20 Métro stations: 102 Rue Franklin (No. 25 bis): 179-80, Raffaelli, Jean: 109 180, 183 Railway stations: 25, 134-5 St Augustin: 136 Redgrave, Richard: 46 Redon, Odilon: 84, 109 St Eugène: 135, 136 St Jean de Montmartre: 145, 146, Renoir, Auguste: 68, 69, 70, 80, 109, St Ouen Docks: 125 Revue des arts décoratifs: 108 Richardson, Henry Hobson: 65, 65, Samaritaine Store: 104 Paris International Exhibition 1889: 101, 142, 164-5, 186, 252 138, 140 Ricketts, Charles: 91, 106 Parker, Barry: 176 Rickman, Thomas: 130 Pasquali: 230 n. 26 Riemerschmid, Richard: 34, 110, 176, Paul, Bruno: 36 206, 223 n. 87 Paxton, Sir Joseph: 132, 133 Rimbaud, Jean: 89 Perret, Auguste: 179-80, 180, 183, Rinaldi, Antonio: 118 184, 199, 201, 214, 238 n. 1, 244, River Forest, Illinois, Winslow House: 186, 188 Philadelphia, Broad Street Station: Riverside, Illinois, Coonley House: 132 190 Germantown Cricket Club: 66, 66 Roche, Martin: 141 Jayne Building: 124-5, 125 Root, J. W.: 142, 143, 252 Picasso, Pablo: 116

Rossetti, Dante Gabriel: 22, 49, 90,

227 n. 5

Pissarro, Camille: 86

Rousseau, Henri: 70, 79, 80-81, 81, 82,88 Ruskin, John: 19, 22, 23, 25, 26, 28, 39, 133, 134, 135, 146, 151 Saarinen, Eliel: 238 n. 4 Sachlichkeit: 32-3, 38, 152 St Louis, Wainright Building: 141-2, 141 Wainwright Tomb, Bellefontaine Cemetery: 240 n. 14 Saintenoy, Paul: 104 Salon des Indépendants: 109 Salon du Champs de Mars: 109 Salt, Sir Titus: 176 Saltaire: 176 Santa Coloma de Cervelló: 111, 112 Sant'Elia, Antonio: 37, 38, 210–11, 212, 224 n. 25, 244 Saulnier, Jules: 125 Schäfer, Wilhelm: 34 Schelling, F. W. J. von: 21 Schiele, E.: 238 n. 18 Schiller, J. C. F. von: 21 Schinkel, C. F.: 121, 204, 206 Schlaf, Johannes: 108 Schmidt, Karl: 34 Schröder, R. A.: 202, 203, 240 nn. 21, 22 Schultze-Naumburg, Paul: 33 Schuyler, Montgomery: 28 Schuylkill Bridge: 128 Schwabe, Carlos: 238 n. 19 Scott, Sir George Gilbert: 19–20, 56, 134 Sedding, John D.: 26-7, 116 Segantini, Giovanni: 109 Selmersheim, Tony: 102, 108 Semper, Gottfried: 56, 122

Serrurier-Bovy, Gustave: 98, 108, 110,

Seurat, Georges: 70, 77-9, 79, 80, 82,

Seven Lamps of Architecture (Ruskin):

253

109

Sérusier, Paul: 74, 78

Shannon, Charles: 91 Shaw, Richard Norman: 60-62, 60-61, 63, 64, 65, 66, 144, 148, 154, 157, 162, 176, 194, 246 Sheerness Naval Dockyard: 124, 124 Shelley, Percy Bysshe: 21 Shrewsbury, St Alkmund: 130 St Chad: 129 Sickert, Walter: 109 Siemens, W. von: 140 Signac, Paul: 109, 247, 248 Simplizissimus: 108 Sisley, Alfred: 109 Sitte, Camillo: 177-8 Six, Les: 102 Slöjdsförening: 36 Smirke, Sir Robert: 119, 129 Smith, Dunbar: 162, 163 Soane, Sir John: 118, 130 Sommaruga, Giuseppe: 229 n. 26 Städtebau, Der (periodical): 178 Städtebau, Der (Sitte): 177 Steer, Wilson: 109 Steinlen, T. A.: 77 Steuart, George: 129 Stile Liberty: 110 Street, G. E.: 22, 26, 58 Strutt, William: 119, 120, 121 Stuck, Franz von: 108 Studio: 93, 107-8, 174 Sturgis, Russell: 28 Stuttgart, railway station: 239 n. 4 Sullivan, Louis: 27, 28, 29, 31, 96-8, 97, 101, 141-2, 141, 176, 184, 186, 187-8, 229 n. 25, 240 n. 14, 244 Sumner, Heywood: 91, 110 Sunderland Bridge: 126 Swiss Werkbund: 36 Tavenasa Bridge: 183, 186 Telford, Thomas: 126, 127, 128 Tiffany, Louis C.: 102, 103, 108, 244 Tomorrow (Howard): 176

23, 133

Shackleford, Grane House: 159, 161

Toorop, Jan: 70, 84, 85-6, 88, 89, 94, 95, 98, 106, 108, 110, 175, 227 n. 20, 238 n. 19
Toulouse-Lautrec, Henri de: 77, 109, 110
Tourcoing, spinning mill: 146
Townsend, C. Harrison: 108, 110, 164-5, 164-5, 236 n. 14, 249

True Principles of Pointed or Christian Architecture, The (Pugin): 47 Turner, C. A. P.: 184

Turner, J. M. W.: 135, 211 *Typenmöbel*: 35

Uccle, van de Velde's house, chairs: 100, 100, 101

Uhde, Fritz: 109 Unit furniture: 35 Unwin, Raymond: 176

Vallotton, Félix: 76–7, 77, 80, 108, 248

van de Velde, Henri: 27, 28, 29–30, 36, 37, 39, 98, 99–101, 100, 105, 106, 108, 110, 142, 148, 151, 175, 184, 221 n. 45, 228 n. 13, 229 n. 21, 244, 253

van Gogh, Vincent: 70, 71-3, 72, 75, 80, 87, 89, 109, 150, 151

Verlaine, Paul: 89, 108 Ver Sacrum: 108, 174

Victoria and Albert Museum: 56, 106, 226 n. 12

Vienna, Post Office Savings Bank: 200-201, 202

Railway Station: 239 n. 4

Ringstrasse: 177

Sezession: 30, 105, 108, 173, 174, 195, 196, 202-3

Steiner House: 200, 201

Vienna Sezession Exhibition 1900: 166, 174

Vingt, Les: 85,98–9,109,151,221 n.45 Viollet-le-Duc, E.-E.: 32, 104, 112, 125, 136–8, 137, 146 Voysey, Charles F. Annesley: 29, 39, 107, 108, 110, 148-50, 149, 152, 153, 154, 156, 157-62, 158-63, 164, 165, 169, 171, 175, 186-7, 228 n. 8, 236 n. 11, 238 n. 19, 253

Wagner, Otto: 27, 28, 30, 194-5, 200-201, 202, 244, 253

Walker, Emery: 54, 154 Walter, Thomas U.: 124, 125

Ward, William E.: 144

Wärndorfer, Fritz: 174, 240 n. 13

Watt, James: 45, 110 Wayss, G. A.: 144 Webb, Philip: 57-9, 58-60

Wedgwood, Josiah: 20 Weimar Art School: 36, 38

Staatliches Bauhaus: 38

Werkbund, see Deutscher Werkbund, Austrian Werkbund, Swiss Werkbund

Whistler, J. A. McNeill: 64, 108, 109, 150-51, 235 n. 4, 236 nn. 5, 6

White, Stanford: 65-6, 66, 195

Whitman, Walt: 27

Wiener Werkstätte: 174, 195, 240 n. 13

Wilde, Oscar: 27, 89, 236 n. 7 Wilkins, William: 119

Wilkinson, John: 126, 129

Woodward, Benjamin: 135 Wright, Frank Lloyd: 27-8, 31, 39,

169, 184, 186–93, *188–92*, 195, 201, 214, 239 n. 10

Wyatt, James: 118
Wyatt, Sir Matthew Digby: 46, 48,

Yachting Style: 101 Youth Movement: 152

Zola, Émile: 27

133-4